RUNNING BEYOND

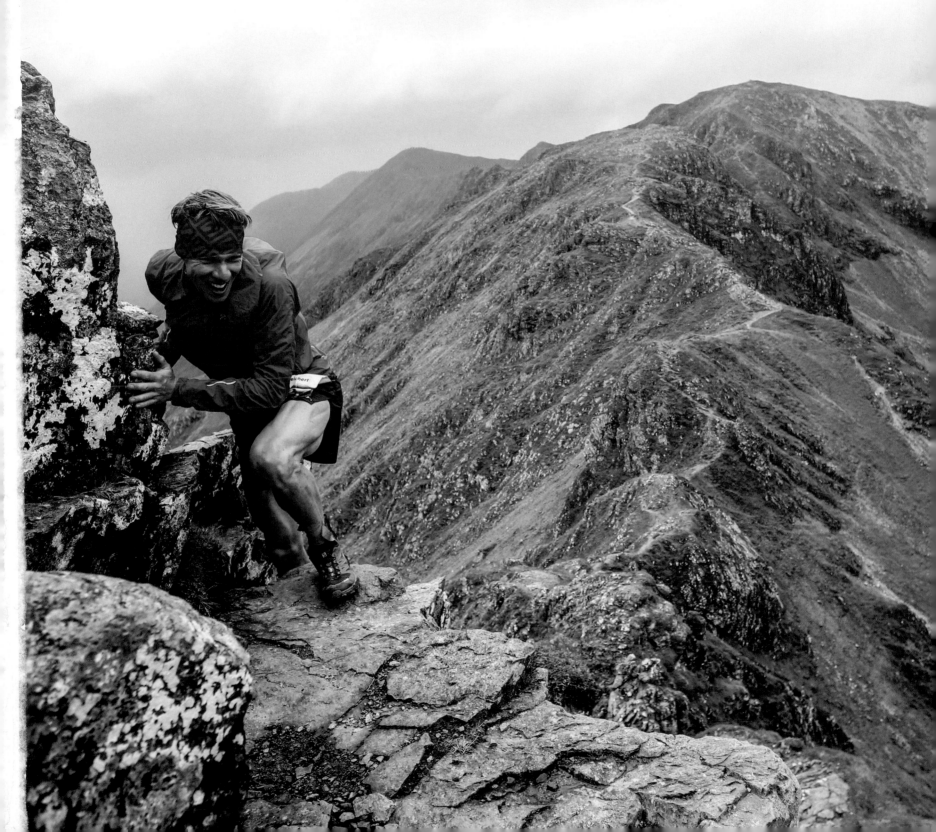

Brimming with creative inspiration, how-to projects and useful information to enrich your everyday life, Quarto Knows is a favourite destination for those pursing their interests and passions. Visit our site and dig deeper with our books into your area of interest: Quarto Creates, Quarto Cooks, Quarto Homes, Quarto Lives, Quarto Drives, Quarto Explores, Quarto Gifts, or Quarto Kids.

www.QuartoKnows.com

First published in 2016 by Aurum Press,
an imprint of The Quarto Group
The Old Brewery
6 Blundell Street
London, N7 9BH
United Kingdom

A catalogue record for this book is available from the British Library.

ISBN 978 1 78131 525 5
Ebook ISBN 978 1 78131 650 4

3 5 7 9 10 8 6 4 2
2018 2020 2019 2017

Designed by The Urban Ant Ltd
Maps by Mark Franklin
Printed in China

RUNNING BEYOND

Epic ultra, trail and skyrunning races

Ian Corless
Foreword by Kilian Jornet

Aurum
Press

Contents

Foreword ... 06

Introduction .. 08

Transvulcania Ultramarathon 12

Transgrancanaria ... 22

Haría Extreme .. 30

Ultra Skymarathon Madeira 36

Ultra Pirineu .. 40

Zegama–Aizkorri ... 46

Ronda dels Cims ... 52

Trail Menorca Camí de Cavalls 60

Ice Trail Tarentaise ... 66

La Grande Trail des Templiers 74

Mont-Blanc 80km .. 78

Ultra-Trail du Mont-Blanc 84

Dragon's Back Race ... 90

Lakeland 100 & 50 ... 96

Glen Coe Skyline ... 102

Mourne Skyline MTR 108

Tromsø SkyRace .. 116

Sierre–Zinal .. 122

Matterhorn Ultraks .. 130

Transalpine-Run .. 138

Dolomites Skyrace and VK 140

Limone Extreme .. 146

Trofeo Kima ... 152

Marathon des Sables ... 160

Comrades Marathon .. 168

Richtersveld Transfrontier Wildrun 170

Iznik Ultra .. 180

Lantau 2 Peaks .. 186

Everest Trail Race ... 192

Buffalo Stampede ... 202

Run the Rut ... 204

Superior 100 ... 210

Western States ... 216

Grand to Grand .. 218

The Coastal Challenge .. 228

Glossary .. 236

Acknowledgements .. 237

Index ... 238

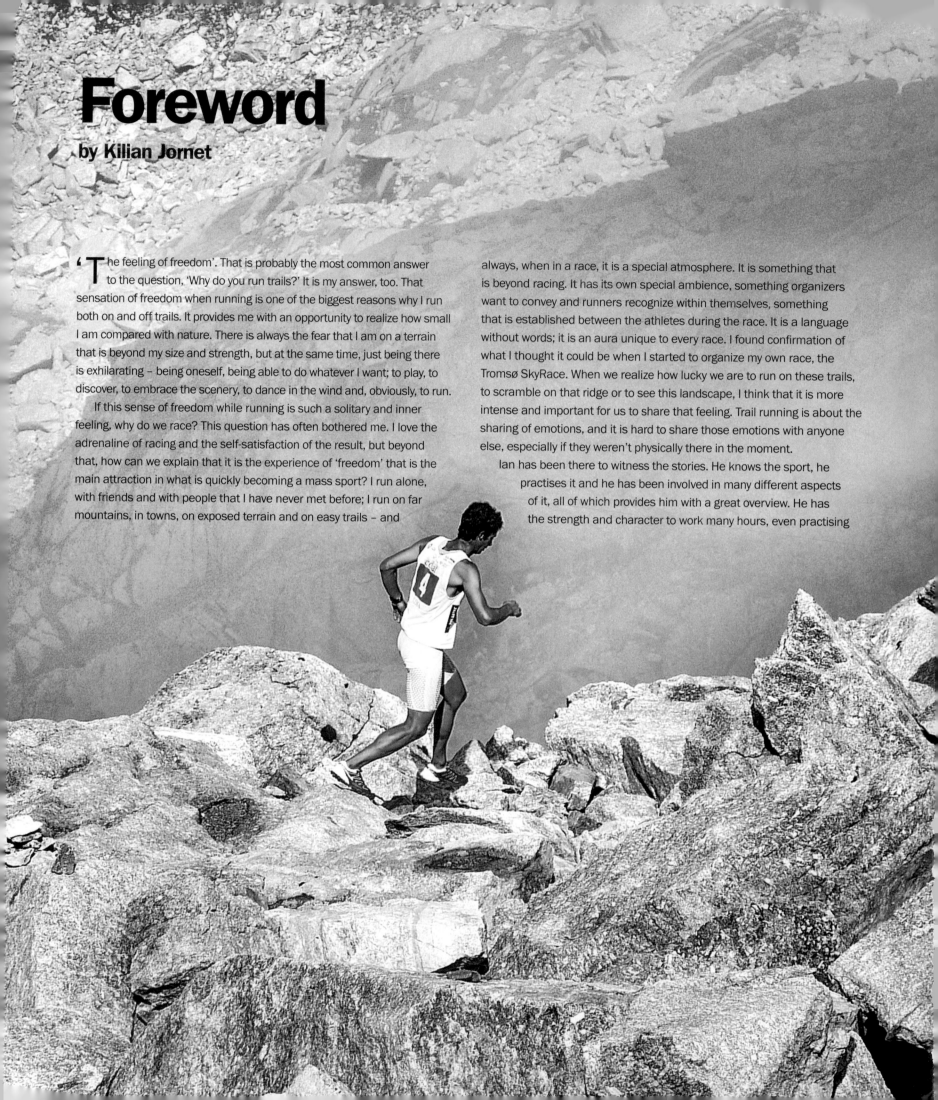

Foreword

by Kilian Jornet

'The feeling of freedom'. That is probably the most common answer to the question, 'Why do you run trails?' It is my answer, too. That sensation of freedom when running is one of the biggest reasons why I run both on and off trails. It provides me with an opportunity to realize how small I am compared with nature. There is always the fear that I am on a terrain that is beyond my size and strength, but at the same time, just being there is exhilarating – being oneself, being able to do whatever I want; to play, to discover, to embrace the scenery, to dance in the wind and, obviously, to run.

If this sense of freedom while running is such a solitary and inner feeling, why do we race? This question has often bothered me. I love the adrenaline of racing and the self-satisfaction of the result, but beyond that, how can we explain that it is the experience of 'freedom' that is the main attraction in what is quickly becoming a mass sport? I run alone, with friends and with people that I have never met before; I run on far mountains, in towns, on exposed terrain and on easy trails – and

always, when in a race, it is a special atmosphere. It is something that is beyond racing. It has its own special ambience, something organizers want to convey and runners recognize within themselves, something that is established between the athletes during the race. It is a language without words; it is an aura unique to every race. I found confirmation of what I thought it could be when I started to organize my own race, the Tromsø SkyRace. When we realize how lucky we are to run on these trails, to scramble on that ridge or to see this landscape, I think that it is more intense and important for us to share that feeling. Trail running is about the sharing of emotions, and it is hard to share those emotions with anyone else, especially if they weren't physically there in the moment.

Ian has been there to witness the stories. He knows the sport, he practises it and he has been involved in many different aspects of it, all of which provides him with a great overview. He has the strength and character to work many hours, even practising

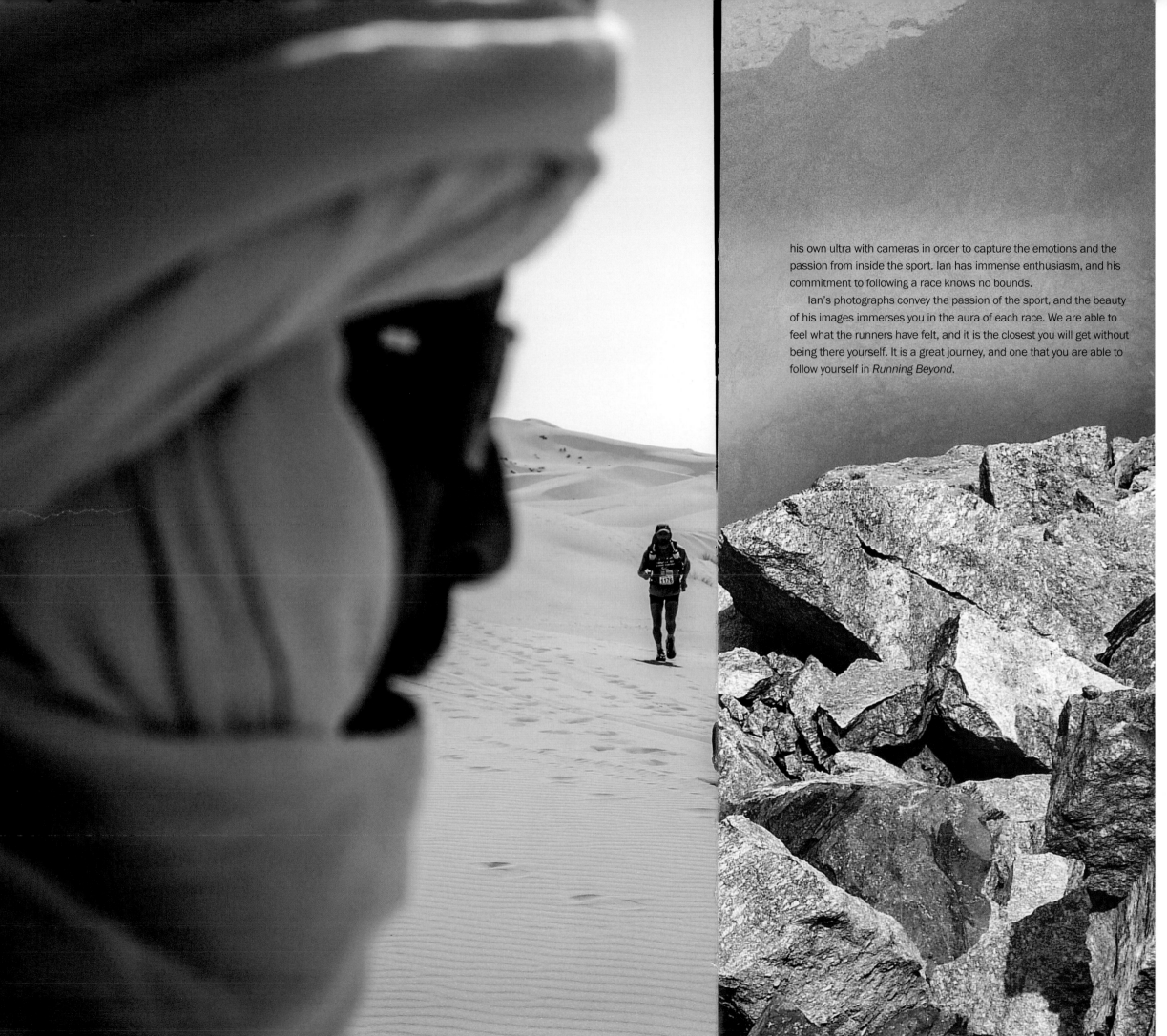

his own ultra with cameras in order to capture the emotions and the passion from inside the sport. Ian has immense enthusiasm, and his commitment to following a race knows no bounds.

Ian's photographs convey the passion of the sport, and the beauty of his images immerses you in the aura of each race. We are able to feel what the runners have felt, and it is the closest you will get without being there yourself. It is a great journey, and one that you are able to follow yourself in *Running Beyond*.

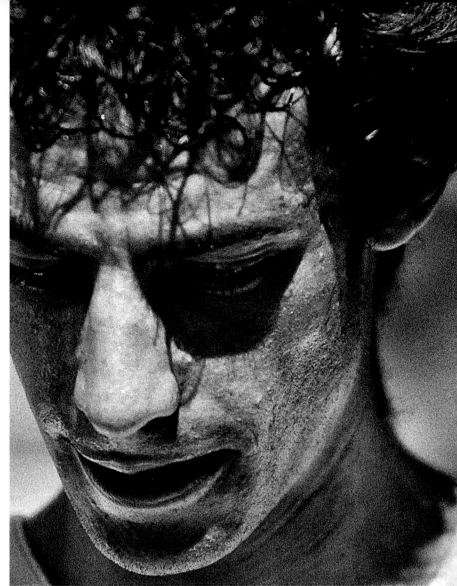

❛ I RUN ALONE, WITH FRIENDS and with people I've never met before.'

Kilian Jornet

Kilian Jornet runs in the sky, across one of the many technical ridges at the iconic Trofeo Kima in Italy. It is a race he has won multiple times and holds the course record for.

Introduction

I was above the clouds. In the distance, two silhouettes broke the horizon and the buzz of a low-flying helicopter confirmed the arrival of Kilian Jornet and Dakota Jones. The sun was beating down, but the high altitude and the gently blowing wind reduced the ambient temperature to a bearable 'chilly'. Running the switchback bends in the trail, the duo climbed the technical terrain towards me as though it was smooth asphalt. I was photographing two of the best mountain runners in the world in a race that soon would become legendary in the world of trail, mountain, ultra and skyrunning: Transvulcania. I was hooked.

Running, and in particular trail running, is a spontaneous, organic, holistic and unassuming sport. In a world where technology bombards us daily, the opportunity to find solace on a stretch of dirt, on the side of a mountain or, if one is fortunate enough, in the clouds, is a process that I have found to be an essential part of my daily life. Trails offer a freedom and an isolation from the assault on the senses of urban life.

Producing a book like *Running Beyond* is, of course, personal. I am lucky to have had the opportunity to have interwoven my love for both sport and photography, and to enjoy a profession that I would not trade for anything. The words and images bound between the front and back covers of this book are not all encompassing; this is not an A–Z volume of trail running. It is instead a journey of experiences, documented over four years to provide an insight into what I consider to be some of the most wonderful races that the world has to offer.

I have run the trails, climbed the mountains, sat in the rain, snow, wind, sun, cloud and intense heat, and I have waited. I have waited for a story to unfold in front of me, as these incredible athletes tackle some of the world's most extreme terrains and conditions. Photography captures a millisecond in time and, in doing so, tells the story of runner and race.

Through watching great champions and following the last man or woman to the line, I have witnessed a universal truth. Trail running is more than a sport; it is a metaphor for life. Boundaries are removed, languages are eradicated and the trails become a playground of sharing. It is an opportunity to understand the process of our innate ability for perpetual forward motion. At times the journey is a brutal one and we fail; on other days it is euphoric and rewarding. There are no guarantees.

Amphitheatres of rock, grass and trail have replaced the Coliseum, and today our gladiators are runners, working their c▮ battle to the line. Running long, running high and run▮ the goal; untethered from daily woes, our sport offers▮

From the high peaks of the Dolomites and the bea▮ Costa Rican jungle, to the dry, arid desolation of the Sa▮ of Nepal and the rugged, jagged and brutal slopes of I▮ is a gateway to what is possible. It is a doorway to ano▮ list of experiences and opportunities that affords you, ▮ my memories so that you can create new memories of ▮

I hope I have created a new trail with *Running Bey▮ beginning but no end. It is you who must create the e▮ Flick through the pages, stop, dream and make plans▮

I will see you on the trails, and as you pass, say h▮ freedom that the trails provide is for us all. I, for one, ▮ with the world, and writing *Running Beyond* has prov▮

BELOW: The stunning Himalayan mountains, in Nepal.

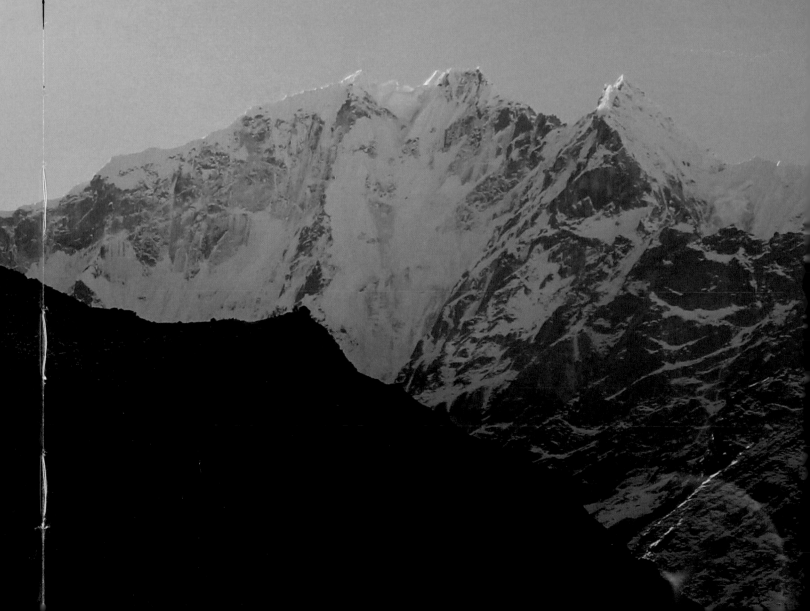

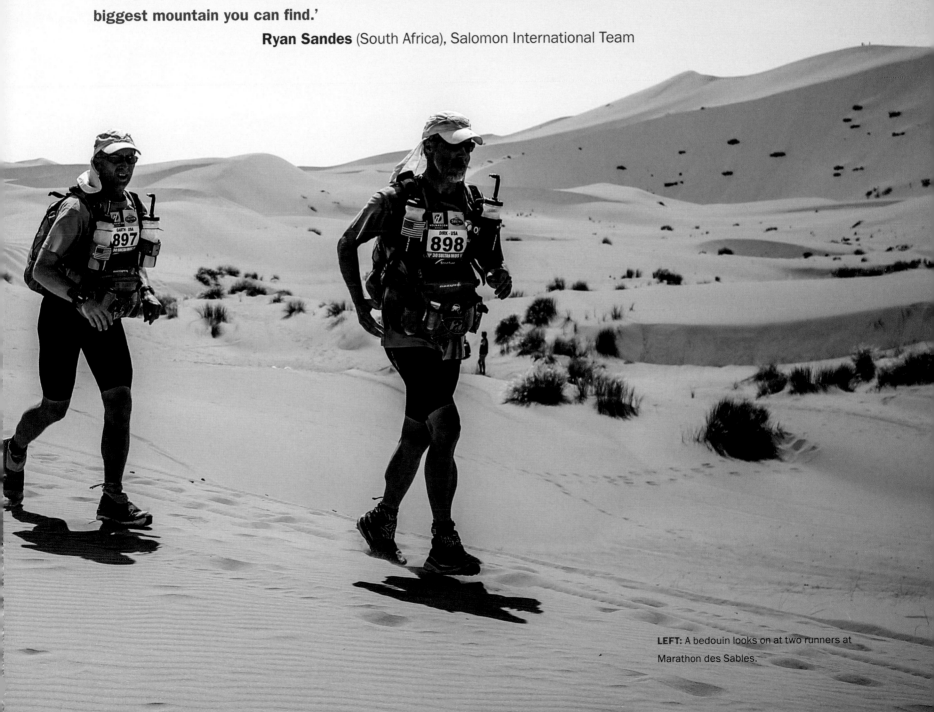

' IAN HAS BEEN DOCUMENTING TRAIL RUNNING SINCE I CAN REMEMBER.
His images, writing and podcasts have played a major role in showcasing
our sport and growing it into the global sport it has become today. Ian is
really well respected in the trail-running community; extremely passionate,
he really understands what trail running is about and this you can see in his
incredible images. Ian captures the runner's emotion, the natural beauty
and race atmosphere – making me want to put on my shoes and head out
the door for a run. *Running Beyond* is a must-get book for all trail runners.
The epic visuals will make you want to put on your shoes and run up the
biggest mountain you can find.'

Ryan Sandes (South Africa), Salomon International Team

LEFT: A bedouin looks on at two runners at
Marathon des Sables.

Transvulcania Ultramarathon 74km

Spain

Mountains, volcanos, beaches, forests, a tropical rainforest, tiny villages and breathtaking views; La Palma is the jewel in the Canaries' crown. Many consider it to be the most beautiful and idyllic Canary Island – unspoilt by tourism and ideal for rest, peace and quiet, it is a treasure for the walker, hiker or runner.

Although the island is relatively small, it is shaped like a question mark and each curve has many surprisingly different areas of natural beauty. The south of the island is dominated by the dramatic Cumbre Vieja – a central spine of steep volcanos that create a blackened wasteland in stark contrast to the wild and green vistas of the north. Linking the two sides is the Caldera, the largest water-erosion crater in the world. Its steep slopes inside and out create a natural central ridge.

These incredible rock formations create the perfect landscape for a mountain race. The Transvulcania Ultramarathon follows the famous GR131 route that takes runners from the sea in the south to the sea in the north. In its origins, this path connected the localities furthest away from each other.

The race route starts at the Fuencaliente lighthouse at sea level and follows the GR131 all the way to Tazacorte port, finishing with a sting in the tail as runners are tested with a final climb up to the town in Los Llanos de Aridane. It's a logical route with no ambiguity.

Anna Frost, from New Zealand, has made the race her own ever since winning in 2012. 'The start is chaos, people sprint and then suddenly you are in a one-metre-wide trail. Rocks are everywhere, it's a black sandpit and it's dark. Along with that you have supporters making noise; it really is bonkers. To get around people you have to go around the rocks. It's a volcano, after all, and the floor moves. After Los Canarios, around seven kilometres, I like to push on.'

From Los Canarios, dense pine forests offer a stark contrast to the opening kilometres. Under foot, the terrain now mixes black lava sand with pine needles and rocks, but running is easier than the climb and offers an opportunity to stretch the legs to full stride.

Climbing up, the trees eventually start to subside and you emerge in the 'Route of the Volcanos'. The southern ridge of the island is where

RIGHT: Niandi Carmont runs above the clouds on the Transvulcania course.
NEXT PAGE: Fuencaliente lighthouse signifies the early-morning start – from sea to mountains.

Transvulcania Ultramarathon 74km

Spain

Mountains, volcanos, beaches, forests, a tropical rainforest, tiny villages and breathtaking views; La Palma is the jewel in the Canaries' crown. Many consider it to be the most beautiful and idyllic Canary Island – unspoilt by tourism and ideal for rest, peace and quiet, it is a treasure for the walker, hiker or runner.

Although the island is relatively small, it is shaped like a question mark and each curve has many surprisingly different areas of natural beauty. The south of the island is dominated by the dramatic Cumbre Vieja – a central spine of steep volcanos that create a blackened wasteland in stark contrast to the wild and green vistas of the north. Linking the two sides is the Caldera, the largest water-erosion crater in the world. Its steep slopes inside and out create a natural central ridge.

These incredible rock formations create the perfect landscape for a mountain race. The Transvulcania Ultramarathon follows the famous GR131 route that takes runners from the sea in the south to the sea in the north. In its origins, this path connected the localities furthest away from each other.

The race route starts at the Fuencaliente lighthouse at sea level and follows the GR131 all the way to Tazacorte port, finishing with a sting in the tail as runners are tested with a final climb up to the town in Los Llanos de Aridane. It's a logical route with no ambiguity.

Anna Frost, from New Zealand, has made the race her own ever since winning in 2012. 'The start is chaos, people sprint and then suddenly you are in a one-metre-wide trail. Rocks are everywhere, it's a black sandpit and it's dark. Along with that you have supporters making noise; it really is bonkers. To get around people you have to go around the rocks. It's a volcano, after all, and the floor moves. After Los Canarios, around seven kilometres, I like to push on.'

From Los Canarios, dense pine forests offer a stark contrast to the opening kilometres. Under foot, the terrain now mixes black lava sand with pine needles and rocks, but running is easier than the climb and offers an opportunity to stretch the legs to full stride.

Climbing up, the trees eventually start to subside and you emerge in the 'Route of the Volcanos'. The southern ridge of the island is where

RIGHT: Niandi Carmont runs above the clouds on the Transvulcania course.
NEXT PAGE: Fuencaliente lighthouse signifies the early-morning start – from sea to mountains.

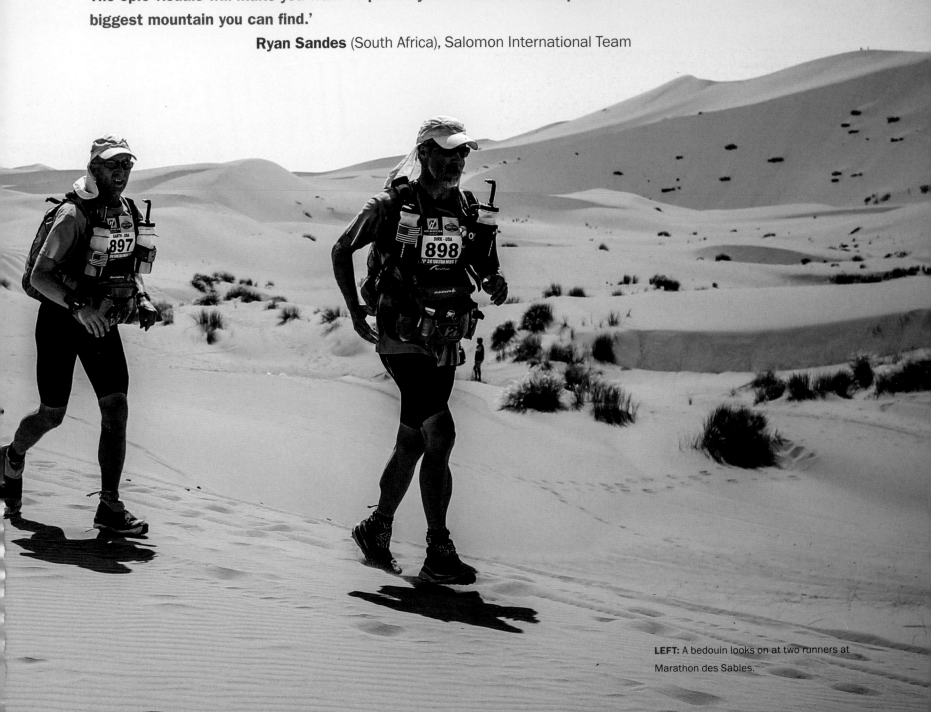

'IAN HAS BEEN DOCUMENTING TRAIL RUNNING SINCE I CAN REMEMBER. His images, writing and podcasts have played a major role in showcasing our sport and growing it into the global sport it has become today. Ian is really well respected in the trail-running community; extremely passionate, he really understands what trail running is about and this you can see in his incredible images. Ian captures the runner's emotion, the natural beauty and race atmosphere – making me want to put on my shoes and head out the door for a run. *Running Beyond* is a must-get book for all trail runners. The epic visuals will make you want to put on your shoes and run up the biggest mountain you can find.'

Ryan Sandes (South Africa), Salomon International Team

LEFT: A bedouin looks on at two runners at Marathon des Sables.

his own ultra with cameras in order to capture the emotions and the passion from inside the sport. Ian has immense enthusiasm, and his commitment to following a race knows no bounds.

Ian's photographs convey the passion of the sport, and the beauty of his images immerses you in the aura of each race. We are able to feel what the runners have felt, and it is the closest you will get without being there yourself. It is a great journey, and one that you are able to follow yourself in *Running Beyond*.

❛ I RUN ALONE, WITH FRIENDS and with people I've never met before.'

Kilian Jornet

Kilian Jornet runs in the sky, across one of the many technical ridges at the iconic Trofeo Kima in Italy. It is a race he has won multiple times and holds the course record for.

Introduction

I was above the clouds. In the distance, two silhouettes broke the horizon and the buzz of a low-flying helicopter confirmed the arrival of Kilian Jornet and Dakota Jones. The sun was beating down, but the high altitude and the gently blowing wind reduced the ambient temperature to a bearable 'chilly'. Running the switchback bends in the trail, the duo climbed the technical terrain towards me as though it was smooth asphalt. I was photographing two of the best mountain runners in the world in a race that soon would become legendary in the world of trail, mountain, ultra and skyrunning: Transvulcania. I was hooked.

Running, and in particular trail running, is a spontaneous, organic, holistic and unassuming sport. In a world where technology bombards us daily, the opportunity to find solace on a stretch of dirt, on the side of a mountain or, if one is fortunate enough, in the clouds, is a process that I have found to be an essential part of my daily life. Trails offer a freedom and an isolation from the assault on the senses of urban life.

Producing a book like *Running Beyond* is, of course, personal. I am lucky to have had the opportunity to have interwoven my love for both sport and photography, and to enjoy a profession that I would not trade for anything. The words and images bound

between the front and back covers of this book are not all encompassing; this is not an A–Z volume of trail running. It is instead a journey of experiences, documented over four years to provide an insight into what I consider to be some of the most wonderful races that the world has to offer.

I have run the trails, climbed the mountains, sat in the rain, snow, wind, sun, cloud and intense heat, and I have waited. I have waited for a story to unfold in front of me, as these incredible athletes tackle some of the world's most extreme terrains and conditions. Photography captures a millisecond in time and, in doing so, tells the story of runner and race.

Through watching great champions and following the last man or woman to the line, I have witnessed a universal truth. Trail running is more than a sport; it is a metaphor for life. Boundaries are removed, languages are eradicated and the trails become a playground of sharing. It is an opportunity to understand the process of our innate ability for perpetual forward motion. At times the journey is a brutal one and we fail; on other days it is euphoric and rewarding. There are no guarantees.

Amphitheatres of rock, grass and trail have replaced the Coliseum, and today our gladiators are runners, working their craft head to head in a battle to the line. Running long, running high and running free is ultimately the goal; untethered from daily woes, our sport offers freedom.

From the high peaks of the Dolomites and the beauty and heat of a Costa Rican jungle, to the dry, arid desolation of the Sahara, the high peaks of Nepal and the rugged, jagged and brutal slopes of Italy, *Running Beyond* is a gateway to what is possible. It is a doorway to another world, a bucket list of experiences and opportunities that affords you, the reader, to relive my memories so that you can create new memories of your own.

I hope I have created a new trail with *Running Beyond*, one with a beginning but no end. It is you who must create the end of this journey. Flick through the pages, stop, dream and make plans.

I will see you on the trails, and as you pass, say hello. After all, the freedom that the trails provide is for us all. I, for one, want to share them with the world, and writing *Running Beyond* has provided that opportunity.

BELOW: The stunning Himalayan mountains, in Nepal.

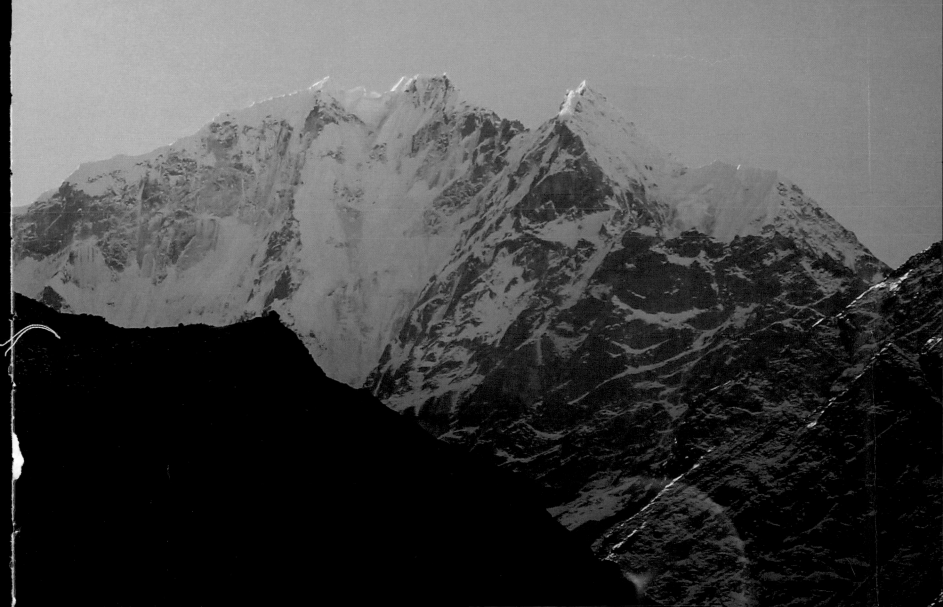

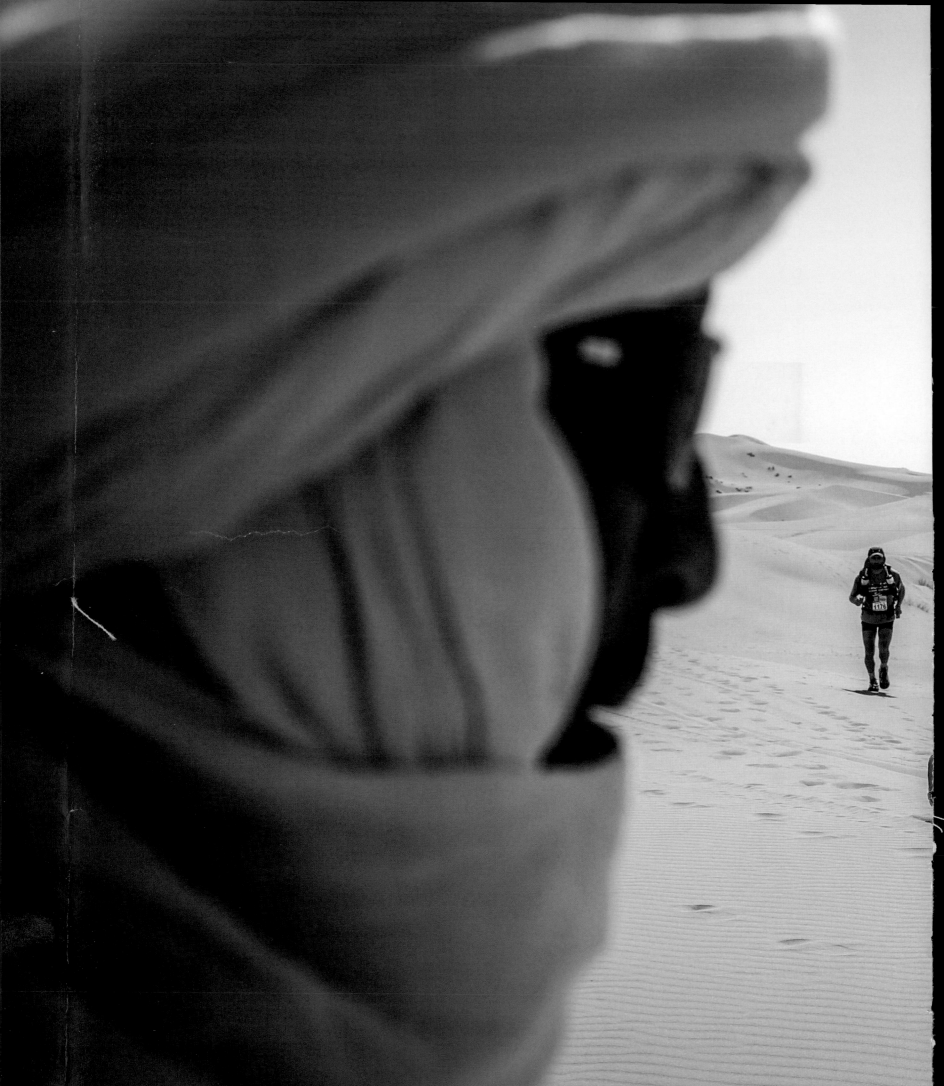

most of the volcanos are lined up. Early sections of the course include two key volcanos, San Antonio and Teneguía, the latter last erupting in 1971. The first kilometres are tough going, and most certainly a struggle on race day with some 1,500-plus runners. The path is often narrow, with loose black sand or rocks. It is an incredible route, sometimes very runnable, at other times hard work due to the increasing steepness of the path and loose, deep lava sand.

The final sections of the volcano route offer good, fast running to El Pilar. Heading north for the crest of La Cumbre Nueva, a forest trail leads to El Reventón (1,350 metres). Initially this section provides some of the easiest running so far; the gradients are easier and underfoot one has fewer obstacles.

The path climbs the successive and increasingly high peaks to the Taburiente crater. The rim is an incredible natural wonder, offering technical running terrain, constant changes in elevation and some of the most amazing views you will ever see. Depending on the weather systems, you will either have clear blue skies and the ability to look out

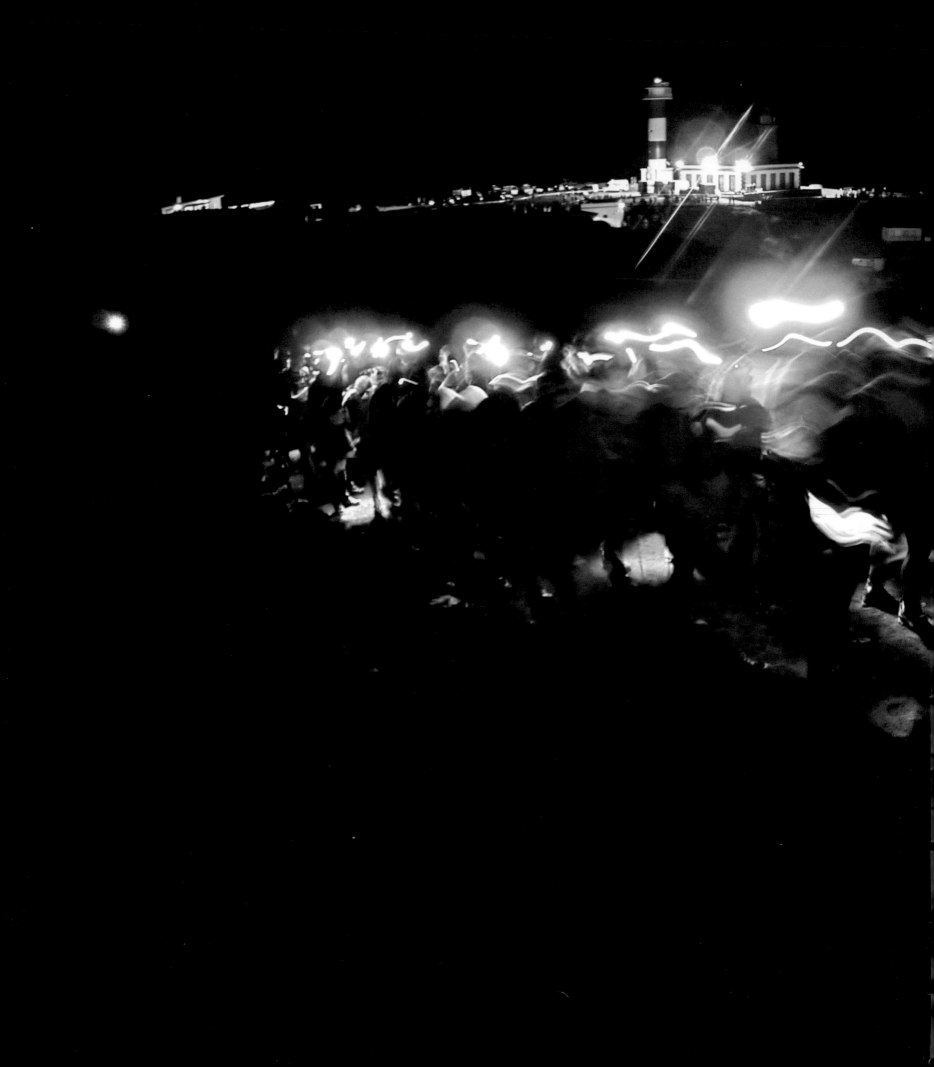

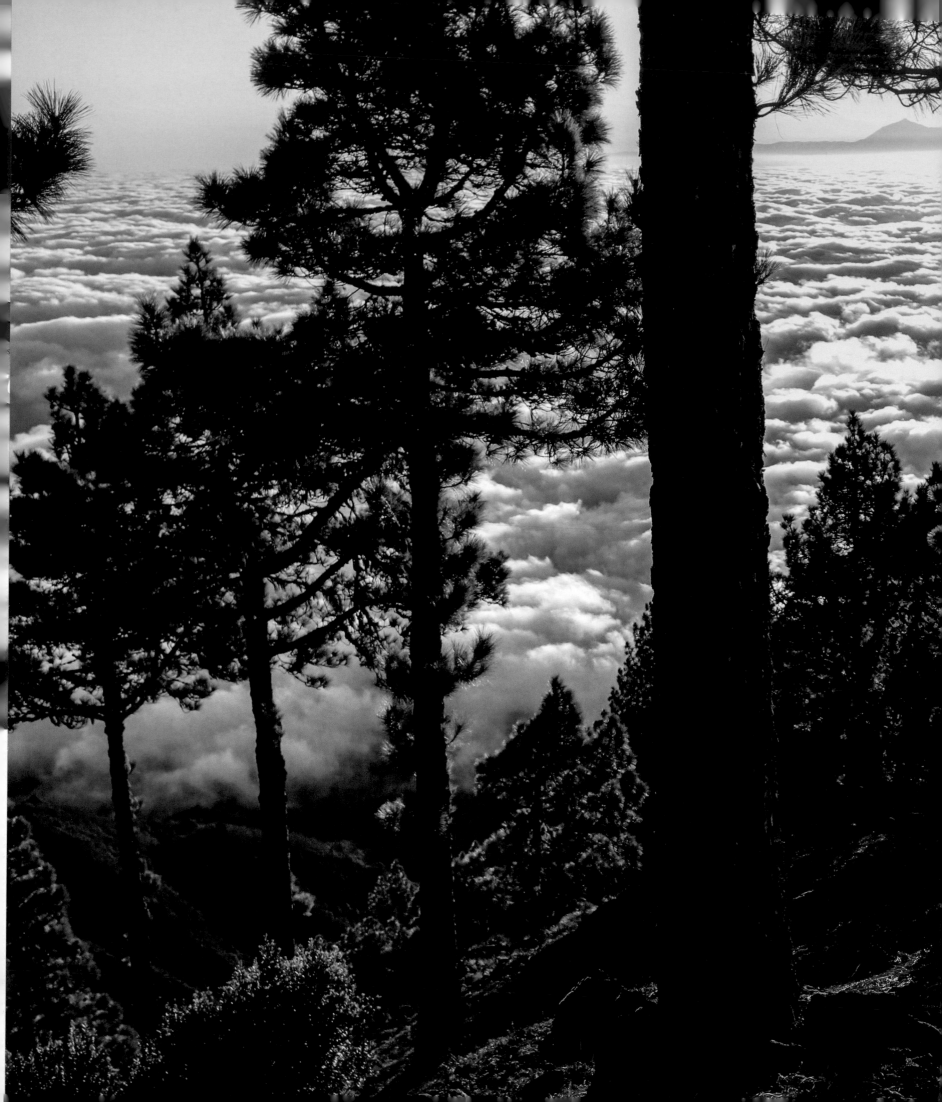

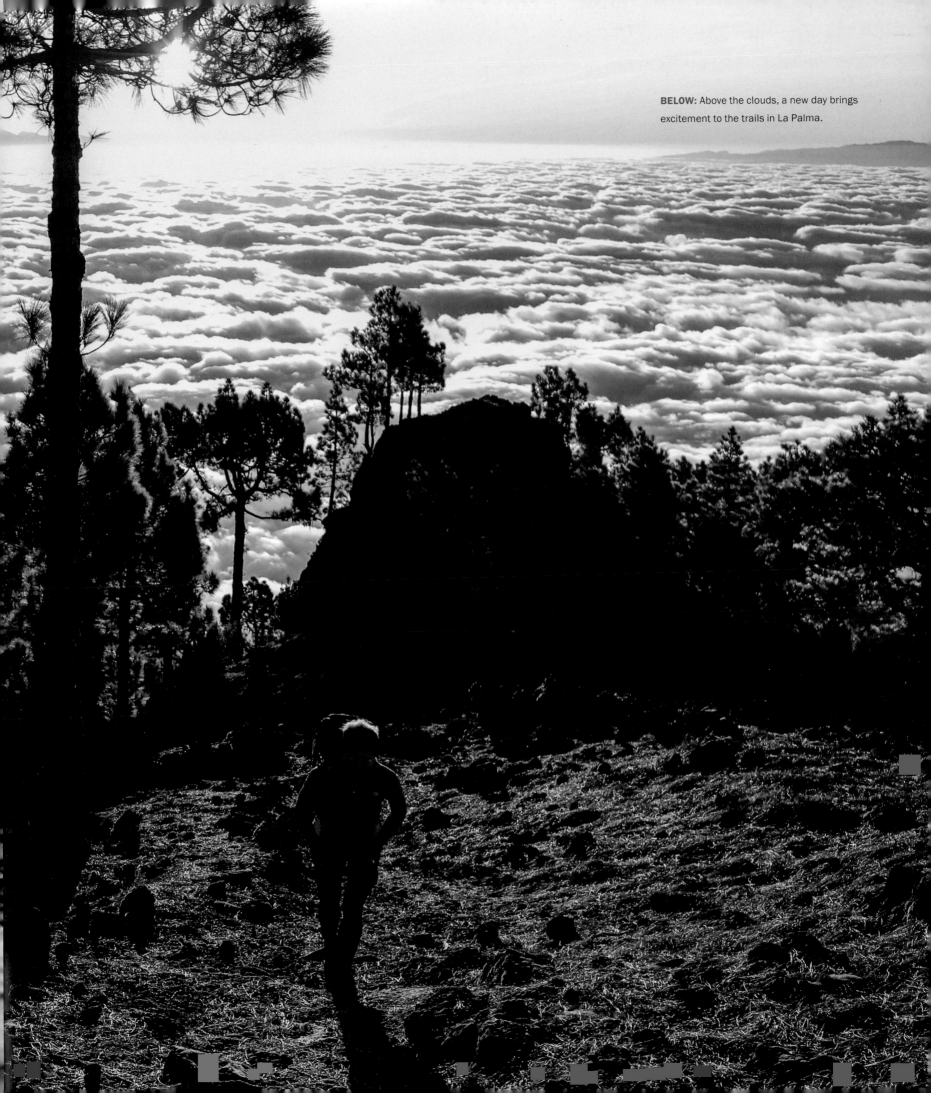

BELOW: Above the clouds, a new day brings excitement to the trails in La Palma.

the crowds in the port... it is uplifting. I also had guys I was overtaking shouting encouragement, "Go Anna, go Anna." It was brilliant.'

The GR131 stops in Tazacorte, but the Transvulcania Ultramarathon organizers have a sting in the tail, as the final kilometres take you back up to the town of Los Llanos where a rapturous welcome awaits.

'Your legs are like jelly after running downhill for 90 minutes,' said Frost, telling the story of the closing kilometres. 'In the port I just refocused. The riverbed wasn't a surprise but when you hit the beach and your feet sink, it isn't great, particularly knowing the road is just at the side. Mentally it is exhausting, but it is a beautiful trail. You have cliff walls and you do get some shade. For me, I just knew it was nothing in the bigger picture, I knew I could hold on and keep going at a decent pace.'

The final roads of Los Llanos drag on as the heat beats down, but the crowds can be heard and they pull the runners in to a glorious finish. 'It's amazing; you can hear the noise from a long way off,' says Frost. 'The final stretch seems miles away. I assumed the record was off! I was appreciating the time and I was enjoying the crowds. It was crazy, they were Mexican-waving, cheering and clapping. It was only on the final few hundred metres that I realized that the course record was on. I turned the corner, saw the official clock and I took a breath and had to push, push and push for the record.'

It's a day that Anna Frost will never forget, and of course it's a day that all runners never forget. The trails of La Palma are special – they are like no other. At times relentless and brutal, but at all times beautiful. When you reach the finish you will arrive as a champion; believe me, you will have earned it.

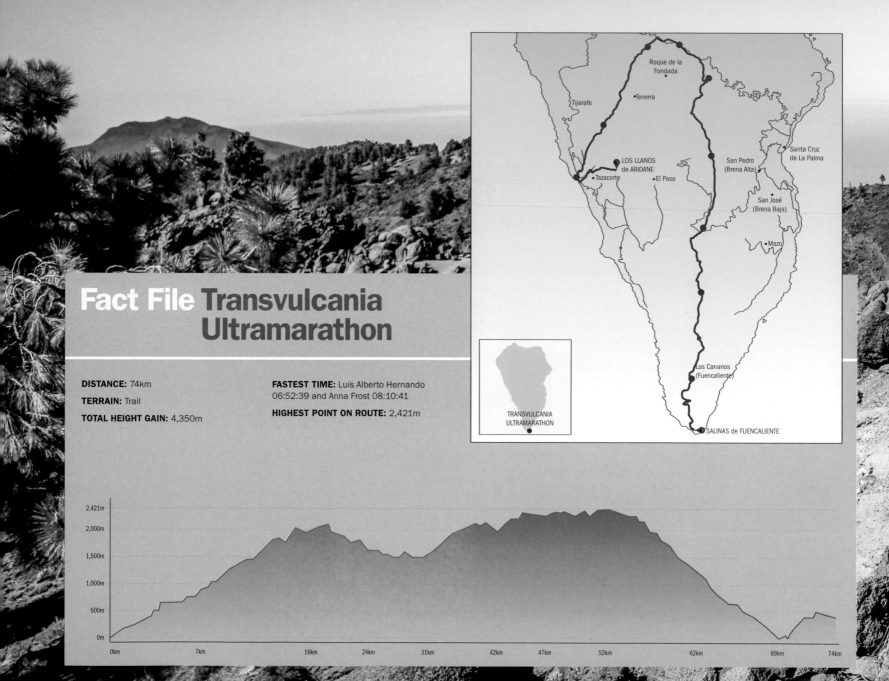

Fact File Transvulcania Ultramarathon

DISTANCE: 74km

TERRAIN: Trail

TOTAL HEIGHT GAIN: 4,350m

FASTEST TIME: Luis Alberto Hernando 06:52:39 and Anna Frost 08:10:41

HIGHEST POINT ON ROUTE: 2,421m

Roque de la Fondada

Tijarafe · Tenerra

LOS LLANOS de ARIDANE · Tazacorte · El Paso

San Pedro (Brena Alta)

Santa Cruz de La Palma

San José (Brena Baja)

· Mazo

Los Canarios (Fuencaliente)

SALINAS de FUENCALIENTE

TRANSVULCANIA ULTRAMARATHON

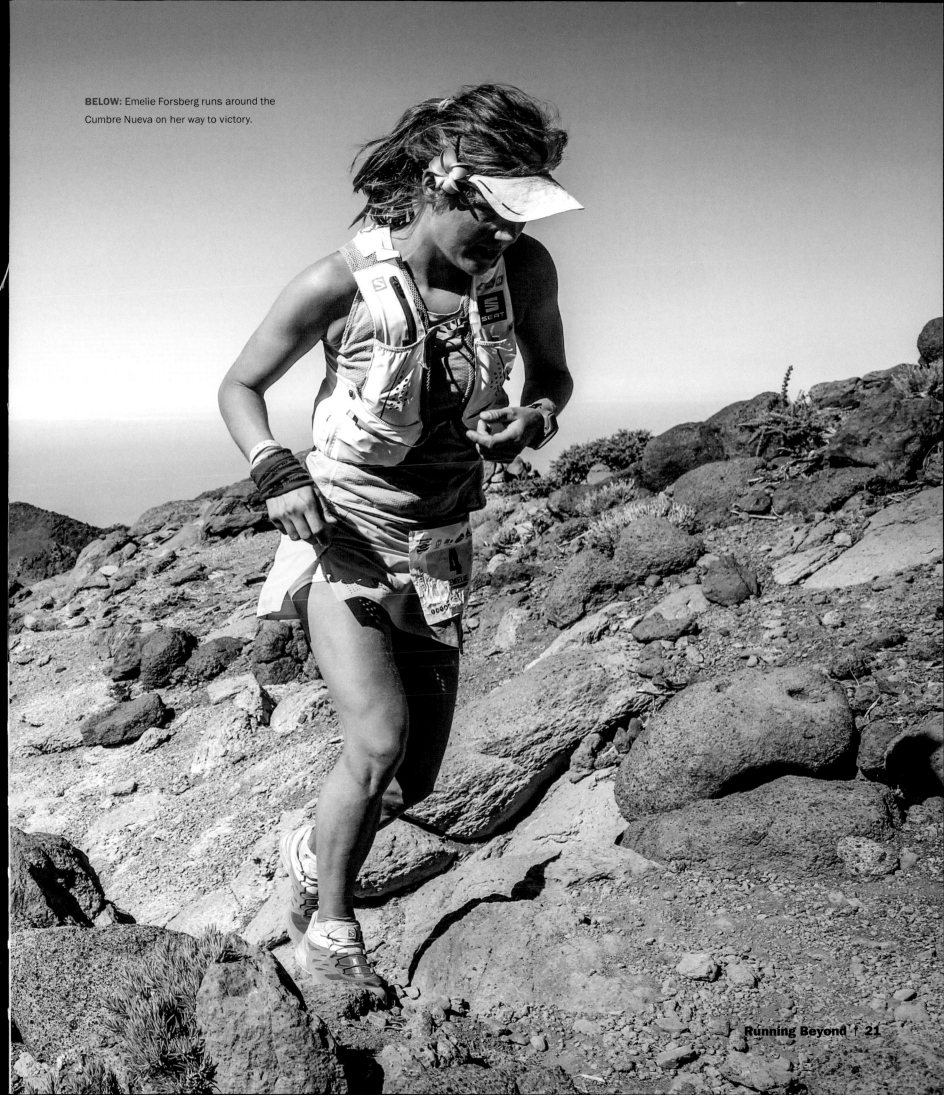

BELOW: Emelie Forsberg runs around the Cumbre Nueva on her way to victory.

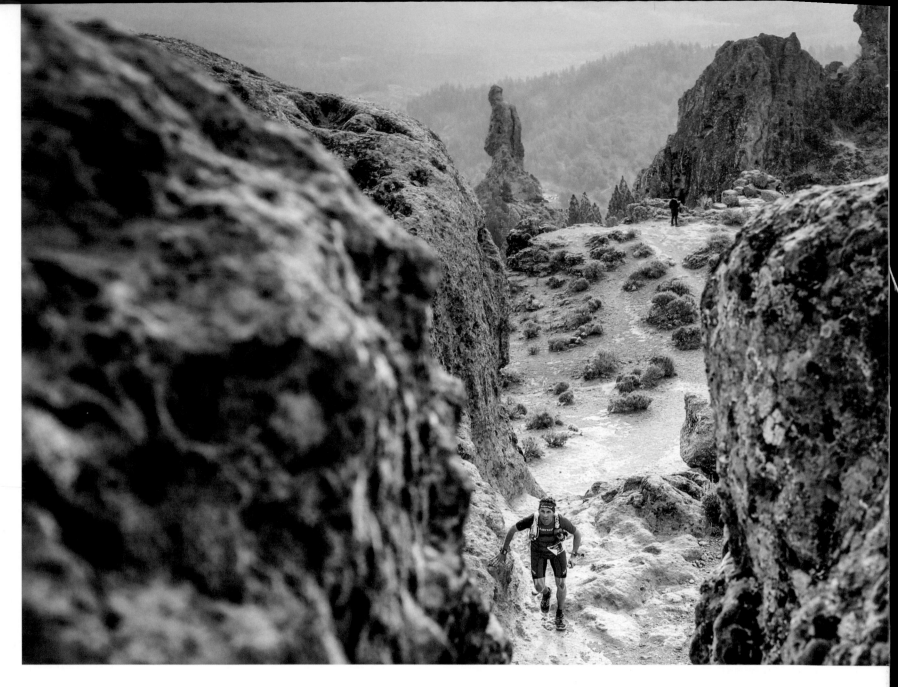

Starting at midnight, hours of darkness add to the challenge, especially when one considers that the opening 10 kilometres are straight up from the sea to the first summit.

'The course starts with a nearly immediate 1,240-metre climb off the pier… followed by a rollicking 600-metre descent and another 600-plus-metre climb,' said the USA's Anton Krupicka, racing at Transgrancanaria for the first time in 2015. 'This first 30 kilometres or so were spectacular, engaging trail racing. It is one of the few sections of race course I've experienced that closely mimics the kind of track I enjoy most in training – steep, technical, heads-up, sometimes barely-there trail.'

Artenara, at just over 30 kilometres covered, transitions the runners from climbing to running on contouring paths with minimal elevation change. For the most part, the trails are not technical. At 56 kilometres, Teror breaks up the running and, for the front runners, the imminent arrival of dawn is something to hold on to as a beautiful, steep climb to Talayón and beyond follows.

Dropping from the summit to Tejeda (at 71 kilometres), the penultimate big push of the day follows from Garanon to the highest summit of the race and the highest point of the island, Pico de las Nieves. Arguably this is one of the most stunning sections of the whole Transgrancanaria course; the early-morning rays illuminate the landscape, making it appear not of this world. Roque Nublo, a key and iconic marker, provides a short out-and-back section before the final and lengthy drop to the finish line via Tunte, Ayagaures, Parque Sur and the Maspalomas finish.

'I deliberately flew to Gran Canaria one week before the race to let my body adjust to the changes and, more importantly, to have time for recuperation,' said Gediminas Grinius, 2015 champion and course record holder. 'The 2015 edition had a stacked field of elite runners. I wasn't at all worried or concerned, as my main aim was to improve upon my 2014 time and position [16:11 and 11th place] and hopefully have a good race with the top runners along the course.'

Grinius had a great race, his determination, pacing and cool, calm, collected approach proving to be the perfect strategy for the race. 'Having learnt from my 2014 experience that from Pico de las Nieves to Artenara

is a very long technical descent, I had trained on this section trying to familiarize myself with every stone on the trail,' he recalls. 'Last year I was absolutely broken on this part, but now I was confident and my running was very smooth. With the finish line drawing closer, I noticed that my time was good enough for the course record. I adjusted my plan once again and I started to race for the record.'

Despite the drop to the line, the terrain (mostly) remains relentless; a mix of dust, sand and rock only made increasingly worse as the temperatures and humidity increase with the passing of the day. A cruel sting in the tail comes at the very end, with the most nontechnical running of the day – a stone-and-concrete river bed that leads the runners for many kilometres to the finish close to the sea. It's like running in a concrete cauldron.

A route that logically traverses a geographic feature – in this scenario, an entire island – plus the opportunity to travel to a foreign land and race with high-level competition – make the Transgrancanaria the ultimate early-season kick-off to get a wonderful European racing season under way.

ABOVE LEFT: Between the rocks at the stunning Roque Nublo.
ABOVE: Ryan Sandes from South Africa, champion of the 2015 edition.

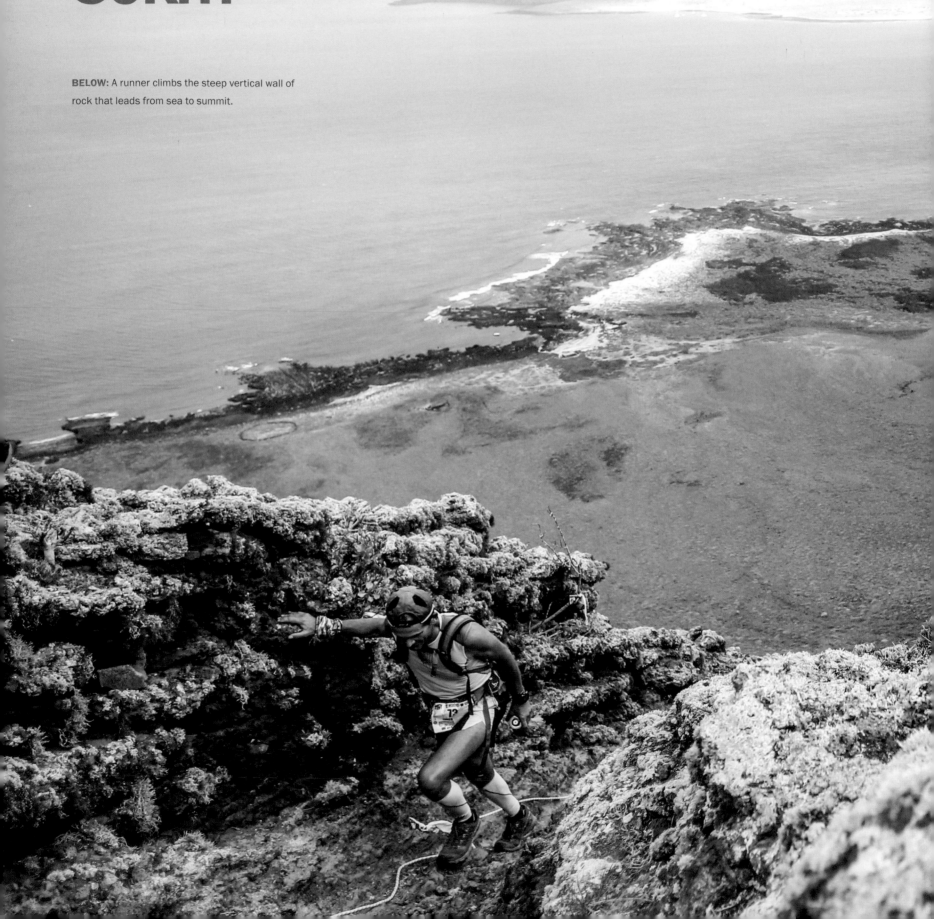

Haría Extreme
80km
Lanzarote

BELOW: A runner climbs the steep vertical wall of rock that leads from sea to summit.

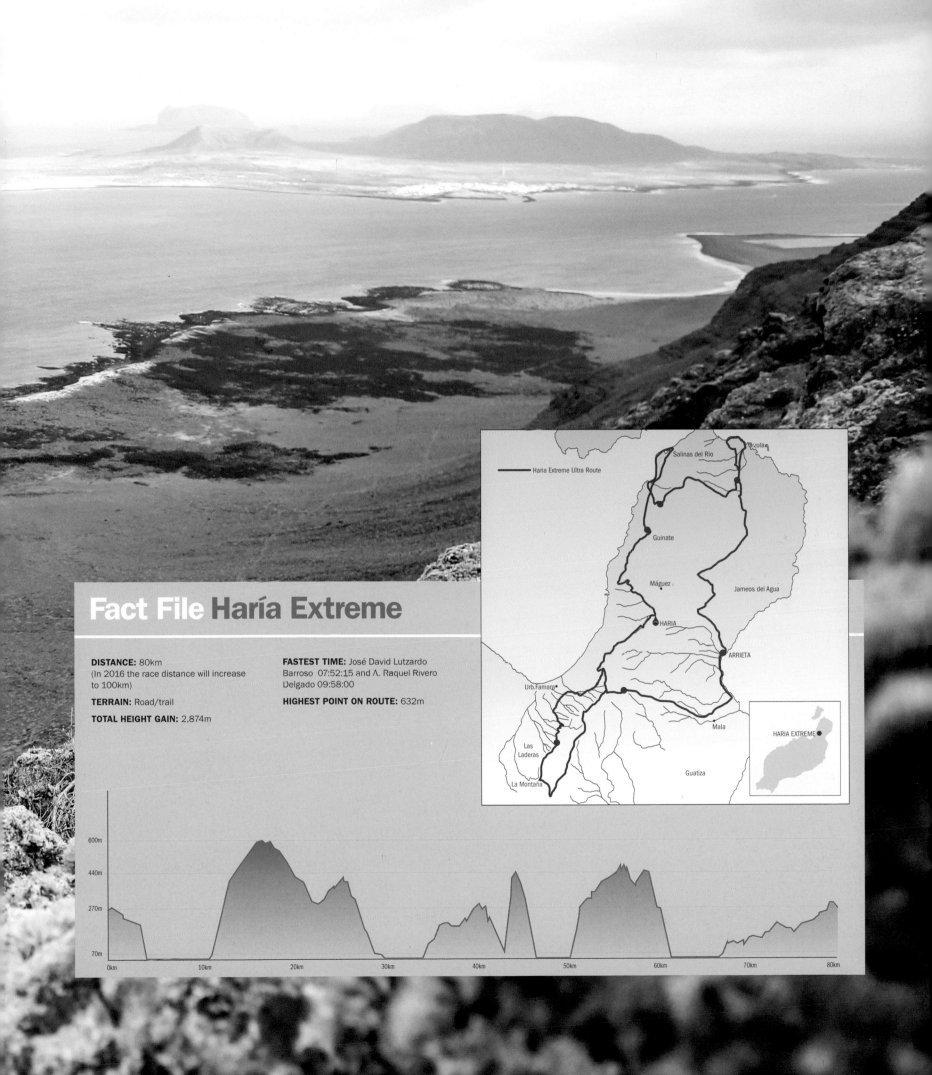

Fact File Haría Extreme

DISTANCE: 80km
(In 2016 the race distance will increase to 100km)

TERRAIN: Road/trail

TOTAL HEIGHT GAIN: 2,874m

FASTEST TIME: José David Lutzardo Barroso 07:52:15 and A. Raquel Rivero Delgado 09:58:00

HIGHEST POINT ON ROUTE: 632m

— Haria Extreme Ultra Route

Salinas del Rio
Orzola
Guinate
Máguez
Jameos del Agua
HARIA
ARRIETA
Urb. Famara
Mala
Las Laderas
HARIA EXTREME
La Montaña
Guatiza

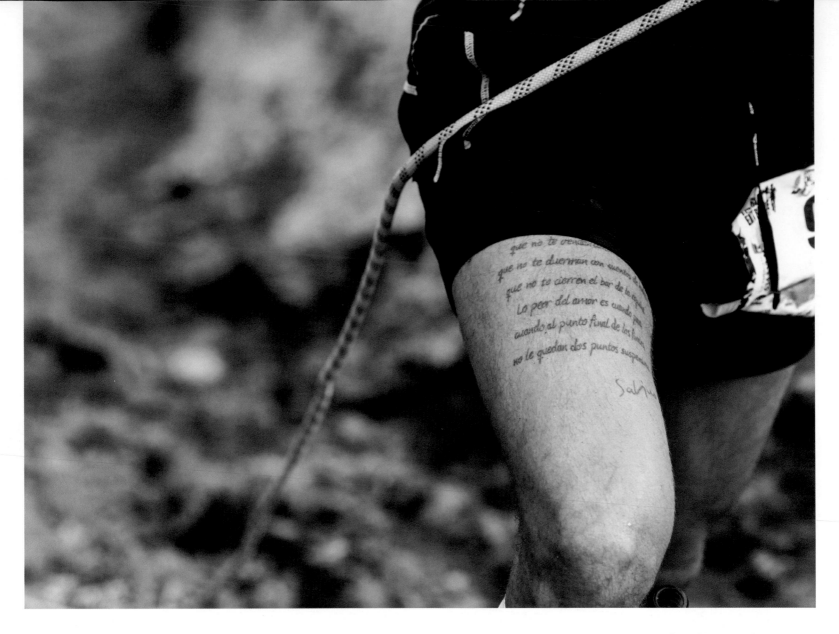

The island of Lanzarote has long been a mecca for endurance sports. Club La Santa, a sports holiday complex located just outside the small coastal village of La Santa, has attracted sports people of all disciplines for years. This is, after all, the home of Ironman Lanzarote, arguably one of the toughest in the world.

Zigor Iturrieta, an experienced trail, mountain and ultra runner and host of a cookery show called Txoriene on Basque television, has raced in Lanzarote many times. 'I cannot fail in a race that takes place in an environment as spectacular as that offered by the island of Lanzarote,' Iturrieta said ahead of the 2015 edition of the race. 'Above all, the locals and supporters are some of the best in the world. They make me feel at home and encourage everyone, from the first to the last.'

Lanzarote's proximity to the coast of Africa generally means that it has a good all-year-round climate. This makes the island the perfect place to train or race.

Haría Extreme sits perfectly in Lanzarote's bigger picture. Haría is a small village located inland in the northernmost parts. To the west of the municipality it is largely mountainous; the coastline rises steeply from the sea. Numerous viewpoints, known locally as *miradors*, offer some of the island's most spectacular views, Mirador del Rio being the most well

known. It is a key tourist attraction and one of the highest points on the island. In addition, Haría's quaint traditional streets, street market and small, selective gift shops make it a popular stopping-off point for tourists.

For one weekend of the year, normal day-to-day life comes to a halt and this sleepy Canary town is taken over by a series of races called Haría Extreme. The main event in previous years has been 80 kilometres in length, with over 2,800 metres of vertical gain. However, in 2016 a new 100-kilometre event launched, taking in more regions of this very special place.

The Famara mountains are a key feature of the racing, as they provide mixed and challenging terrain with incredible views out over the sea to Lanzarote's closest island, La Graciosa, which is less than one kilometre away via boat. Stunning ridges and single-track trails are overshadowed by a key feature of the racing – a stunning, near-vertical climb, aided by rope, from the sea to the summit at Guinate.

Jagged and irregular rocks provide a natural obstacle course. At times a clear section allows a faster pace, but the unpredictable nature of the terrain requires 100 per cent concentration. Relax, and it could be very painful if you fall.

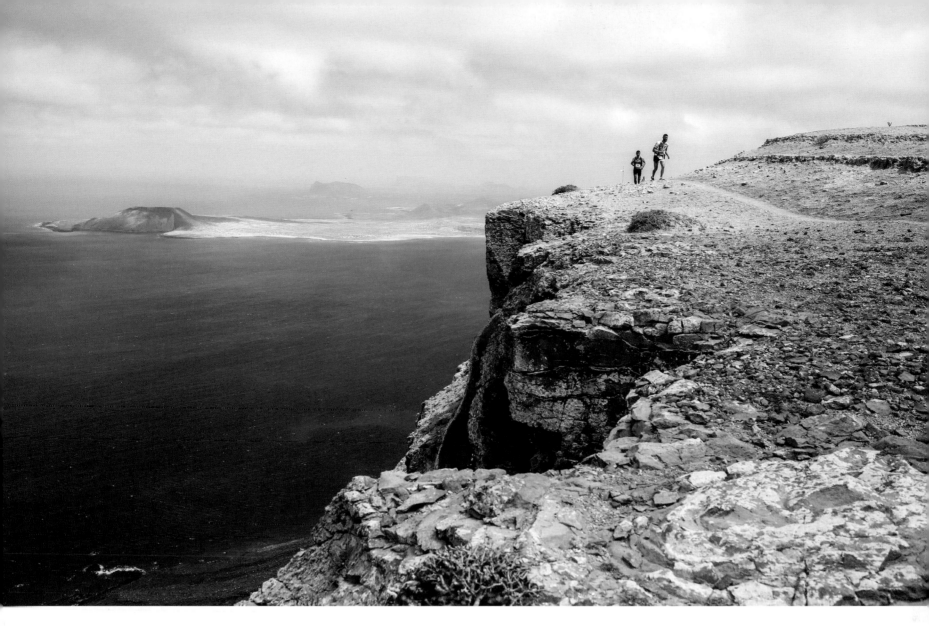

Experienced and well-travelled ultra runner Niandi Carmont participated in the 2015 edition of the race. '[It is] an undefinable course that is a mix between Africa and Europe in more ways than one, offering the ultra runner a challenge and great variety,' said Carmont post race. 'One minute you are hopping and skipping in between dense, prickly thorn bush and jagged, rocky lava fields; the next minute you're stretching your legs on very runnable fire-track or running on a sandy beach section. Before you know it, you are making your way up a volcano or a mountainous section in a steep gully with only a rope to keep your balance and hoist yourself up. Running along a cliff edge, I was watching crashing waves against massive rocks and out at sea, other smaller islands. The climate was equally surprising; cool at the outset, boiling hot during the day, shady sections interspersed with exposed sections with the African sun beating down. I loved the race!'

Lanzarote is renowned as a volcanic island. Their mascot is a red devil, a significant reminder that the early volcanic eruptions were believed to be the work of Satan. Over a six-year period, from 1730 to 1736, the island was hit by a series of volcanic eruptions, producing thirty-two new volcanos in a stretch of just 18 kilometres. Lava covered a quarter of the island's surface, and 100 smaller volcanos were

❝ I CANNOT FAIL IN A RACE THAT TAKES PLACE in an environment as spectacular as that offered by the island of Lanzarote.'

Zigor Iturrieta

ABOVE: Running the stunning ridgelines with the island of La Graciosa in the distance.
OPPOSITE: The tattooed words of a song are a mantra for this runner.

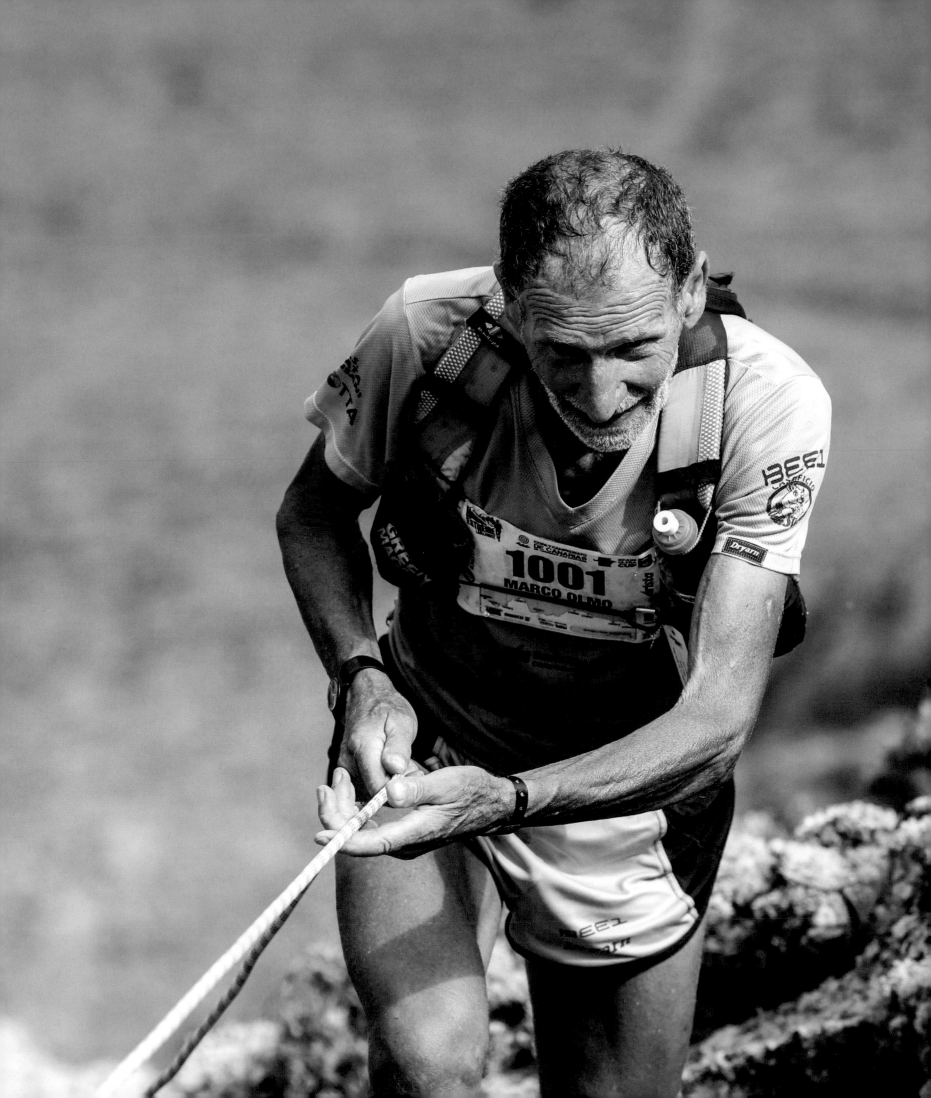

located in the area called Montañas del Fuego, the 'Mountains of Fire' now known as Timanfaya National Park.

It's impossible to get away from the volcanic nature of the island. Timanfaya National Park is dark, irregular and foreboding in its aggressive landscape. It is here that the 100-kilometre race is run. But despite the harshness, Timanfaya holds immense beauty. Lanzarote's coastline is 213 kilometres long, of which 10 kilometres are sand, 16 kilometres are beach and the remainder is rock, often resembling a lunar landscape. The mountain ranges of Famara in the north and the Ajaches to the south provide the key landscape. South of the Famara mountain range is the El Jable desert, which separates Famara and Timanfaya National Park.

It's this biodiverse landscape that provides Haría with its extreme status; sand, rocks, lava, hard-packed trail and tough, short climbs make up the racing. At times, barren, open stretches of beach only lead to blackened, loose sand and jagged rock. Think of a scene from *Planet of the Apes* and you wouldn't be far wrong. The main race visits the Montañas del Fuego, La Geria, Playa de Famara, Costa Teguise, Malpaís de la Corona and key resorts such as El Mirador del Río, Bajo El Risco de Famara and the ascent to Guinate, among others.

Marciano Acuña, mayor of Haría, is keen to point out that Haría Extreme is much more than a mountain race. 'We have a reputation for taking good care of the landscape and our people, we are proud to do so for consecutive years. Haría is rural and shows Lanzarote in a very rural and traditional way.'

The challenges, although extreme at times, are possible for anyone to undertake, and with a selection of distances on offer, it's possible to find a race that suits one's ability. The Canary Islands are rich in opportunities for trail and mountain running; Haria takes those experiences and opportunities one step further and makes them extreme.

LEFT: Italian running legend, Marco Olmo.

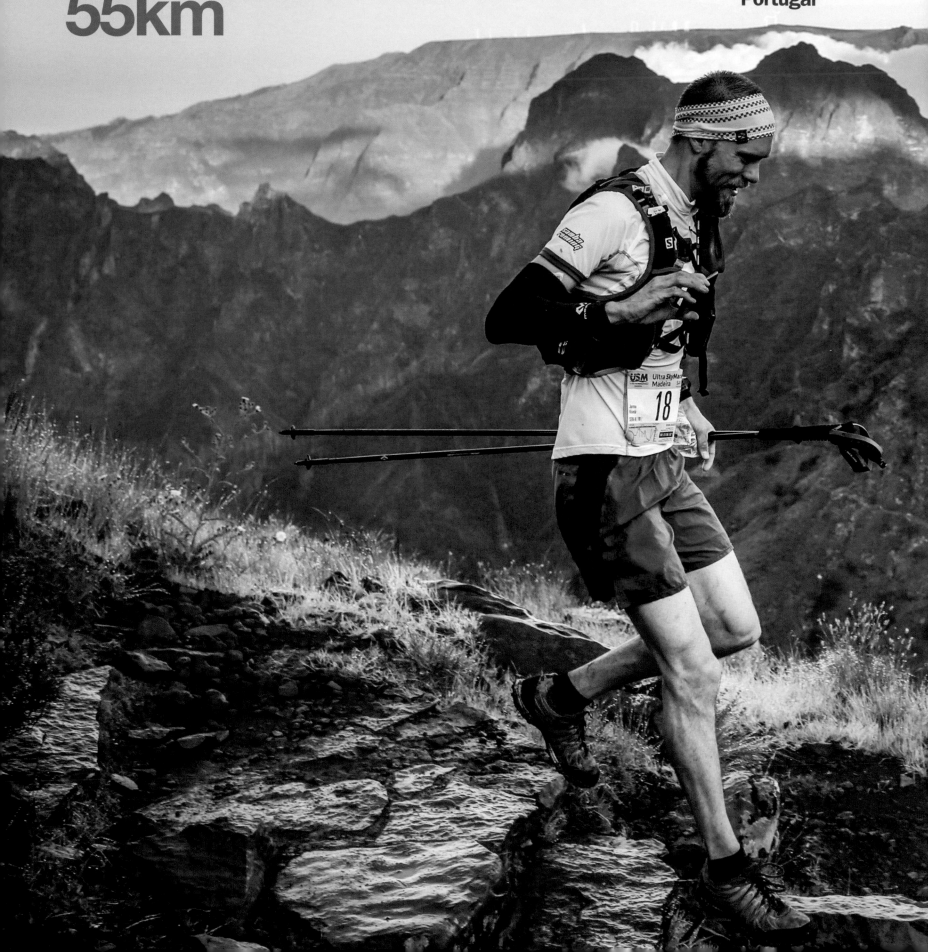

Ultra Skymarathon Madeira
55km
Portugal

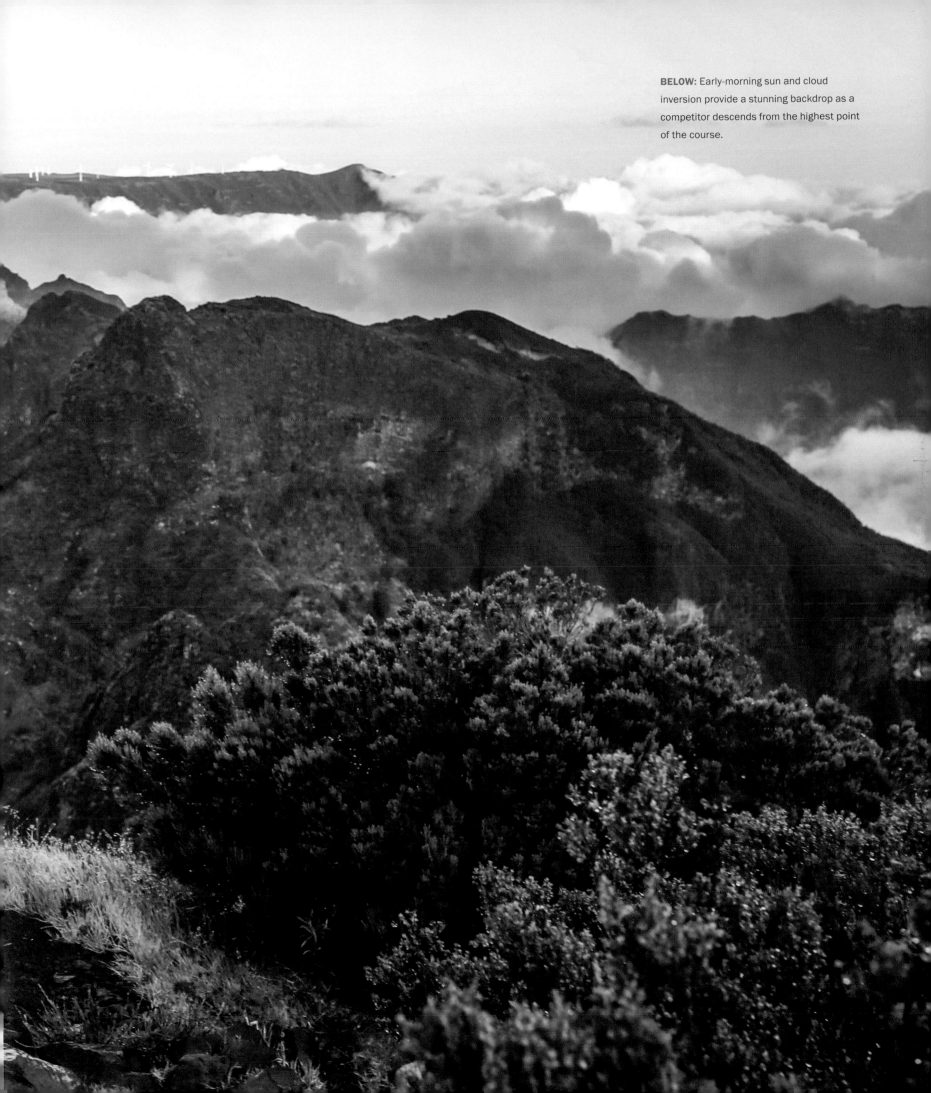

BELOW: Early-morning sun and cloud inversion provide a stunning backdrop as a competitor descends from the highest point of the course.

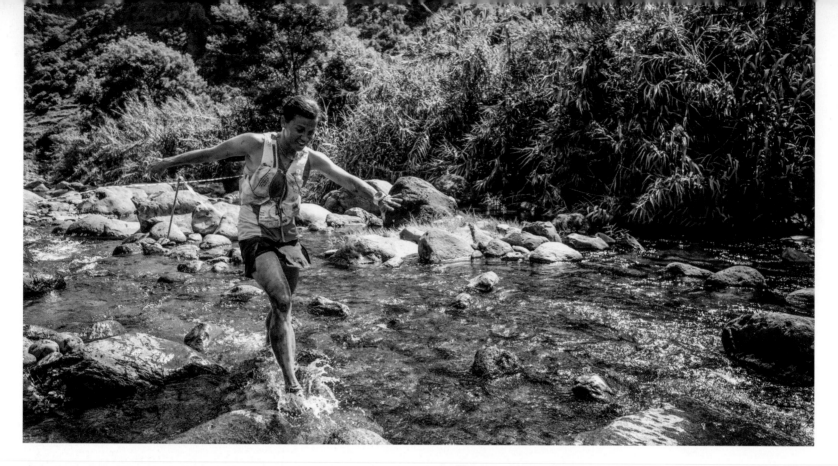

Running and ultra running really is booming in Portugal, and Carlos Sá and Ester Alves, amongst others, are paving the way. The island of Madeira lies west and slightly south of mainland Portugal in the Atlantic Ocean and has an incredible natural landscape that cries out for challenging races. A popular year-round resort due to mild winters and long summers, Madeira is of volcanic origin and has an extremely rugged topography, making it the perfect location for an endurance event.

The Ultra Skymarathon Madeira (USM) is a technical mountain race that consists of steep slopes and trails covering a distance of 55 kilometres with 4,000 metres of vertical gain. It is no ordinary race, but one that combines mixed elements in a wonderful natural playground for the adventurous runner. There are passages that require grade-two technical climbing expertise, stunning mountain scenery, sea cliffs and even an up-river, boulder-hopping scramble.

It starts in the town of Santana, a northern municipality of the island of Madeira, which has been a UNESCO World Biosphere Reserve since 2011. Darkness and the glow of head torches are the only company the runners have for the early-morning start. They disappear down a road before heading up a climb of 1,400 metres to Encumeada Alta (1,750 metres).

Laurel forest trails and steps are followed by a section of *via ferrata* before a final push to the summit of Pico Ruivo (1,861 metres) and amazing views out over the island. Pico Ruivo is the highest point on Madeira and is arguably the centre point of the USM race. Reached only by foot, it is often accessed via Pico do Arieiro, the third-highest peak on the island.

The terrain is lush and green, and in the distance single lines of trail head off in all directions. Trees vary in appearance; some are green, but others look as if they have been burnt and are devoid of vegetation, like fingers pushing out of the ground.

Cloud inversion happens often here, and suddenly runners can feel as though they are floating. In the distance, as the altitude changes, islands appear amongst a sea of clouds. 'The views when the mist lifted were incredible,' says Ricky Lightfoot, the 2015 champion. 'It was almost as though I was running in another race.'

Crossing ridges, the cloud rolls in and then out. Pico do Canario, at 1,138 metres, is considered a highlight of the race and includes another section of *via ferrata* before dropping down to Cascalho and Calhau de São Jorge, where the coast and the sea arrive. The race is not over yet, though. Crossing a section of beach, a zigzag path once again leads up to a plateau. A sudden sharp and technical drop brings the runners back to sea level and a technical run up through a flowing river bed. Boulder hopping adds to the excitement before the final climb, via Ilha and Queimadas, to return to Santana and the finish.

'USM is one of, if not the, hardest races I have ever done,' says US-based mountain runner, Stevie Kremer. 'The terrain is relentless and conditions under foot just make it so much harder than others.'

ABOVE: The USA's Stevie Kremer navigates a technical riverbed section on her way to victory in 2015.
OPPOSITE: 2015 champion Ricky Lightfoot, from the UK.

Fact File Ultra Skymarathon Madeira

DISTANCE: 55km

TERRAIN: Trail

TOTAL HEIGHT GAIN: 4,000m

FASTEST TIME: Ricky Lightfoot 06:09:56
Stevie Kremer 7:33:37

HIGHEST POINT ON ROUTE: 1,861m

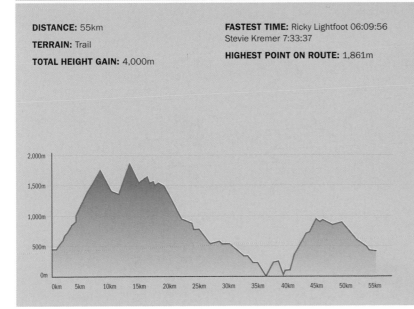

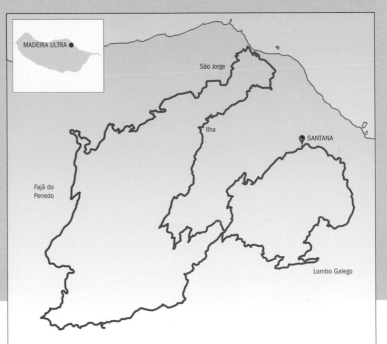

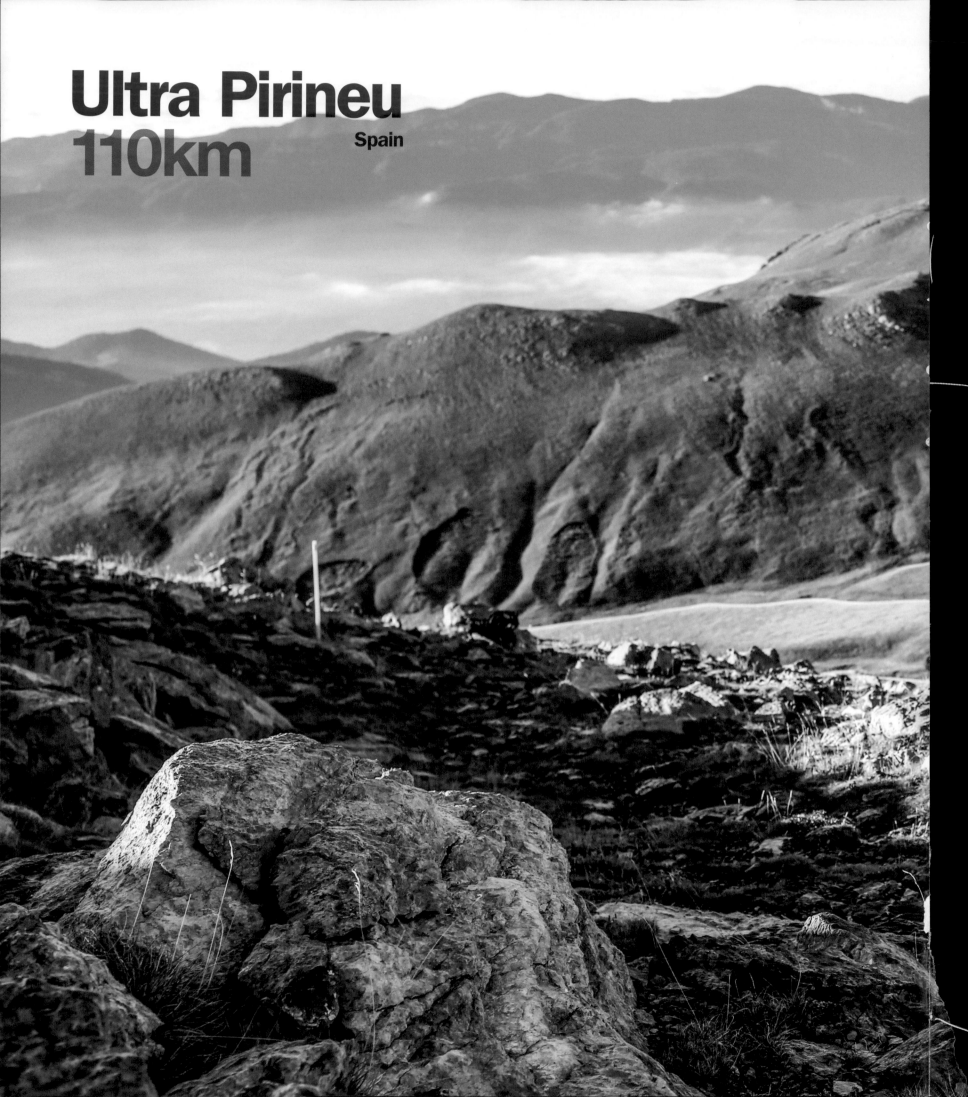

Ultra Pirineu
110km

Spain

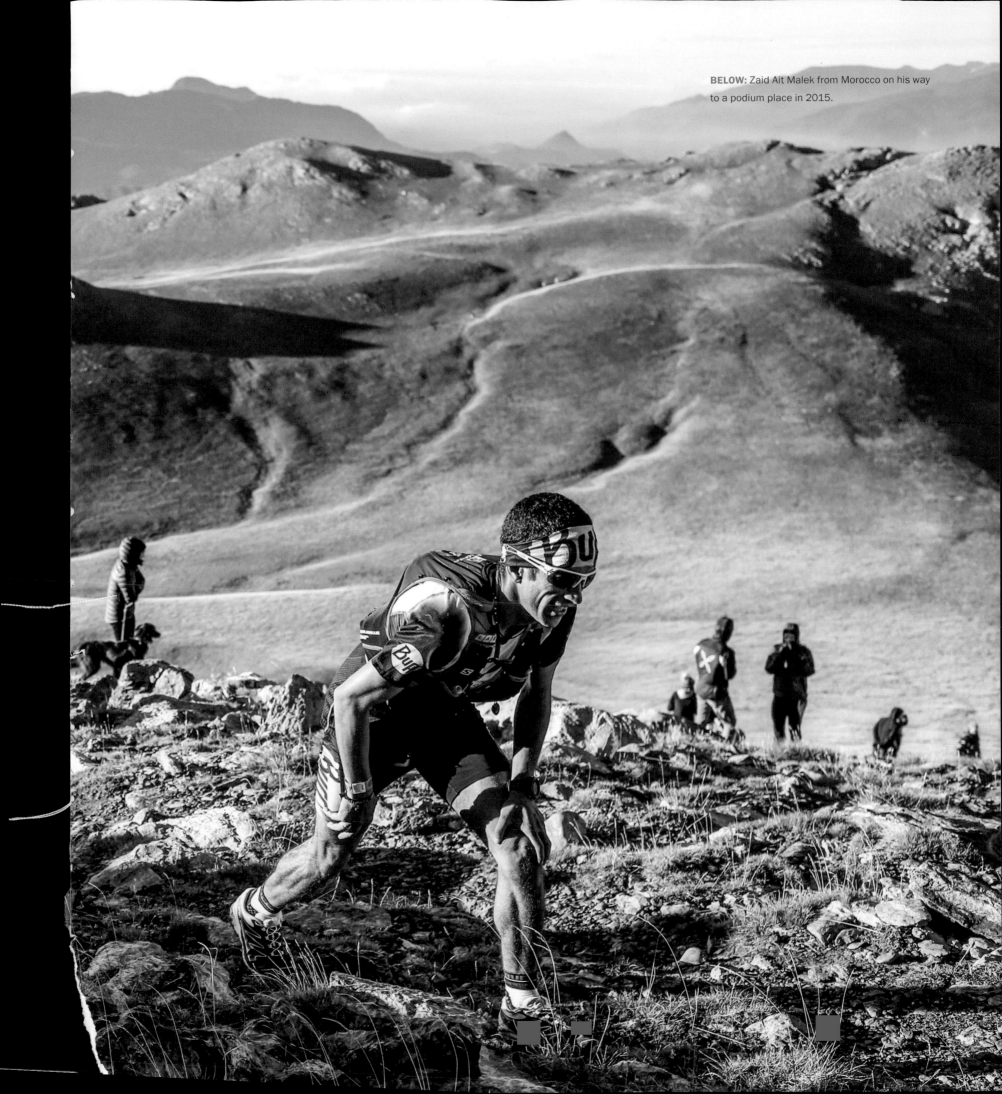

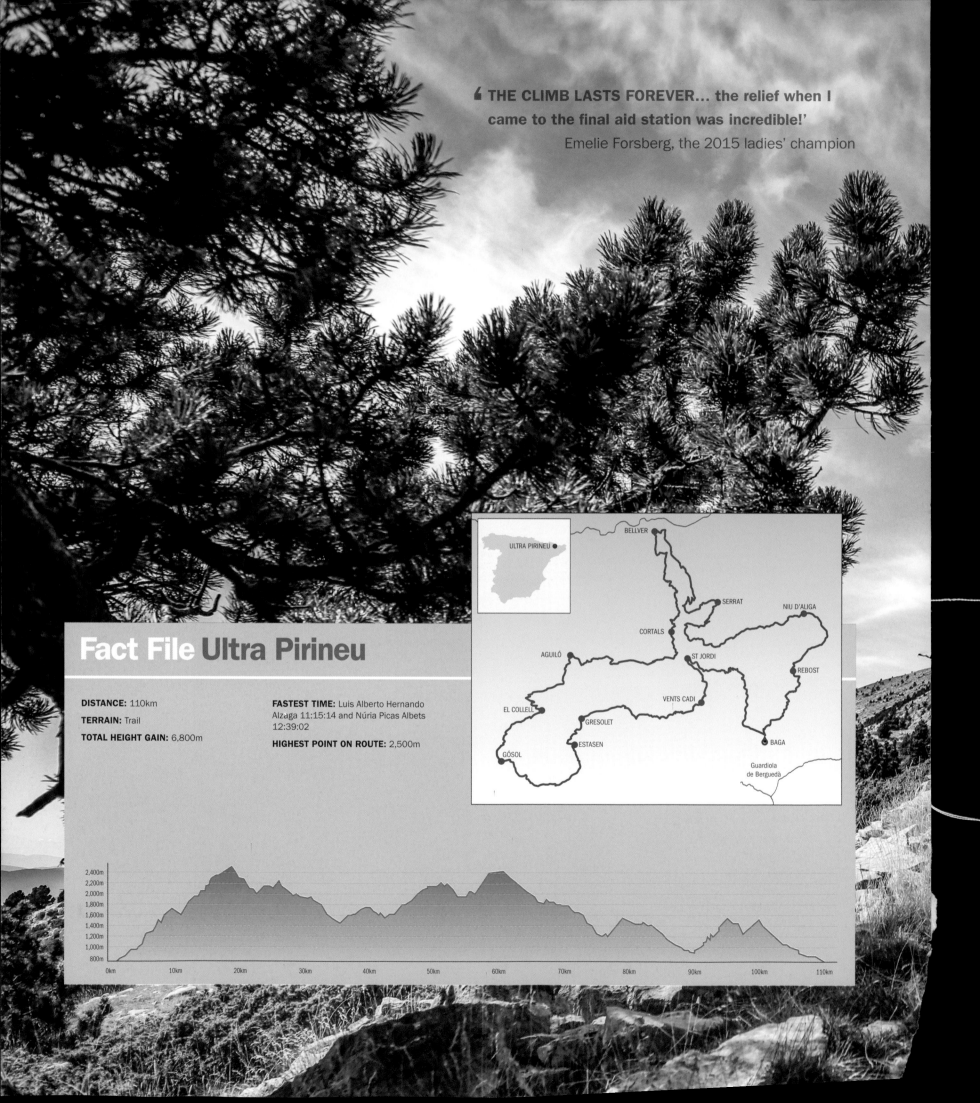

'THE CLIMB LASTS FOREVER... the relief when I came to the final aid station was incredible!'
Emelie Forsberg, the 2015 ladies' champion

Fact File Ultra Pirineu

DISTANCE: 110km

TERRAIN: Trail

TOTAL HEIGHT GAIN: 6,800m

FASTEST TIME: Luis Alberto Hernando Alzaga 11:15:14 and Núria Picas Albets 12:39:02

HIGHEST POINT ON ROUTE: 2,500m

Ultra running to Spain is like football to the UK: the fans are a passionate, motivated group of individuals who come together as a whole to create a cohesive army of fanatical supporters. Baga, the home of Ultra Pirineu, is located in Catalonia; it may come as no surprise that the Catalans take their support to the next level.

110 kilometres in length, with 6,800 metres of positive gain, the race takes place in the Cadí-Moixeró Natural Park. On paper, the route looks almost like a badly drawn figure of eight laid on its side. The profile is a little like the dental record for a great white shark, as it includes several key peaks, the highest coming very early in the race with just 14 kilometres covered at Niu d'Aliga, 2,500 metres high. Comprised of primarily trail (75 per cent), the route also includes a small percentage of asphalt and track. It's a tough and challenging race that has often been made considerably more taxing due to inclement weather.

BELOW: Kilian Jornet running on home ground on his way to another emphatic victory.

Baga, considered the capital of Alt Berguedá, is located 785 metres above sea level, approximately two hours north of Barcelona at the head of the Llobregat river in the northern mountainous area of the Serra del Cadí mountain range. Founded in AD 9, the town still has many areas that hark back to those old days, providing a very traditional feel to the Ultra Pirineu series of races. Redesigned in the 13th century, Baga provides a rare example of medieval planning thanks to the work of Galceran IV de Pinos. Close to Cerdanya, a hub for winter sports, the town now very much concentrates on rural tourism with the decline of the textile and mining industries, a key source of the area's economic success in the eighteenth, nineteenth and twentieth centuries.

The Cadí-Moixeró Natural Park is the hub for the racing. Established in 1983, it stretches more than 30 kilometres over the mountain ranges of Serra de Moixeró and Serra del Cadí, both part of the pre-Pyrenees.

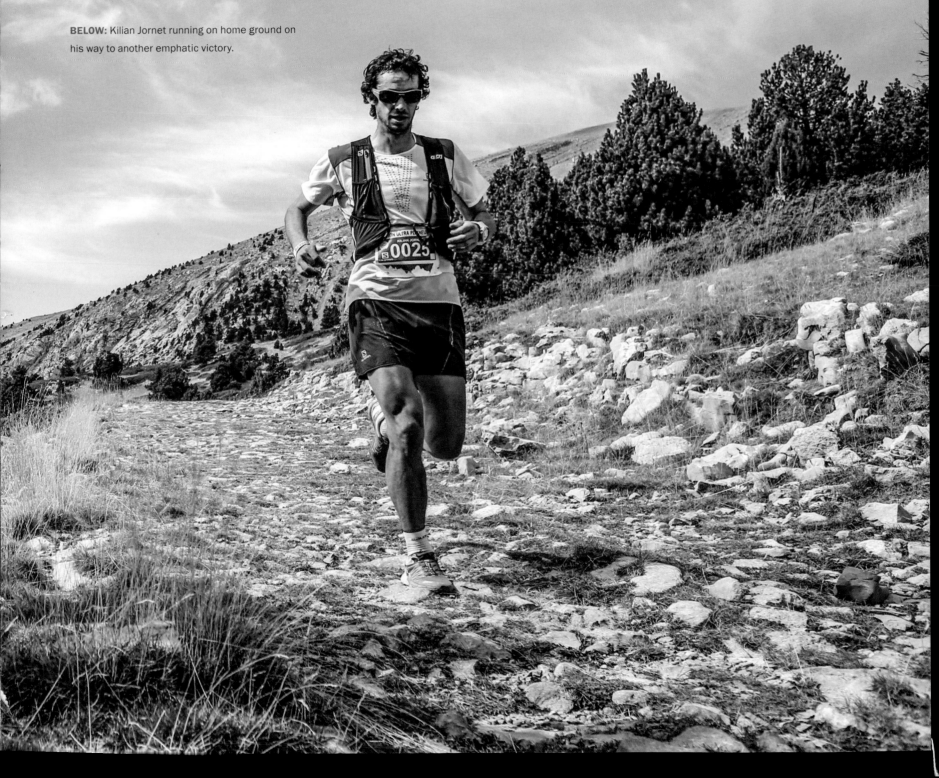

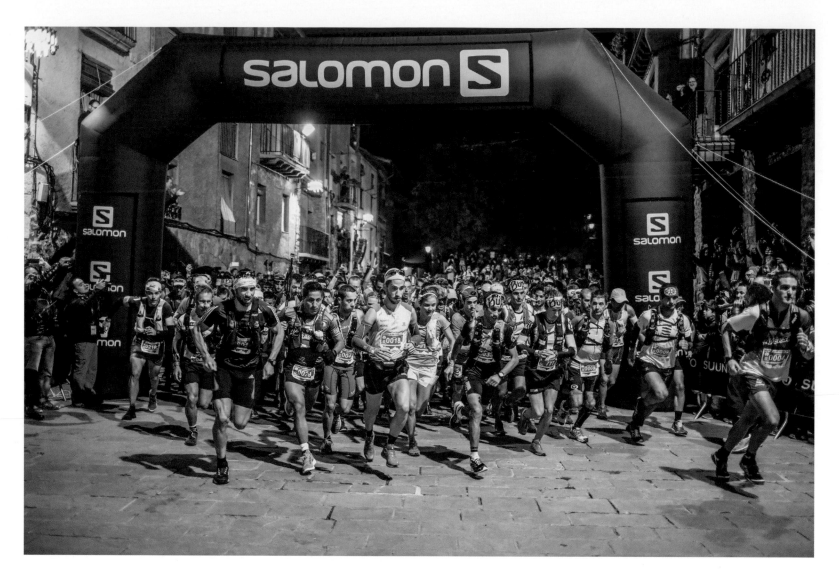

From the off, the racing is hard. The narrow streets of Baga and the enclosed medieval square host the start, and the charge of 1,000 runners at the toll of 7am make the opening minutes a heart-pounding, adrenaline-rushed sprint – ironic for a race that will take the winner 11-plus hours to complete.

Immediately it's hand on knees and straight into the first and highest climb of the day. Anton Krupicka summed it up so well when he ran the 2012 edition, then just (just!) 84 kilometres: 'The "running" is hand-on-knees, nose-on-the-ground, Euro-death-grunt stuff that will have you dreaming of douche grade.'

It's a dangerous mountain to start a race with. The commitment just to get to the top requires 100-per-cent effort, and this is all coming in the opening hours of a very long day on an exceptionally tough course. Finally breaking the tree line, the rugged terrain reveals itself and the first peak, with refuge, will finally come into sight. On a clear day, the views are incredible. The crowd support is also phenomenal. It's a frenzy of noise, cowbells and screaming. 'The sunrise and the people during the first climb to Niu was so energizing!' as Emelie Forsberg said in her post-race report.

What goes up must come down, and the first descent is single-track, off-camber trails with technical sections in and amongst trees. Sections

of *via ferrata* are present on rock, a clear sign of the severity of the terrain. Rolling terrain provides some respite, but it is early days. Forsberg continues, 'After that to kilometre 40 and the village of Bellver, it was smooth and nice undulation running with a lot of downhill.'

Dropping down, there is a short climb at 28 kilometres to Serrat, which leads to another long descent and an aid at Bellver de Cerdanya. A third of the race completed, a long and relentless series of climbing takes place over the following 25 kilometres through Cortals and Aguiló to the second-highest point of the race, at 2,300 metres.

Be prepared for the checkpoint *refugios* to be serious mob-scenes. People are packed in, yelling and screaming, more often than not smoking and drinking, snapping photos, patting runners on the backs; it's what makes racing in this part of the world so exciting.

Alternating hiking and running, the race is all about economy of effort for those at the front. Effort management is what's required to sustain the energy to the line and hopefully victory. For everyone else, it is survival. At 70 kilometres covered, the race may well be considered to be downhill to the finish in Baga, but no, the race has a series of false flats with a couple of brutal cardiac moments that arrive at 86 and 96

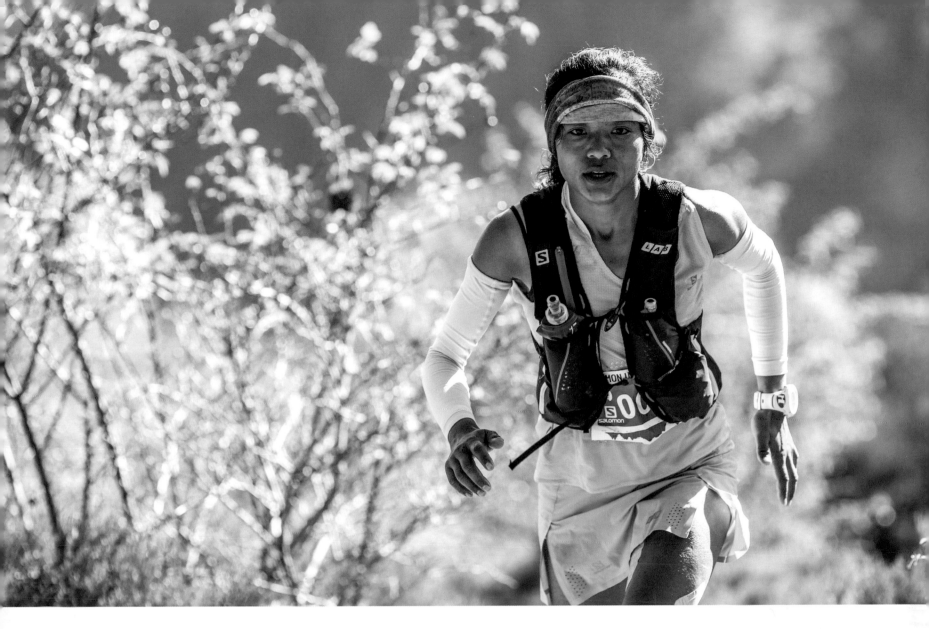

kilometres. The latter is a technical ascent of 1,000 metres to Sant Jordi at 1,500-metres altitude. It's a stunningly scenic canyon, and if it wasn't for the uncontrollable fatigue, it would be a highlight of the race.

'I filled my water bottles and left for the last big climb to Sant Jordi,' recalls Emelie Forsberg, the 2015 ladies' champion. 'The climb lasts forever... the relief when I came to the final aid station was incredible!'

Intersperse the trail with appallingly steep track, slick forest trails with rocks and intense technicality, and one realizes why Ultra Pirineu has become such a key race in the worldwide ultra-running calendar.

The final 10-kilometre drop to the line is broken up with another 200-metre climb with 6 kilometres or so to go. The rapturous high-five welcome from thousands of people in Baga provides some compensation for your efforts on the mountains and trails of the Cadí-Moixeró Natural Park.

'Two kilometres from the finish line, people started to scream that I was the winner,' says Emelie Forsberg. 'I doubted still. The race was not over! Entering the village with all the people standing there, the atmosphere buzzing with energy, I finally realized I had done it.' What an incredible achievement.

Zegama–Aizkorri
42km
Spain

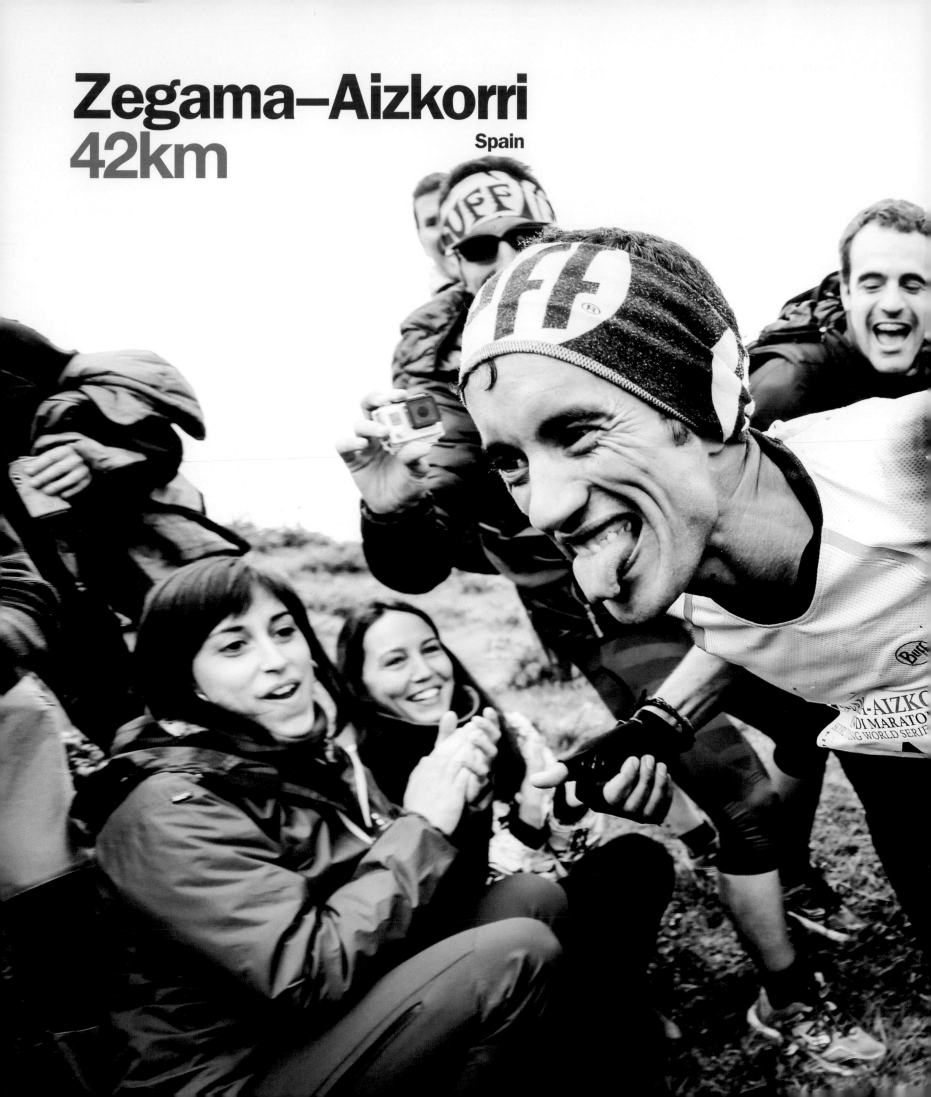

BELOW: Zaid Ait Malek puts on
a show for the crowds.

ABOVE: It really is mud, sweat and tears at Zegama–Aizkorri.

OPPOSITE: The emotion of the finish takes over Maite Maiora.

'Zegama is Zegama!' Ask anyone about Zegama–Aizkorri and that is what the answer will be. 'Zegama? Well, Zegama is Zegama!'

It is truly a unique race. Due to its location, early-season date and unpredictable weather, Zegama–Aizkorri has seen many epic battles. Catalan mountain-running legend Kilian Jornet has won the race an incredible six times. The combination of challenging terrain, vertical gain and descent and typically bad weather fall into the Catalan's hands perfectly – talents that few others express as well as he. It is a race where strength of mind must be matched by the strength of the body.

A quiet and sleepy place, Zegama is transformed on race weekend into a mecca of mountain running. In the early days it was very much a Spanish race, but word travels fast. Now the race is always over-subscribed to a worldwide audience. Gaining an entry is a little like getting tickets to see the Rolling Stones; you need to be online on release day and ready to book immediately.

The course never changes and it is reassuringly predictable. However, as past editions have shown, the weather adds the variety and a glorious, sunny, warm year can be followed with a snowy, wet and miserably cold one. 'It's what makes Zegama so exciting,' explains UK athlete Ricky Lightfoot. 'For me, the terrain, the mountains and the weather is very much like what I get at home in the English fells. I guess that is why British runners do well here.'

Rob Jebb and Angela Mudge pioneered the way for British runners such as Ricky, Tom Owens and Anna Lupton, amongst others. Zegama has also paved the way for current stars in the world of mountain running. For example, it was in the 2012 edition that a little-known Emelie Forsberg first appeared in a high-profile mountain race. In her first race she made the podium; what she has gone on to achieve since has been incredible.

Taking in the four highest peaks in the Basque Autonomous Region (Aritz, Aizkorri, Akategi and Aitxuri, the highest at over 1,500 metres), Zegama–Aizkorri is a classic mountain marathon-distance race, with 5,472 metres of vertical gain.

Departing the town in the early hours, runners take in a loop over the Arratz massif and the sierra of Aizkorri. Otzaurte (kilometre 7) provides an early indication of who the prominent male and female contenders for victory will be, but it's on the legendary climb of Sancti Spiritu – where thousands of spectators line the trail, narrowing it down to a single track – where the action starts to unfold. It has a feel similar to that of a stage on the Tour de France; spectators here are fanatics, passionate and certainly know how to party.

Shouts of *'V-A-M-O-S! Venga, venga, venga!'* fill the air as the first runners arrive. Cowbells are rung, horns are blown and the clapping and cheering provides an ambience second to none. Zegama is Zegama, after all! It's on this climb that the race can be won and lost. From a runner's perspective, it's easy to be overwhelmed by the passion of the crowd – the incredible noise provides a false sense of security, giving you wings that your lungs and legs may not be able to keep up with.

'Sancti Spiritu was just incredible. I wasn't prepared for the frenzy and passion of the crowd,' explains AJ Calitz from South Africa. 'I was

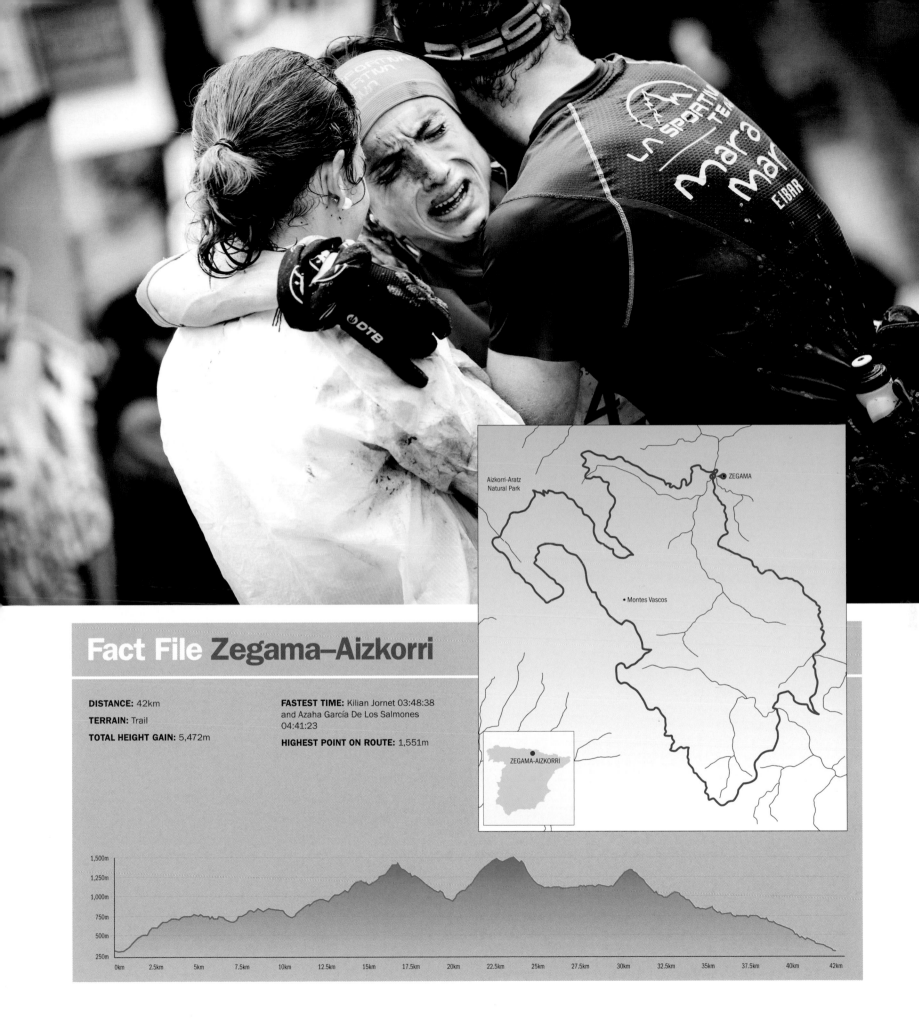

Fact File Zegama–Aizkorri

DISTANCE: 42km

TERRAIN: Trail

TOTAL HEIGHT GAIN: 5,472m

FASTEST TIME: Kilian Jornet 03:48:38 and Azaha García De Los Salmones 04:41:23

HIGHEST POINT ON ROUTE: 1,551m

Aizkorri-Aratz Natural Park

• Montes Vascos

ZEGAMA

ZEGAMA-AIZKORRI

lulled in, pulled along and suddenly I found myself gasping for breath. I pushed too hard and paid the price. After the summit, it was survival.'

A ridge run at altitude leads to the final summit. It's open and exposed, and under foot it's a challenge to remain upright and steadfast. Scrambling over irregular rocks, the final descent arrives. Rock transitions to forest trails and mud, and grip and the technical agility to cover ground without falling is now key. It's a skill that does not come naturally for some, but you will never win Zegama without this God-given ability!

The roads of this sleepy town, now transformed into a hub of colour and noise, lead the runners to the line. Barriers block the streets and thousands are assembled. The banging begins in the distance, a Mexican wave of noise leads the first runner around the final left-hand bend, and then an explosion of flashes and shutter clicks from the assembled press confirm a new champion.

The finish line is a mix of emotion; it really is mud, sweat and tears. A trickle of blood, ripped clothes, bruised hands and legs tell a story. Ask any runner on the finish line what it was like, and they reply quite simply: 'It's Zegama. Zegama is Zegama!'

RIGHT: Elisa Desco from Italy fights the muddy climb.

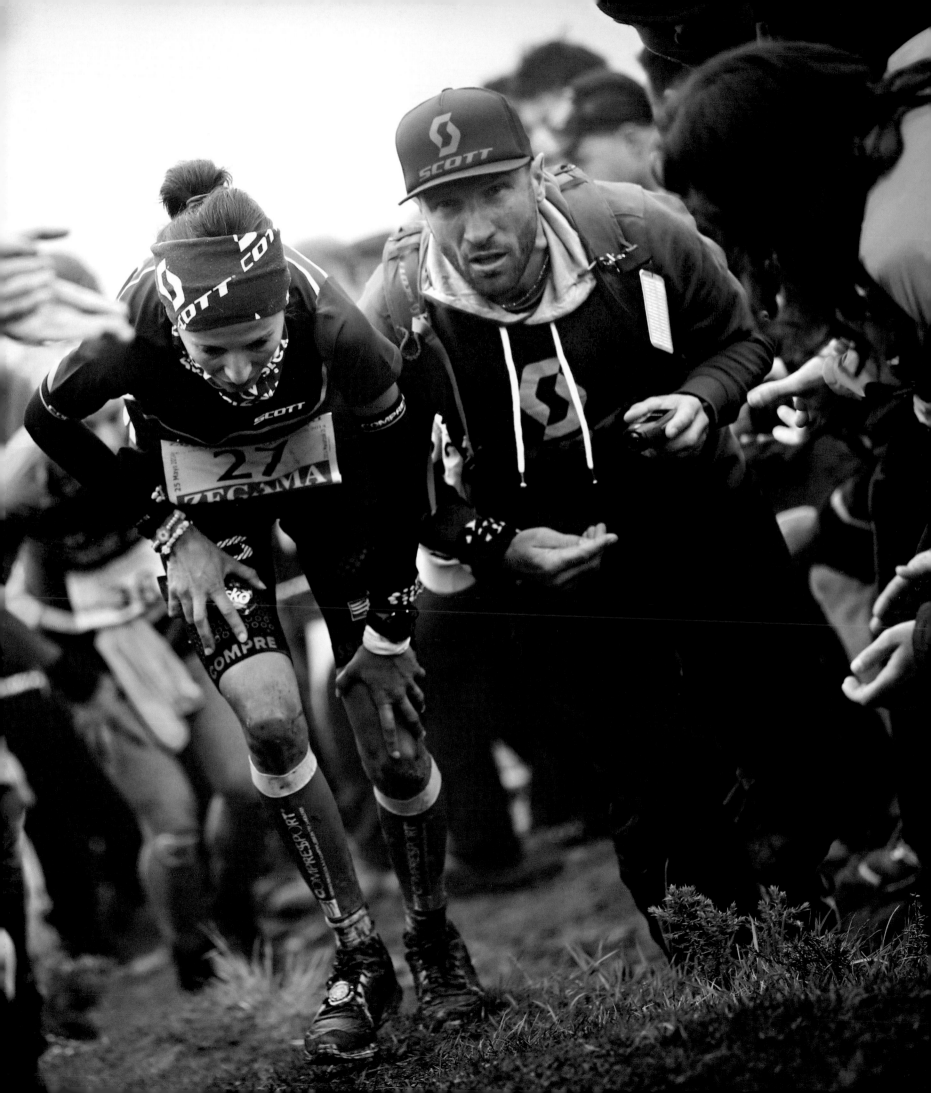

Ronda dels Cims
170km
Andorra

Climbing 13,500 metres of vertical gain over 170 kilometres in the principality of Andorra, the Ronda dels Cims represents one of the most extreme and challenging courses on the mountain-running circuit. It's a wild adventure that takes place on the longest day of the year, a full moon hopefully providing illumination for those long and lonely nighttime hours.

Taking in a circular route, Ordino provides the start and finish for this epic 170-kilometre journey. Passing sixteen peaks or passes over 2,400 metres, the race has an average altitude of just over 2,000 metres. The highest point of the race comes at Coma Pedrosa (2,942 metres), after a long and relentless climb up grassy plains to the summit. It's a high race with stretching panoramic views that include meadows, forests and lakes and, depending on the year, conditions may well deliver the extra treachery of severe snow and ice.

Julien Chorier, winner of the 2013 edition, summed up the experience well after his victory. 'Ronda dels Cims personifies the extreme category for its difficulty', he said. 'A route that goes around one country to the nearest border, [with] wild passes of close to 3,000 metres altitude. What an adventure; what fun to browse the summit of Coma Pedrosa under the full moon to the sound of bagpipes.'

This experience was echoed by the Australian runner Matt Cooper after his first encounter with the route. The altitude-driven course and the severely cold nights were a shock to the system compared with the relative lowlands and warmer climes of the southern hemisphere. The dangers of this extremely challenging race were also experienced first hand by Cooper, who slipped on a rock crossing into ice-cold water. 'Described as one of the hardest 100-plus-mile races in the world, it did not disappoint,' he wrote afterwards. 'Warm sunshine in the early stages

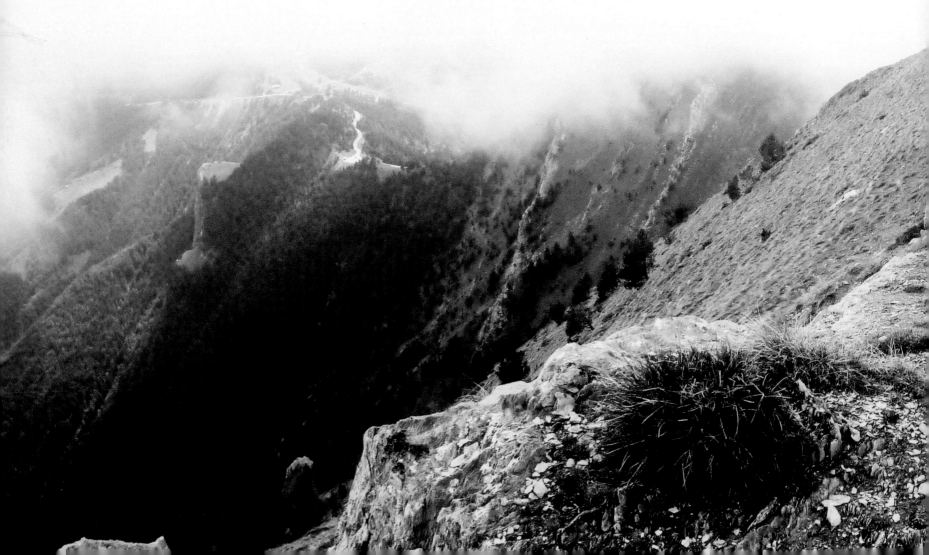

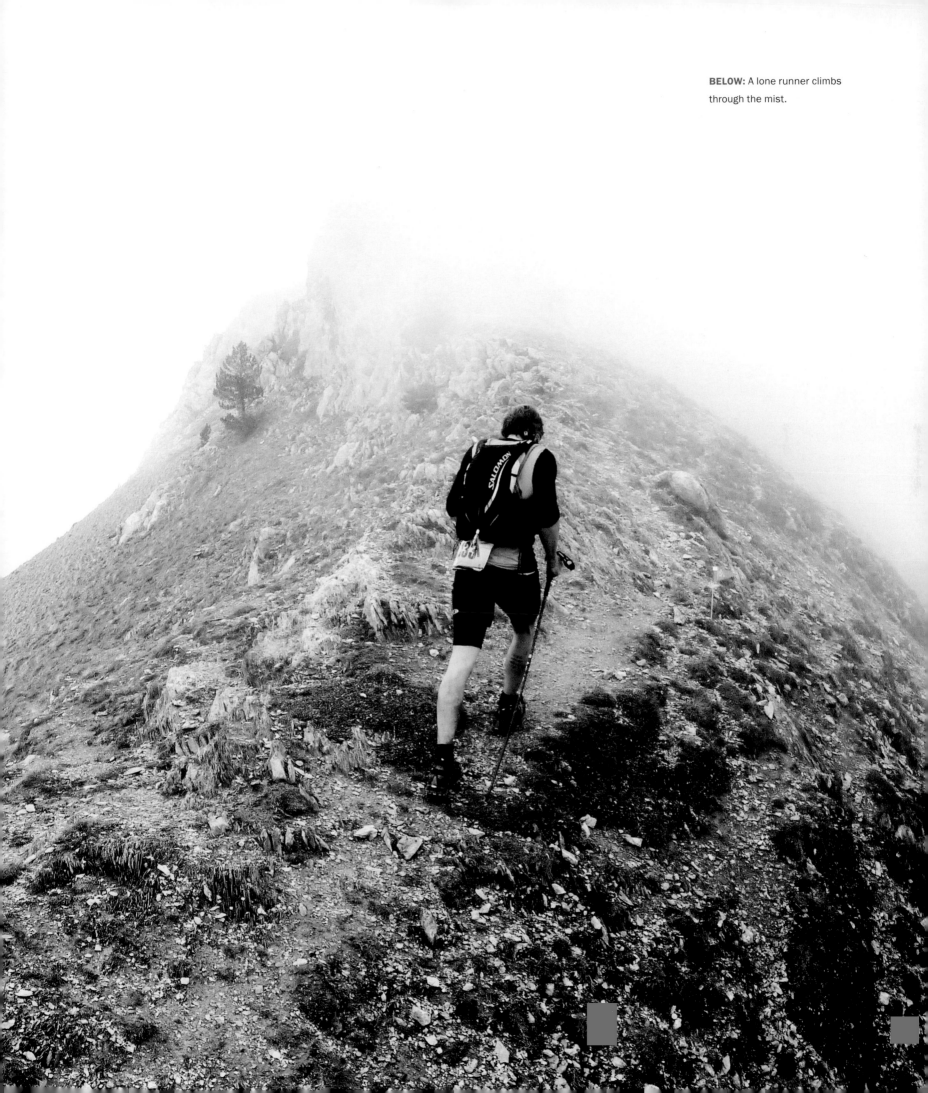

BELOW: A lone runner climbs through the mist.

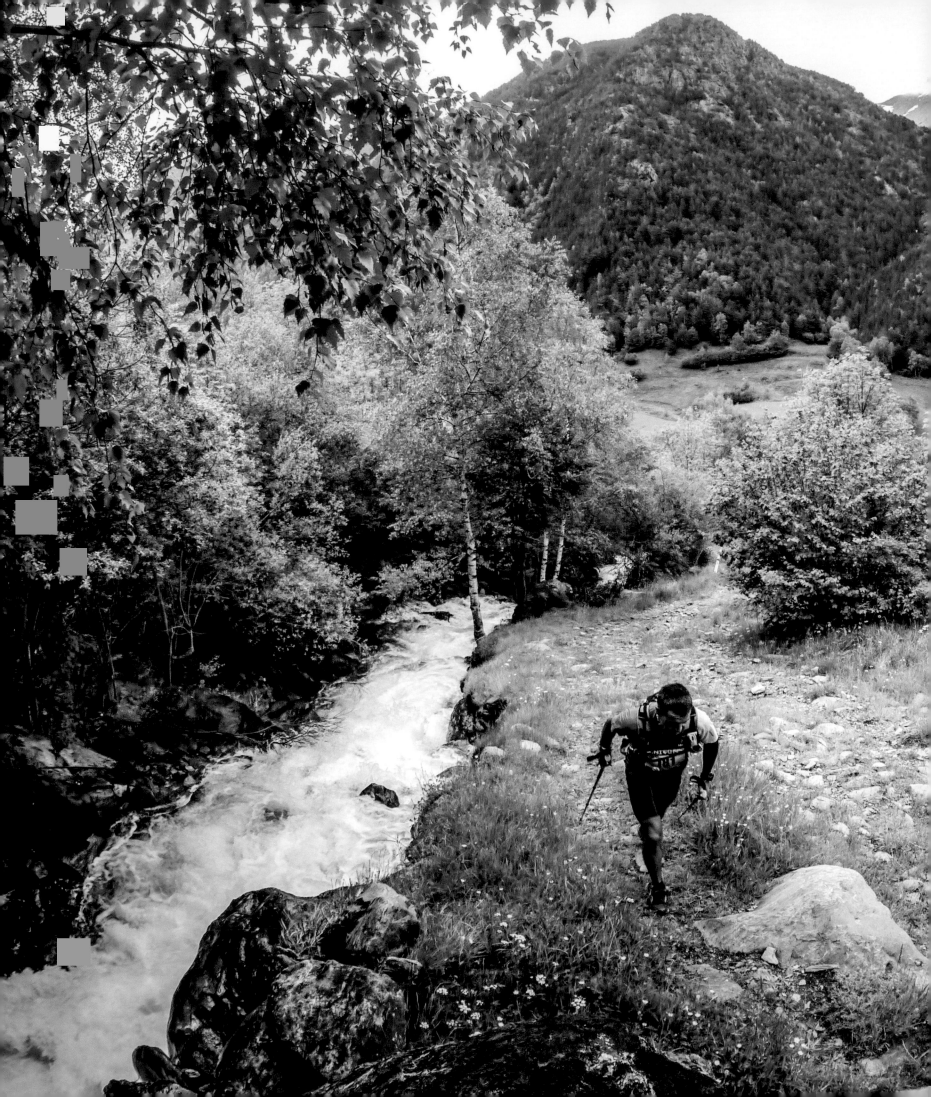

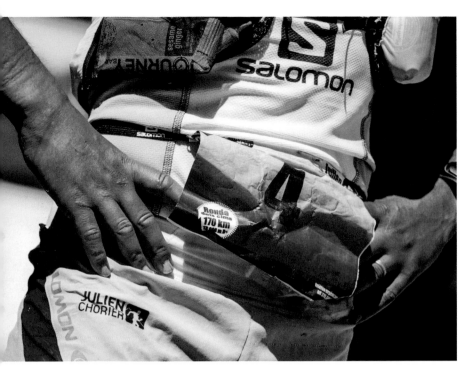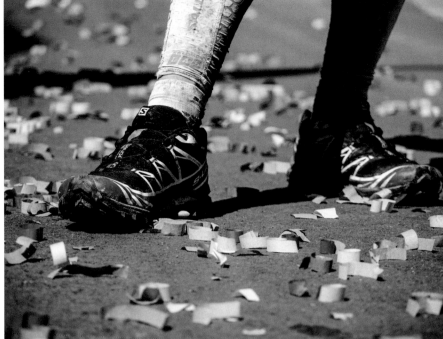

of the race were followed by torrential downpours of rain and cooler temperatures as night arrived. However, as the weather cleared and the glow of the full moon illuminated the night sky, temperatures dropped. It was a long and cold night, turning many sections of the course into unpredictable, slippery sections. I took a dip after a fall. I was lucky, I thought my race would be over, but a new dawn brought a new day, the sun burnt the mist away and temperatures rose, revealing blue skies and a perfect day ahead.'

It is exactly these moments, unique to sky marathons and particularly to be enjoyed on the Ronda, that attract long-distance specialists who are happy to grind out many hours on the trail, irrespective of conditions or terrain. Jared Campbell from the USA is such a runner. He has completed Hardrock 100 multiple times and won Barkley, and his memories of Ronda dels Cims are special. 'It's one tough race, no doubt,' he says. 'It suits my strengths. I treated the race with respect and as one would expect, personal highs are followed with lows. You have to be patient, ease yourself around the course, and I have found consistency is key.'

Andorra sits between France and Spain and benefits from both cultures and the equally impressive terrain of the respective countries, namely the Pyrenees. It is this blend of influences that feeds into its appeal and makes it such a challenging, and therefore appealing, race. When one looks at the history of the event, it's clear to see how difficult the journey around Andorra is by the relatively long winning times, many 30-plus hours. The course has the ability to reduce the strongest

competitor to a shell of their former self. The relentless climbing and descending, the rutted ground, the variable weather – warm during the day and freezing at night. Add to this sleep deprivation, hunger and a wavering lack of consciousness and it's easy to see why Ronda dels Cims is considered one of the hardest challenges in the world.

With all emotion drained from one's body, the will to survive, endure and complete the Ronda challenge is ultimately one of the key requisites before even entering the race. The body can take you so far, but after that the mind must take over. For the American ultra-runner Ben Lewis, it is this combination of the physical and mental challenges that both demands his respect and delivers its unique thrill, '...like every other step in the preceding difficult 12 hours, and every step still to come before I will somehow finish this strange, disorienting journey. After 33 hours and 33 minutes [I] cross the finish line, but beyond the immediate (and long desired) relief to stop moving, a sense of accomplishment or satisfaction eludes... I have survived perhaps the most intense intersection of physical, mental, and emotional challenges I've faced, but in doing so I have seemingly extracted something vital, leaving me shelled, vulnerable, exposed. I curl up on the pavement in a patch of shade. I realize for neither the first nor the last time that this undertaking is not a race, not an athletic contest, but an existential tool.'

For the brave, the tenacity pays off. The Romanesque streets of Ordino, brimming with spectators, will finally welcome the strong home to the screaming and clapping of the assembled crowds, the sweet smell of success no doubt the only thing keeping you going.

ABOVE: Julien Chorier, amongst the scenes of celebration.
OPPOSITE: River, mountains and lush vegetation provide
an inspirational backdrop.

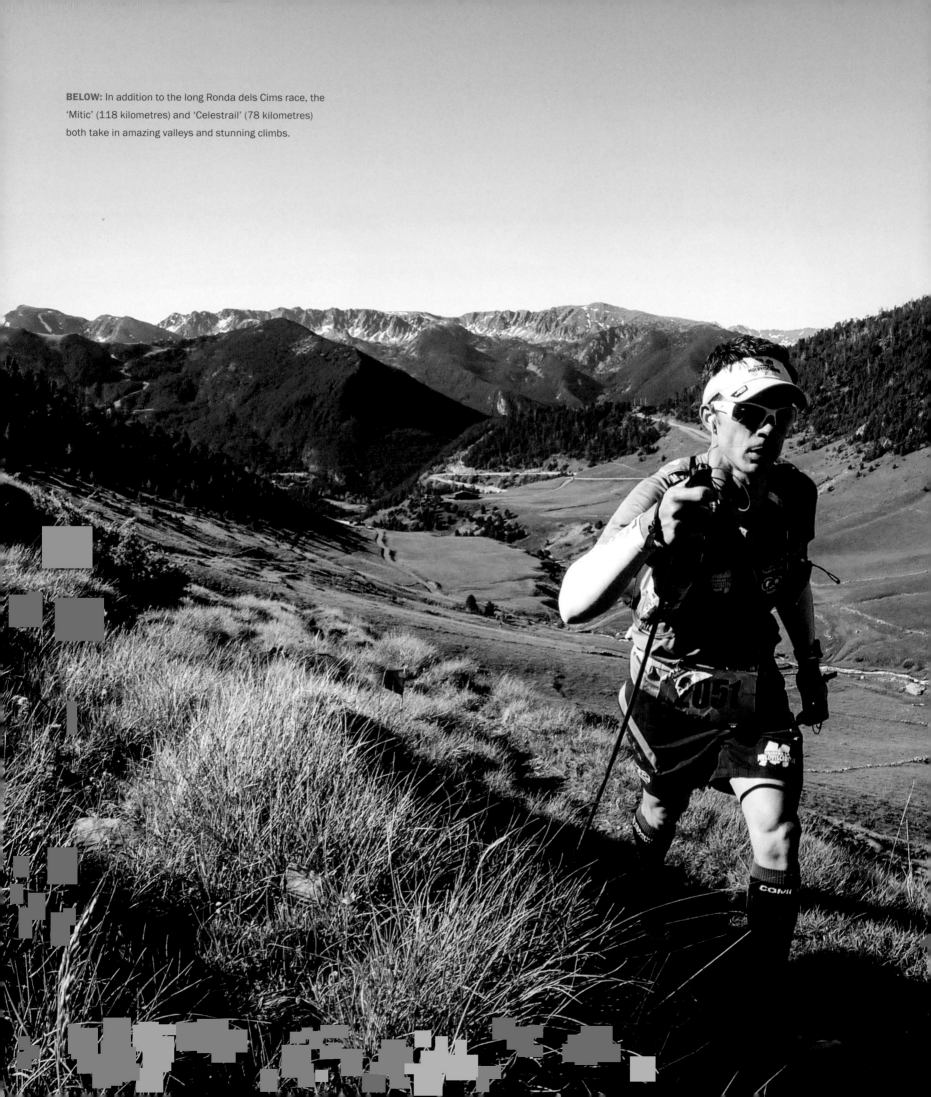

BELOW: In addition to the long Ronda dels Cims race, the 'Mitic' (118 kilometres) and 'Celestrail' (78 kilometres) both take in amazing valleys and stunning climbs.

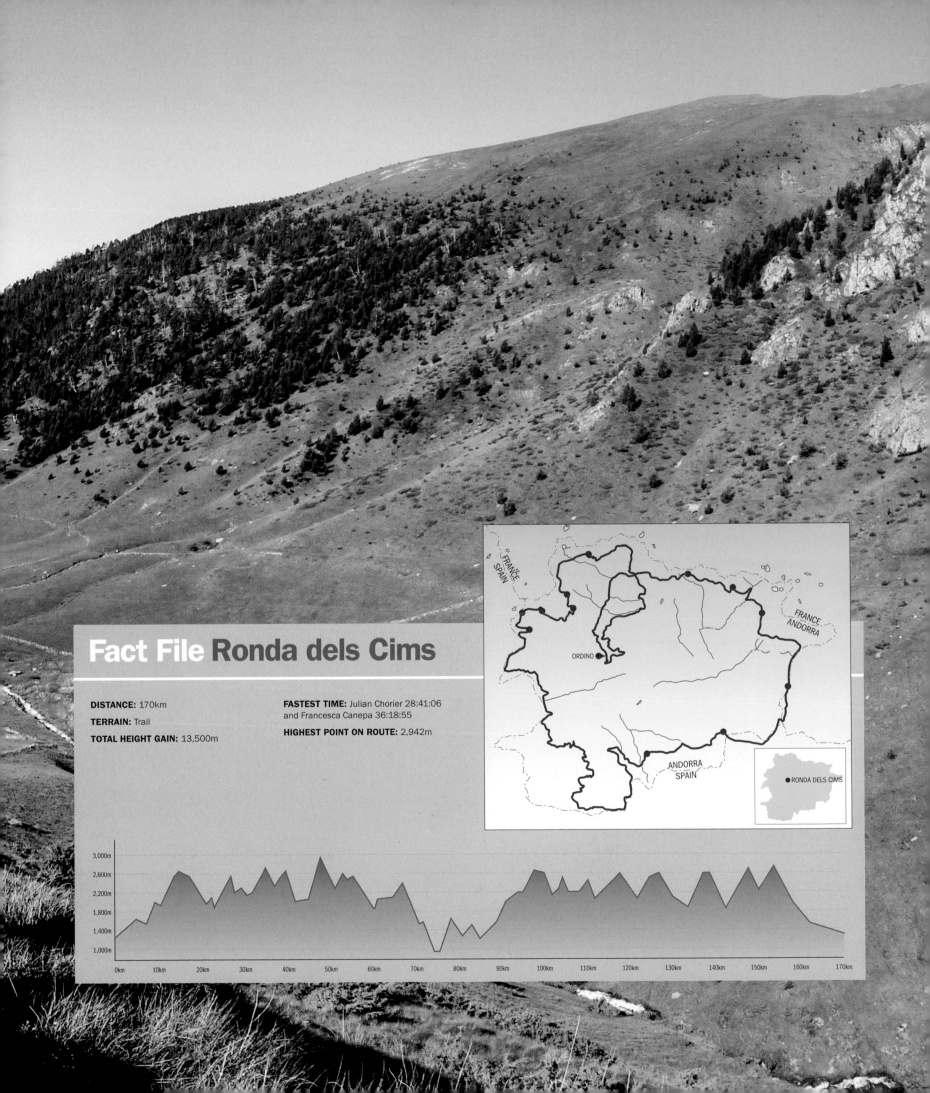

Fact File Ronda dels Cims

DISTANCE: 170km

TERRAIN: Trail

TOTAL HEIGHT GAIN: 13,500m

FASTEST TIME: Julian Chorier 28:41:06
and Francesca Canepa 36:18:55

HIGHEST POINT ON ROUTE: 2,942m

FRANCE
SPAIN

ORDINO

FRANCE
ANDORRA

ANDORRA
SPAIN

RONDA DELS CIMS

Trail Menorca Camí de Cavalls 185km

Spain

East of mainland Spain and northeast of Mallorca, this tiny little island sits in the Balearic Sea and is surrounded by lush, inviting waters of turquoise blue. To the south is Algiers, to the east Sardinia and Corsica; this little jewel of the Balearics is in good company. Take a walk through the cobbled streets of Ciutadella, watch the boats at Fornells or go for a glass of gin at Mahón, a local speciality – life is slow on this island. Start lunch at 2pm and finish at 5pm. Menorca has got it right. Tourism flourishes at a Spanish pace and with a restraint that is hard not to fall in love with.

The trail that runs along the coastline of Menorca, the Camí de Cavalls, was originally established by the settlers of Menorca as part of a defence system. It was patrolled by soldiers on horses, hence the name (*cavall* means 'horse' in Catalan). The path weaves its way in and out of the coast and lets the runners experience varying terrain and views: woodland trails, white beaches with intensely turquoise water, beautiful rock formations, farmland, ravines and urban areas.

RIGHT: Three runners follow each other along the technical and twisty trails.

The profile is undulating with moderate climbs, yet offers a technically challenging experience.

The Trail Menorca Camí de Cavalls is a group of multi-distance races that show the island's beauty to its full potential. Five races encompass the whole of the island by following the way-marked 'Camí de Cavalls' route. Menorca and the Camí de Cavalls work in harmony, offering an incredible way to embrace the beauty of this island; walking or running, anything from 32 to 185 kilometres.

So, five races that manage to introduce the whole island to 900-plus runners from all over the world over three days of running. What could be better? For the brave, hardy and the endurant, the Trail Menorca Camí de Cavalls (TMCdC) is a lengthy 185 kilometres that is not for the faint hearted or the weak. Starting in Ciutadella, runners traverse the island's perimeter in a clockwise direction with the sole objective of arriving back at the town within 46 hours.

The Trail Menorca Costa Nord (TMCN) starts at the same time as the

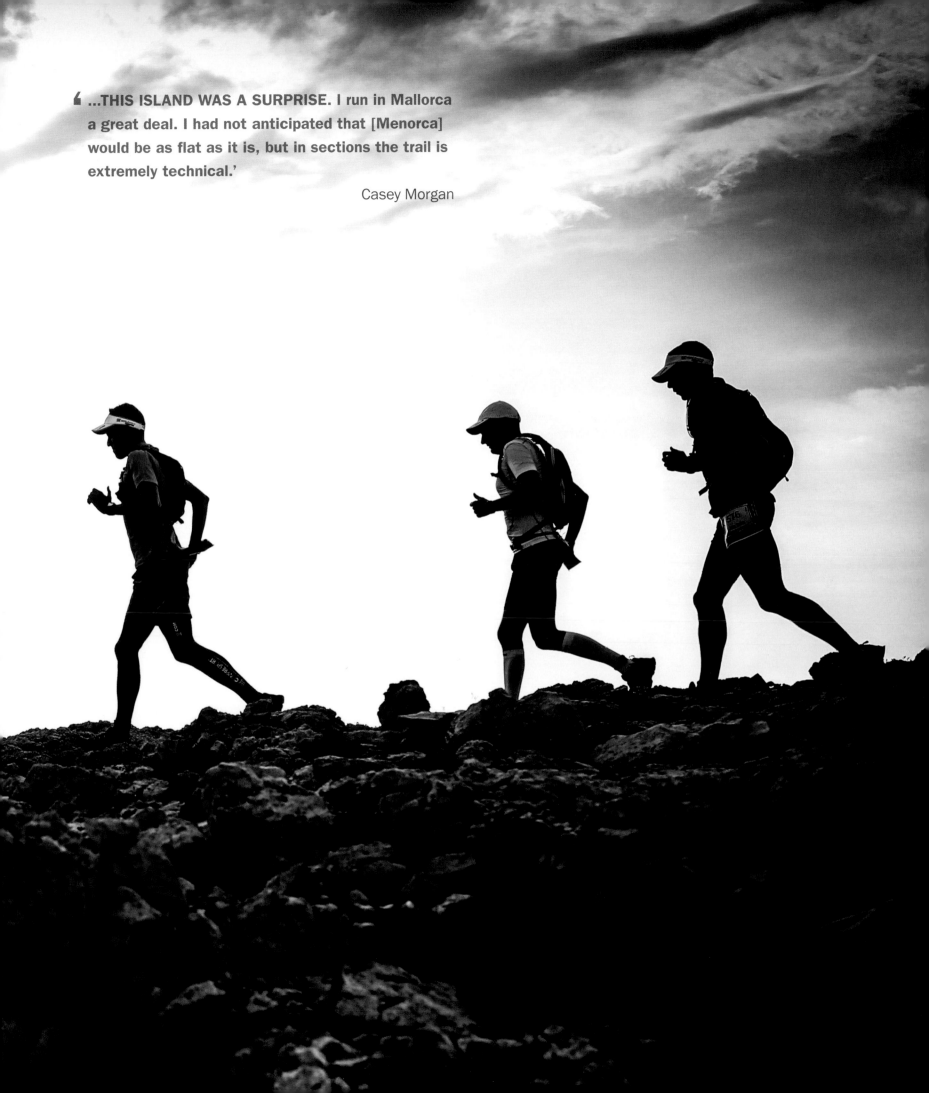

'...THIS ISLAND WAS A SURPRISE. I run in Mallorca a great deal. I had not anticipated that [Menorca] would be as flat as it is, but in sections the trail is extremely technical.'

Casey Morgan

TMCdC but finishes at the opposite end of the island after weaving in, out and up and down the jagged north coast.

In Addaia, 8 ½ hours after the 185-kilometre and 100-kilometre races start, the 32-kilometre Trekking Costa Nord (TCN) starts. Running into the night, darkness changes this quiet island into a playground of trails, coves, woods, forests and beaches. Illuminated by a head torch, it's possible to experience the island in a unique way so seldom seen by others. The striking of the 8am bell releases the 85-kilometre Trail Menorca Costa South (TMCS) runners from Es Castell in the east.

It's a tough question whether TMCS runners have the better course to run in the south or whether the TMCN runners see the best of the island in the north. They are so different. The north is more aggressive – jagged and relentless on the legs, interspersed with stretches of golden sand that pound the calves. The south is lush, green and laced with coves of rock, beaches and a turquoise sea that shines like treasure. Finally, at 11am on day two, the Trekking Costa Sud (TCS) 55-kilometre runners start their journey back to Ciutadella from Cala'n Porter.

Simple in concept, the Trail Menorca team have logistically provided themselves with a task that would give any race director (and team) a serious headache. Maybe it is Menorca and the casual, relaxed way of life that allows this dedicated team of individuals to combine to make a cohesive whole that allows a multi-distance race event to function.

Racing throughout the weekend is often aggressive, fast and impressive, but just like the ethos of the Menorcan people, the racing almost seems unimportant within the context of what this island offers. 'I was amazed by the beauty, the varying terrain and the scenery,' said competitor Elisabet Barnes after her race. 'The final 20 kilometres of the 85-kilometre event, although flat, were brutal. I had just not anticipated that the terrain would be so technical.' Two bloody knees confirmed her effort and commitment. 'We ran on beautiful but equally tough, uneven rock formations, close to the coastline under intense heat. Headwinds in the final kilometres made it exceptionally tough.'

'I have to agree, this island was a surprise,' said Casey Morgan. 'I run in Mallorca a great deal. I had not anticipated that [Menorca] would be as flat as it is, but in sections the trail is extremely technical. The contrast from north to south is also quite amazing. It's a beautiful island.'

With the highest point on the island only around 360 metres, it's a

LEFT: The finish line releases hours of frustration, tiredness and fatigue.
OPPOSITE: Elisabet Barnes on her way to victory and a course record.

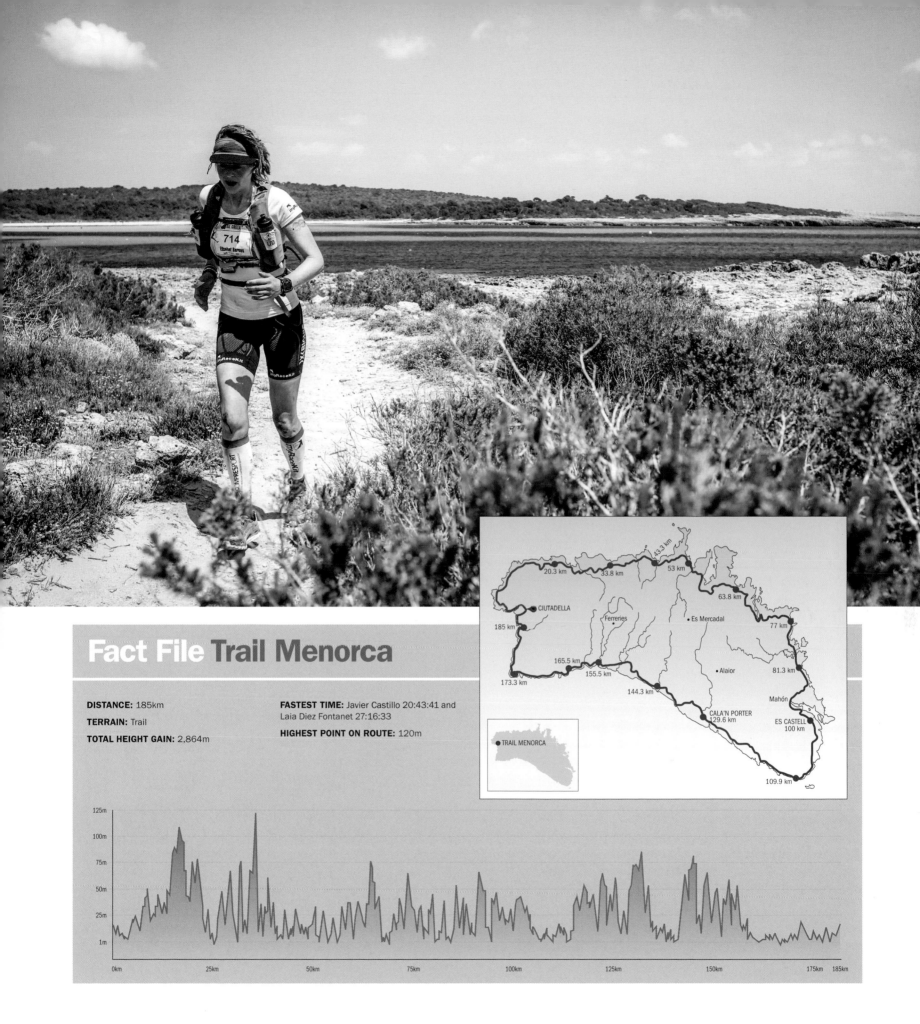

Fact File Trail Menorca

DISTANCE: 185km

TERRAIN: Trail

TOTAL HEIGHT GAIN: 2,864m

FASTEST TIME: Javier Castillo 20:43:41 and Laia Diez Fontanet 27:16:33

HIGHEST POINT ON ROUTE: 120m

Map labels: 20.3 km, 33.8 km, 43.3 km, 53 km, 63.8 km, 77 km, 81.3 km, 100 km, 109.9 km, 129.6 km, 144.3 km, 155.5 km, 165.5 km, 173.3 km, 185 km

CIUTADELLA, Ferreries, Es Mercadal, Alaior, Mahón, CALA'N PORTER, ES CASTELL

TRAIL MENORCA

Elevation profile: 125m, 100m, 75m, 50m, 25m, 1m

0km, 25km, 50km, 75km, 100km, 125km, 150km, 175km, 185km

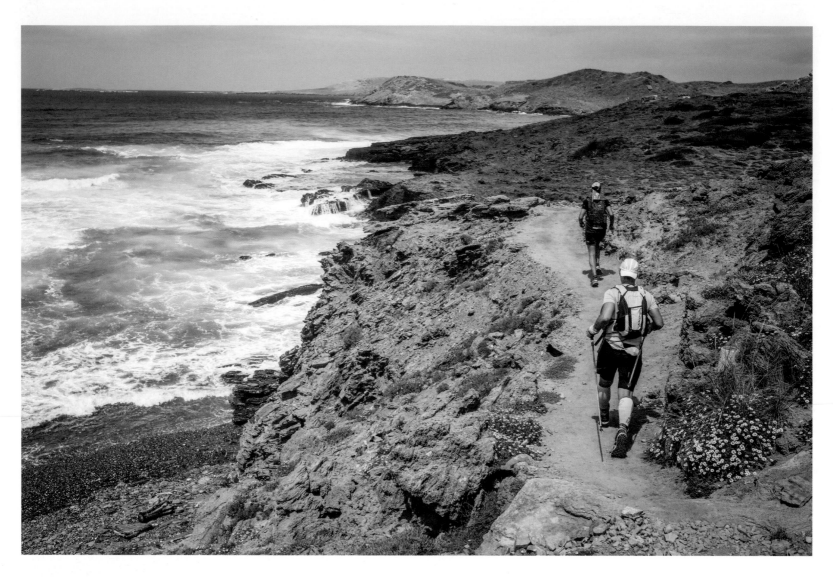

relatively flat island for endurance runners. However, what this chunk of rock in the Balearic Sea lacks in altitude, it makes up for in diversity, beauty and at times technicality.

'I was incredibly surprised at the beauty of the course. I had been told that the TMCN along the north coast was more scenic although much more technical, but to be honest the TMCS was absolutely stunning,' said Niandi Carmont post race. 'The variety of the course is unrivalled – beach sections, little coves of azure, turquoise water, tiny coastal villages, luscious green-flowered fields and cliffs overlooking the island's multitude of pristine bays. The final kilometres of the race take you through the coastal seaside resorts into the finish area at Ciutadella where a welcoming crowd of local supporters and giant paella and free beers await the finishers. The icing on the cake? The beautiful medal with the words "Live the Legend". I really felt I lived the Camí de Cavalls. Until next time!'

ABOVE: Stunning coastal trails weave in and out, making this a truly beautiful route.
OPPOSITE: Casey Morgan, 2015 champion and course record holder for the 85km event.

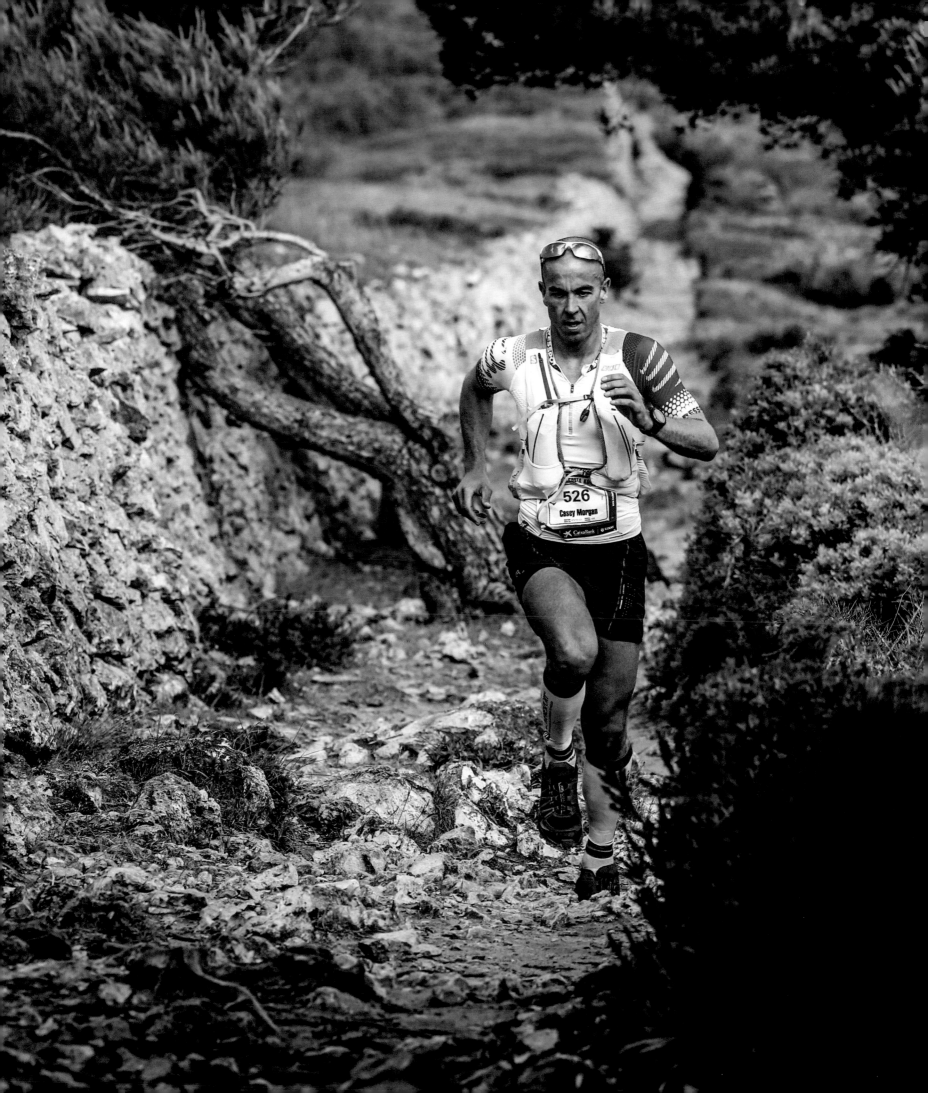

Ice Trail Tarentaise
65km
France

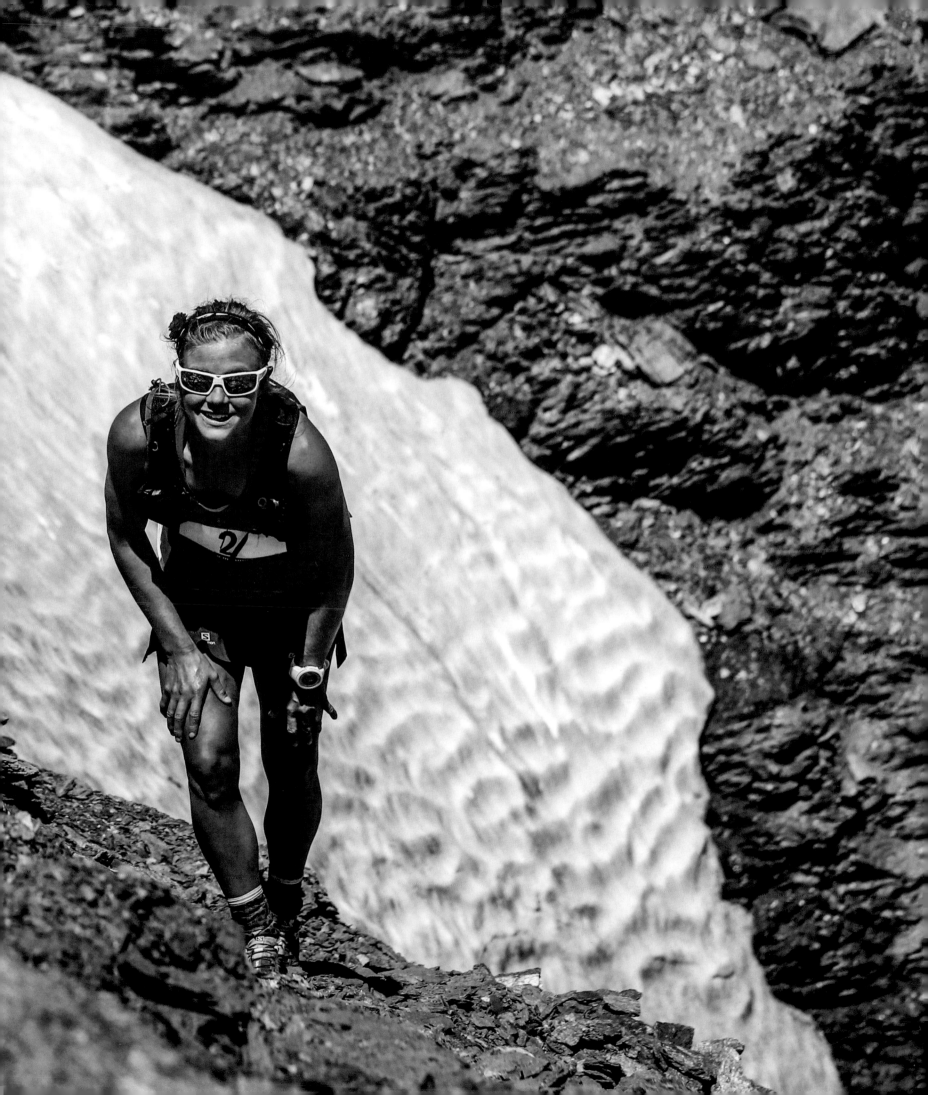

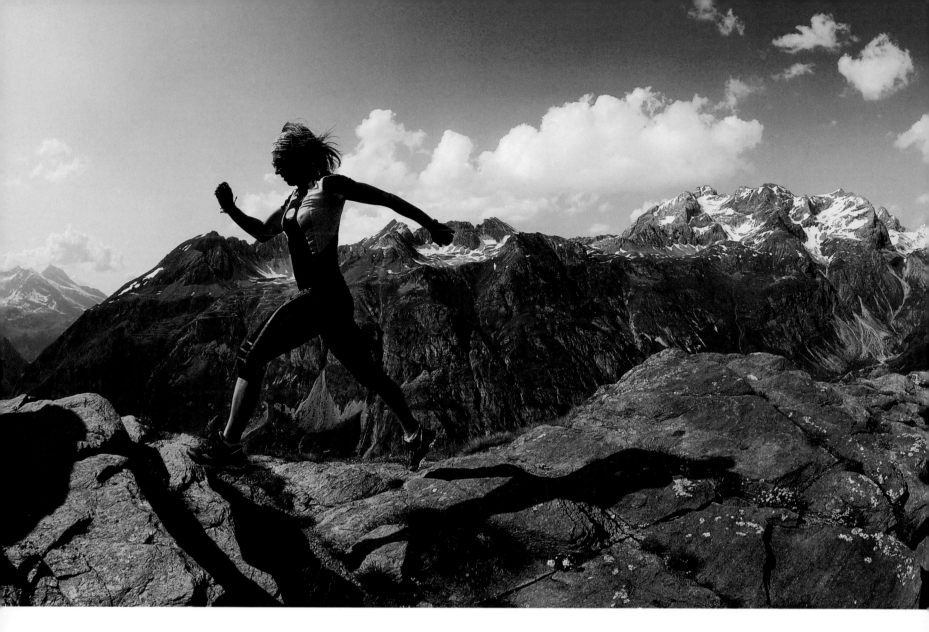

The stunning alpine resort of Val d'Isère is the official home of the Ice Trail Tarentaise. Starting and concluding at this beautiful mountain retreat, as the name suggests it is also the source of the Isère river. The Isère flows through some of the most iconic mountain landscape anywhere. It is a haven for alpinists wanting to test themselves on the iconic slopes of Méribel, Val Thorens and Courchevel. 'Les Trois Vallées' is a ski region in the Tarentaise valley to the south of the town of Moûtiers, partly in the Vanoise National Park. As implied by its name, the area originally consisted of three valleys: Saint-Bon, Allues and Belleville.

The Tarentaise valley and the Ice Trail Tarentaise in many respects personify what runner Kilian Jornet has been pursuing for years. The term 'alpinism' is often perceived in climbing terms, but it is so much more. Traversing glaciers and ascending and descending summits such as Aiguille Pers at 3,386 metres, participants in the Ice Trail Tarentaise will no doubt have a full appreciation of what Kilian and others like him strive for when they use the term 'skyrunning'. Skyrunning is alpinism but without the clutter; it's about being light and moving fast.

The race route has over 60 kilometres above 2,000 metres altitude, and with a highest point of 3,653 metres at Grande Motte, this is not a race to be taken lightly. Echoes of the Tour de France are prevalent when discussing this region, but in spite of featuring the highest paved mountain pass at the Col de l'Iseran (2,770 metres), no bicycles will be seen.

Ropes, ladders, way markers, peaks at over 3,000 metres and around 5,000 metres of ascent and descent guarantee that not all those who toe the line will see the finish. It is a tough race, requiring a steely stubbornness to complete.

French trail-runner Fabien Antolinos, winner of the 2012 and 2013 Templiers races, articulates the event's specific challenges. 'The Ice Trail Tarentaise is a race of pure happiness. To travel in high mountains in running shoes and not boots, moving from summit to summit in an often wild and organic way; it is magic. The highest trails in Europe offer a challenge for any runner, especially when moving as fast as possible and with less oxygen, due to altitude.'

The inaugural event was due to take place in 2011, but severe weather left the organization with no choice but to cancel. Despite this, the 32-kilometre 'Altispeed' did take place and, in extreme conditions, Damien Vouillamoz won the race in just over 3 ½ hours. Virginie Govignon was the fastest woman with a time of 5:14.

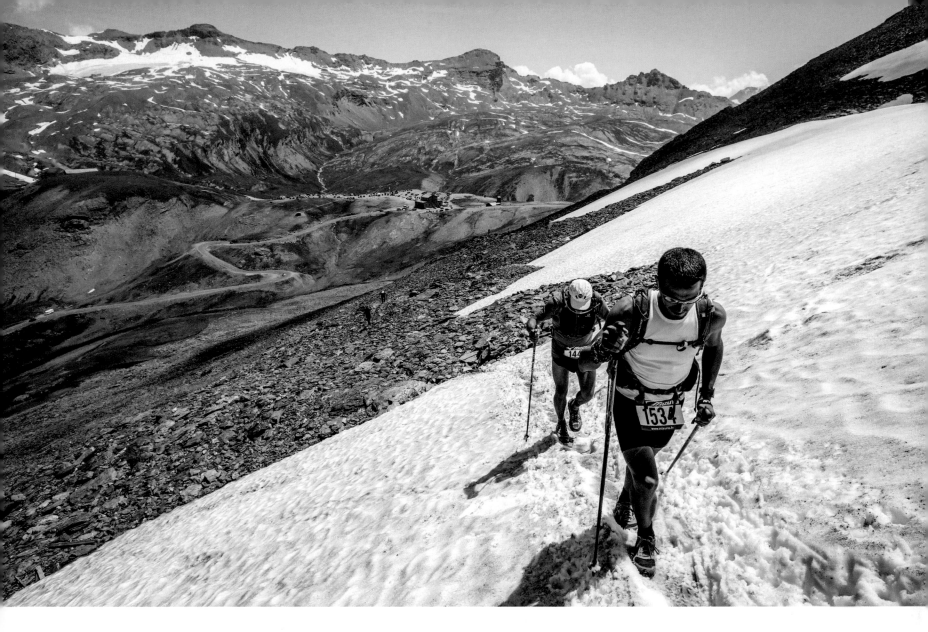

The arrival of the 2012 edition was eagerly anticipated. The shortened version in 2011 had whetted many appetites, especially as the success rate had been around 50 per cent – what would a full course offer? Irrespective of initial weather concerns, the race went ahead. François D'Haene and Anne Valéro were the winners, with times of 8:16:35 and 11:20:13 respectively.

Despite the technical demands of the race, the challenging terrain, the high altitude, the snow, the ice and extreme difficulties, the race and this region continue to attract a plethora of runners. It's easy to understand why – the Grande Motte, for example, is a stunning mountain, and to climb this beast from the lower altitudes in one push is a pure, adrenaline-charged experience. At the summit, a new day breaks and, with the addition of light crampons, participants traverse the glacier; either side is extreme danger.

Depending on the year and the weather conditions, the race can offer varying challenges of terrain and body-climate control. The high altitude of Grande Motte will almost certainly be covered in snow, but the lower peaks and valleys can be clear, or even icy. This was the case in 2013, when deep snow and ice made the paths treacherous work, and for many it exemplified a true mountain race. In contrast,

ABOVE: It's called ice trail for a reason – two runners navigate a tricky section.
OPPOSITE: Francesca Canepa stretches her legs in the days before the race.
PREVIOUS PAGE: Emelie Forsberg smiles her way to another impressive victory.

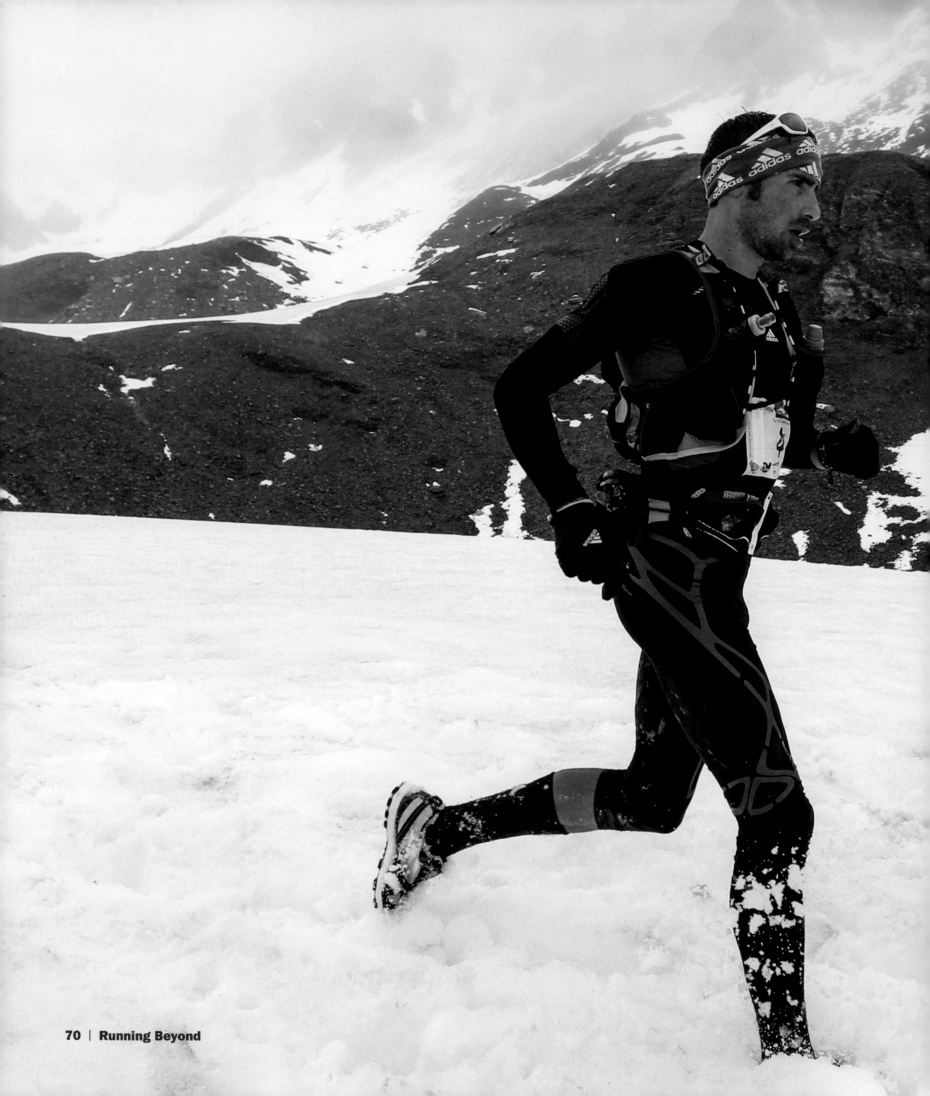

the 2015 edition saw only minimal snow and ice, creating a very different race with only one thread of continuity: incredible beauty, views and landscapes.

In 2015, the race was given the honour of hosting the Skyrunning World Championships and, as in previous years, runners travelled from as far away as Australia and New Zealand to run, climb, hike and traverse the alpine slopes, trails and mountains of France. Luis Alberto Hernando (Spain) and Emelie Forsberg (Sweden) repeated a trio of victories (2013, 2014 and 2015) to be crowned respective champions of the male and female categories.

Due to changes within the Club des Sports (Val D'Isère), in 2016 the Ice Trail Tarentaise was run under a new name with slight adjustments to the course. Some say that the new route is even harder. One thing is for sure: the extreme challenge that has made this region an adrenaline junkie's playground will continue to inspire runners for one of the ultimate skyrunning experiences.

LEFT: Luis Alberto Hernando running across snow fields in 2014.

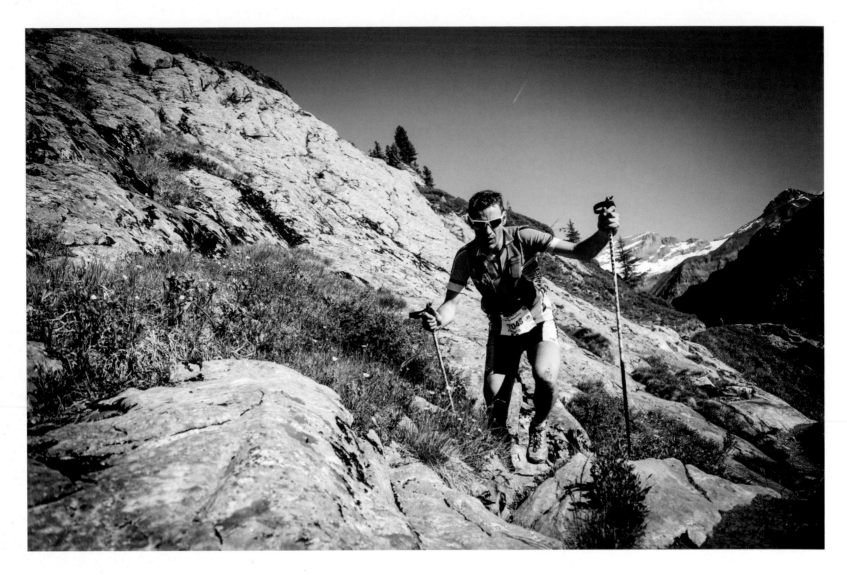

Chamonix has long been considered the mountain endurance capital of the world. Irrespective of your chosen sport, the village, the mountains and the trails provide something for everyone. From a trail- and mountain-running perspective, for many the UTMB (Ultra-Trail du Mont-Blanc – see page 84) has become a flagship of running not only in France but also worldwide. The unique, circular 161-kilometre journey from Chamonix back to Chamonix via France, Italy and Switzerland is a pinnacle of the sport.

In recent years, though, the Mont-Blanc 80km has started to rise and although it is half the distance of its big brother, many consider the challenge almost equal if not harder due to the high elevation and technical aspects. To clarify, the UTMB traverses around many of the peaks in the region; by contrast, the Mont-Blanc 80km goes over them.

The difficulty of the course is matched by its beauty. 82 kilometres in length and with 6,000 metres of positive gain, the race takes a remote and technical route around the Chamonix valley. The terrain is challenging and comprises snow, ice, technical trail and smooth single track, and the maximum allocated time is 24 hours. It may seem like a very achievable challenge, but as any previous competitor will tell you, the race requires 100 per cent commitment, determination and tenacity

to endure a long, tough day in spectacular mountain scenery.

Through huge crowds, music and the glow of head torches, thousands of runners are released onto the trails of this iconic valley. It's a tough start, 10 kilometres straight up to Bellachat refuge and the stunning lone point of Le Brévent at 2,400 metres. As the runners pass through the Tête aux Vents, traversing from La Flégère to Col des Montets, a new day will welcome the runners.

Experienced ski-mountaineer and skyrunner Anna Cometi sums up the early hours of the race: 'The start is at 4am and you reach the first summit just when the sun is rising. With Mont Blanc directly in front of

ABOVE: Franco Colle, of Italy, using poles to traverse the rocks.
OPPOSITE: François D'Haene, of France, in one of the most green and flower-filled parts of the route.

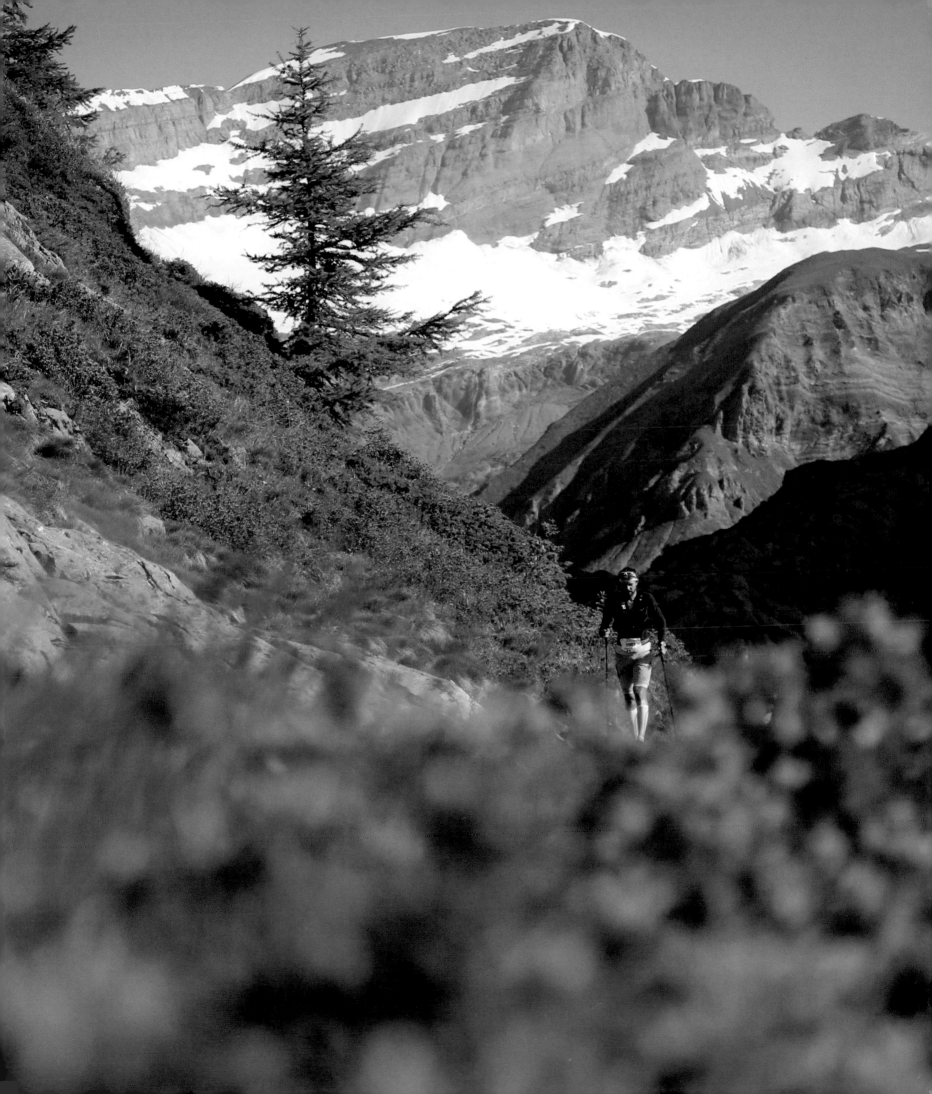

you, the sun hits the mountains; it is simply a wonderful natural gift.'

Hillary Allen from the USA, racing in Europe for the first time, said after her race, 'First of all the race is incredibly inspiring. It was my first time in the Alps, and the views are sweeping and breathtaking. I remember watching the first rays of light hit the valley and Mont Blanc as I summitted Brévent. That definitely gave me some energy and would help me when I hit rough spots. It is one of the hardest races I have ever done and also maybe one of the most beautiful.'

A descent to Mont Buet leads to a very tough and technical climb of approximately 1,300 metres to the Col de la Terrasse at 2,645 metres. From the summit, the mountainous landscape is broken up by the Emosson Dam on the horizon. Descending to Combe de la Veudale, a traverse of the dam leads to La Chapelle and a stunning view of the Mont Blanc range – high, jagged peaks of white breaking on the horizon.

Cometi continues, 'The race is technical due to the variety of terrain – snow, rocks, ice and so on. There aren't many flat kilometres. On the second ascent, Col de la Terrasse, I had a great deal of snow to run through and the views up there were amazing.'

Les Jeurs, the Catagne Hut, the Tête de l'Arolette and the Tête de Balme now bring the runners back in the direction of Chamonix on the opposite side of the mountain range; off to the right, Chamonix can be seen tempting each and every participant back to the line.

'The course is incredible, especially the middle section, where's there's some scrambling and glissading down snow fields,' Allen explains. 'It's challenging – steep ups and downs and not a single flat section make this a true mountain race.'

From the Col des Posettes, the Ardoisières trail leads to the village of Le Tour, the northern balcony leading to Le Planet village and Les Bois via the Rambles trail. The running is now a little easier and less technical, but with 70 kilometres covered, the climb to Montenvers via the Mer de Glace is a stunning and cruel sting in the tail.

'Finally you reach the last ascent, on the way to one of the most emblematic places around Mont Blanc,' Cometi continues. 'You have the huge wall of Aiguille du Midi just above you. It's difficult to not have a really special feeling under these big white mountains, and I'm sure the fatigue and exhaustion adds to the experience.'

The final drop of over 1,000 metres obliterates already tired legs, but the welcome on the streets of Chamonix is a rapturous and emotional one; a full traverse of an entire valley, a crossing of iconic summits and the grandeur of the Aiguille Rouge has been completed.

'I still think of it and I feel moved; there are people all along the main street of Chamonix cheering you!' recalls Anna Cometi. 'For me it is one of the most beautiful races I've ever done. It will always be in a special place in my thoughts.'

❛ WITH MONT BLANC DIRECTLY IN FRONT OF YOU, the sun hits the mountains; it is simply a wonderful natural gift.'

Anna Cometi, experienced
ski-mountaineer and skyrunner

ABOVE: Luis Alberto Hernando unleashes his emotions
with an impressive victory.

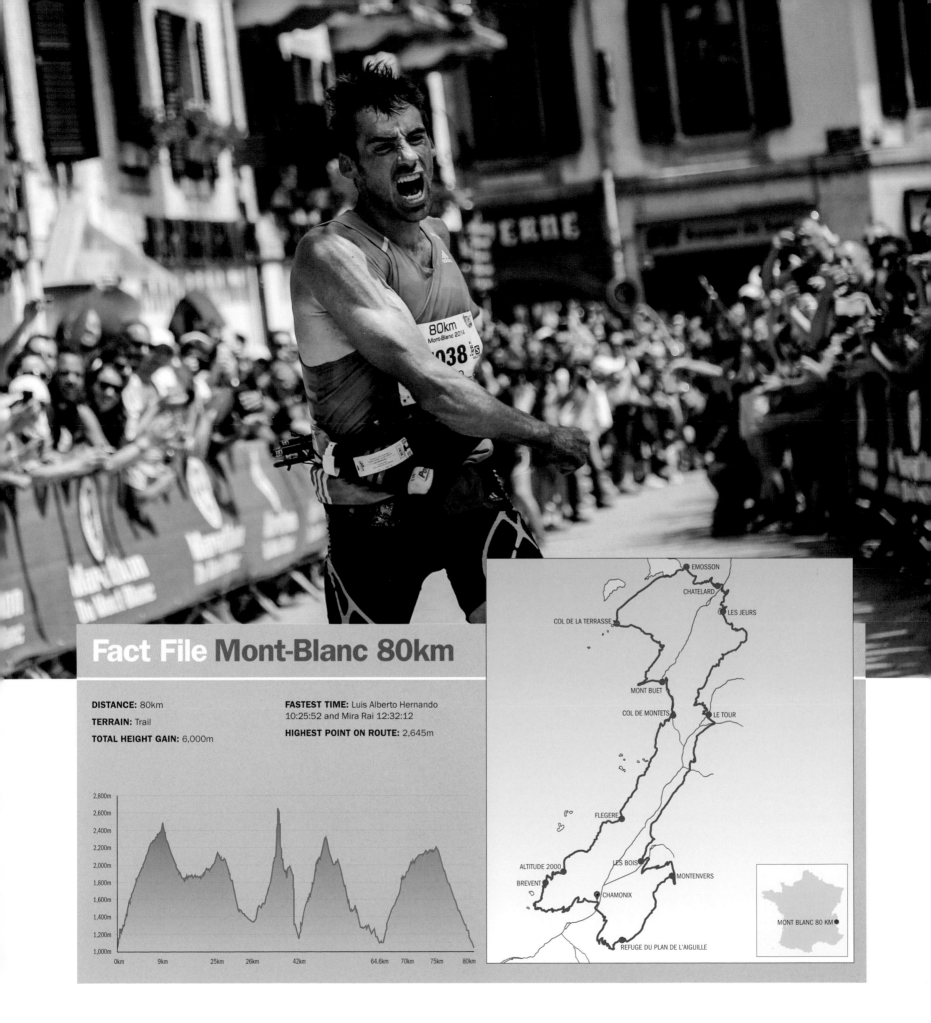

Fact File Mont-Blanc 80km

DISTANCE: 80km

TERRAIN: Trail

TOTAL HEIGHT GAIN: 6,000m

FASTEST TIME: Luis Alberto Hernando
10:25:52 and Mira Rai 12:32:12

HIGHEST POINT ON ROUTE: 2,645m

Ultra-Trail du Mont-Blanc 170km

France

I s the Ultra-Trail du Mont-Blanc (UTMB) the ultimate race? Many a runner thinks it is, and in just thirteen years, the race has grown into arguably the most inspiring ultra in the world.

Created in 2003, the route takes in a loop of the stunning Mont Blanc mountain using the well-marked hiking path that passes through France, Italy, Switzerland and back into France. Due to the nature of the mountains and inclement weather, the route often varies, but in principle the classic UTMB is 166 kilometres in length with 9,500 metres of vertical gain. A popular holiday hike that often takes anything from seven to fourteen days, a series of well-paced refuges provide regular stopping points for food and shelter. Despite the distance, the severity of the course and the hazards, runners are allocated just 60 hours to complete it.

British runner Lizzy Hawker has dominated the event since its creation, winning an unprecedented five times (two on shortened courses in 2010 and 2012), the first victory coming in 2005. 'A beautiful and demanding mountain journey,' is how she describes it. 'Over the years the UTMB has established itself as an iconic race of global repute,

and has been an important influence in the growth in popularity of ultra-distance mountain races. The UTMB offers an experience that draws runners, volunteers, supporters and communities together in something that is so much more than just the race itself – it is something special to be a part of.'

Krissy Moehl, Nikki Kimball and Rory Bosio, all from the USA, have accumulated a total of five victories – two, one and two respectively. Considering the demanding nature of the course, the high mountains and the long distance, this confirms that American female ultra runners are some of the best in the world.

'Coming from the US, I wasn't prepared for the size of the field of runners or spectators. Here in the US, our forest service limits the field size of trail races to several hundred at most, and the courses tend to remain remote throughout the entire distance,' said Nikki Kimball about her 2007 victory. 'I loved UTMB in that every major aid station had huge, boisterous crowds cheering runners on. I love the culture inside and surrounding endurance running, and at UTMB, that endurance culture

advantages that men have, ladies once again triumphed at the Dragon's Back Race and I think that it is brilliant.'

Travelling 300 kilometres under one's own steam does make a runner look inward, and it's enlightening to see how people change from day to day. Some found increased strength from the process, realizing that the mind was actually the supreme endurance tool and not the legs or the lungs. For others, the mind became weak, exhausted from the full-on concentration required to navigate the fastest way to the line. Some participants were getting just four hours sleep before heading out again for another full day.

The Dragon's Back Race is full of highs and lows, and not just in the mountainous sense. Race competitor Mike Evans describes it well: 'So, what a week! What a journey. It is impossible to explain how tough, how mentally and physically challenging it was, but also how spiritual it has been. Cut off from the world, no social media, no showers, just living in the wild with a group of equal enthusiasts.'

The Dragon's Back Race has now gained a reputation as one of 'the' races to do. But too much of a good thing can be bad for you. Ohly realizes this, and as such has made the event biennial, a move that only adds to the mystique.

Dragon's Back Stats

Covering five key regions of Wales, the daily statistics are as follows:
Carneddau, Glyderau and Snowdon: 49.3 kilometres; 3,823-plus metres
Moelwyns and Rhinogs: 53.9 kilometres; 3,544-plus metres
Cadair Idris and Plynlimon: 68.3 kilometres; 3,712-plus metres
Elan Valley: 64.0 kilometres; 2,273-plus metres
Brecon Beacons: 56.5 kilometres; 2,313-plus metres

‘ IT IS IMPOSSIBLE TO EXPLAIN HOW TOUGH, how mentally and physically challenging it was, but also how spiritual it has been.'
Mike Evans, race competitor

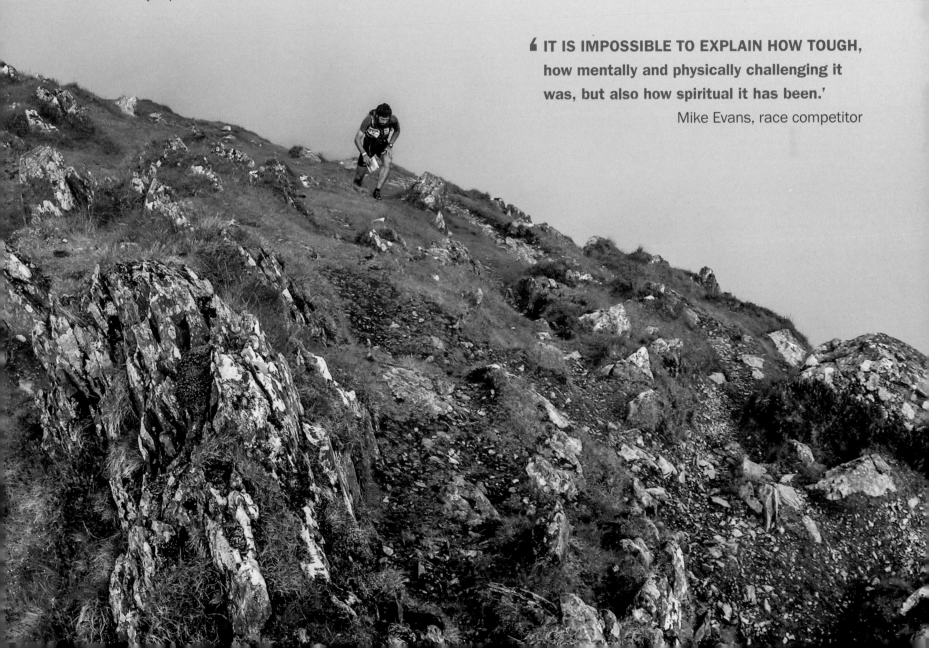

ABOVE: The stunning Welsh mountains provide gritty terrain and beautiful landscape for the UK's toughest race.

RIGHT: Kevin Douglas from the USA traversing Crib Goch on his way to 19th place.

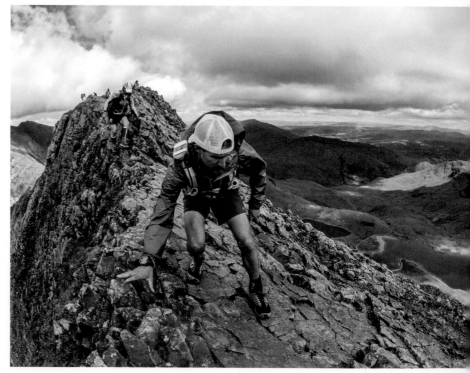

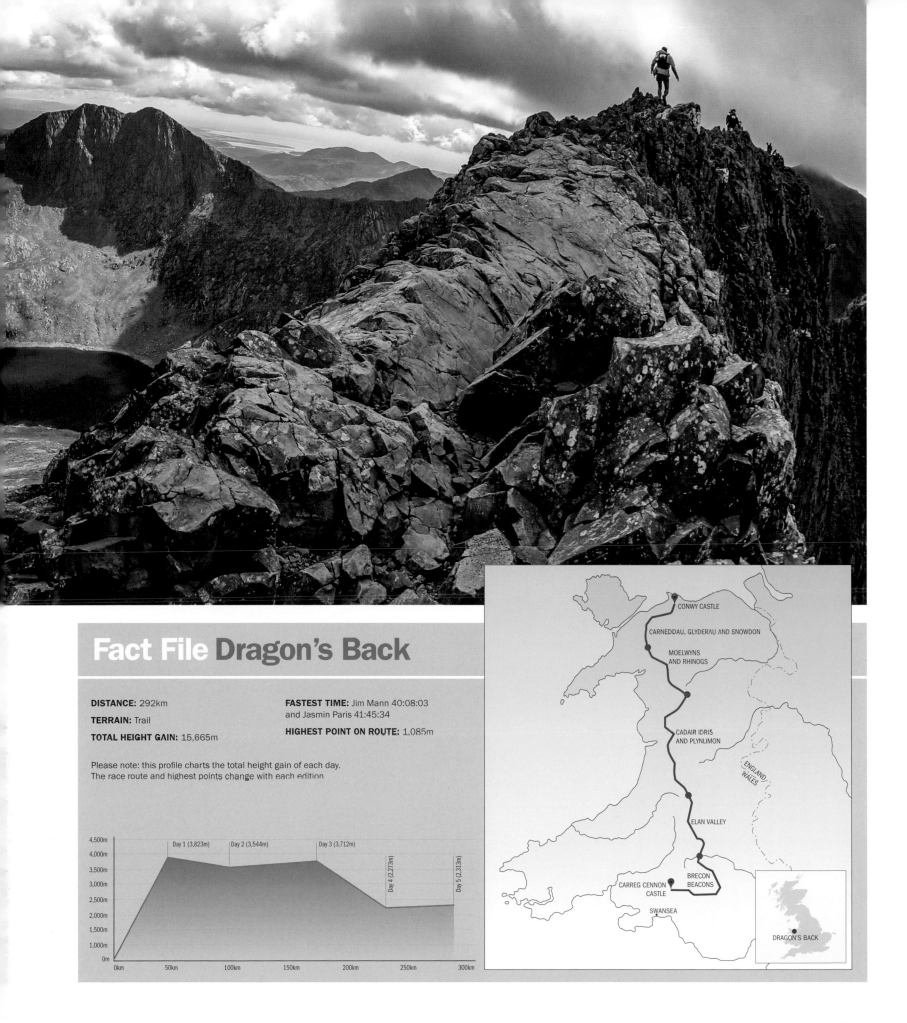

Fact File Dragon's Back

DISTANCE: 292km

TERRAIN: Trail

TOTAL HEIGHT GAIN: 15,665m

FASTEST TIME: Jim Mann 40:08:03 and Jasmin Paris 41:45:34

HIGHEST POINT ON ROUTE: 1,085m

Please note: this profile charts the total height gain of each day. The race route and highest points change with each edition

[Elevation profile chart showing: Day 1 (3,823m), Day 2 (3,544m), Day 3 (3,712m), Day 4 (2,273m), Day 5 (2,313m). Y-axis: 0m to 4,500m. X-axis: 0km to 300km]

[Map of Wales showing route markers: CONWY CASTLE, CARNEDDAU, GLYDERAU AND SNOWDON, MOELWYNS AND RHINOGS, CADAIR IDRIS AND PLYNLIMON, ELAN VALLEY, BRECON BEACONS, CARREG CENNON CASTLE, SWANSEA, ENGLAND WALES. Inset map of UK labelled DRAGON'S BACK]

Lakeland 100 & 50
161km
England

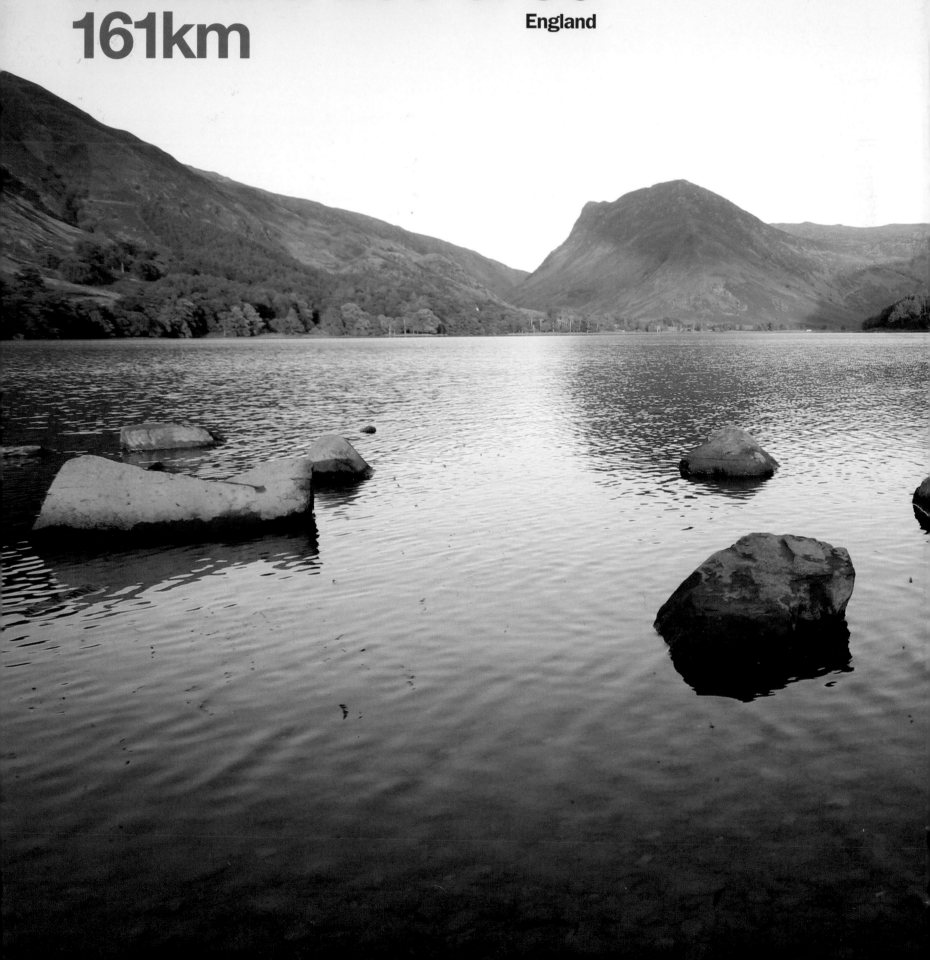

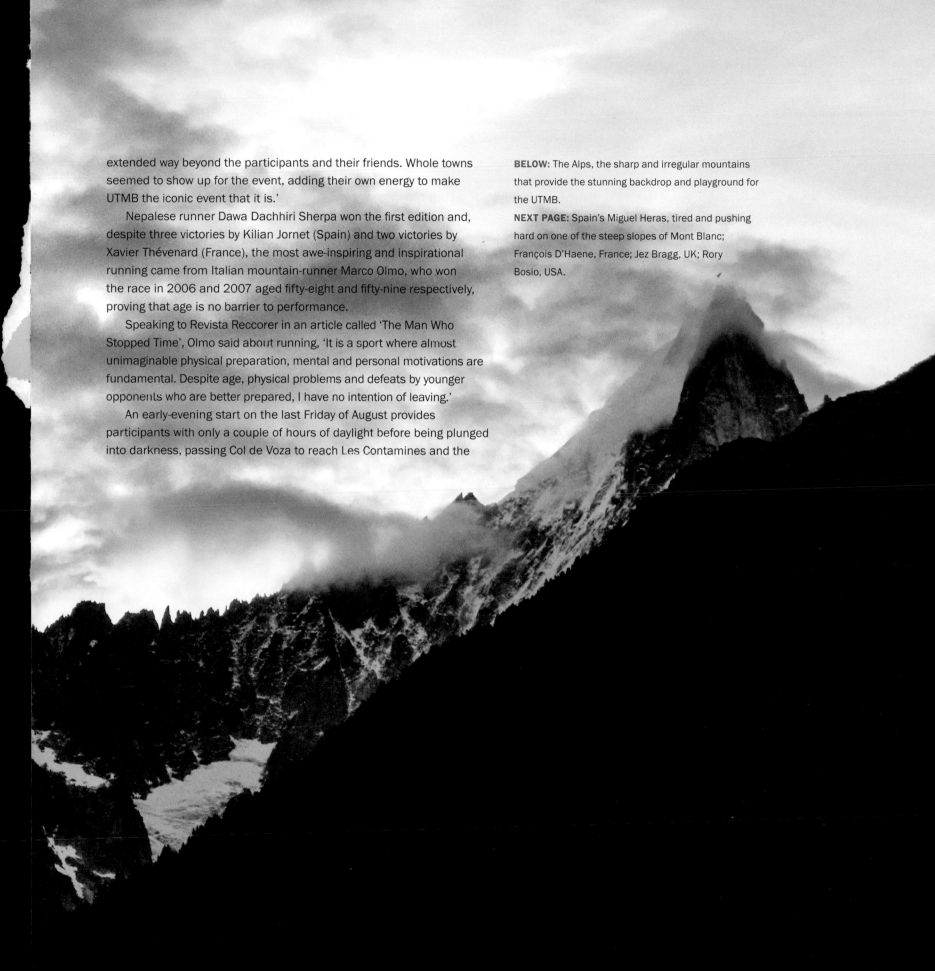

extended way beyond the participants and their friends. Whole towns seemed to show up for the event, adding their own energy to make UTMB the iconic event that it is.'

Nepalese runner Dawa Dachhiri Sherpa won the first edition and, despite three victories by Kilian Jornet (Spain) and two victories by Xavier Thévenard (France), the most awe-inspiring and inspirational running came from Italian mountain-runner Marco Olmo, who won the race in 2006 and 2007 aged fifty-eight and fifty-nine respectively, proving that age is no barrier to performance.

Speaking to Revista Reccorer in an article called 'The Man Who Stopped Time', Olmo said about running, 'It is a sport where almost unimaginable physical preparation, mental and personal motivations are fundamental. Despite age, physical problems and defeats by younger opponents who are better prepared, I have no intention of leaving.'

An early-evening start on the last Friday of August provides participants with only a couple of hours of daylight before being plunged into darkness, passing Col de Voza to reach Les Contamines and the

BELOW: The Alps, the sharp and irregular mountains that provide the stunning backdrop and playground for the UTMB.
NEXT PAGE: Spain's Miguel Heras, tired and pushing hard on one of the steep slopes of Mont Blanc; François D'Haene, France; Jez Bragg, UK; Rory Bosio, USA.

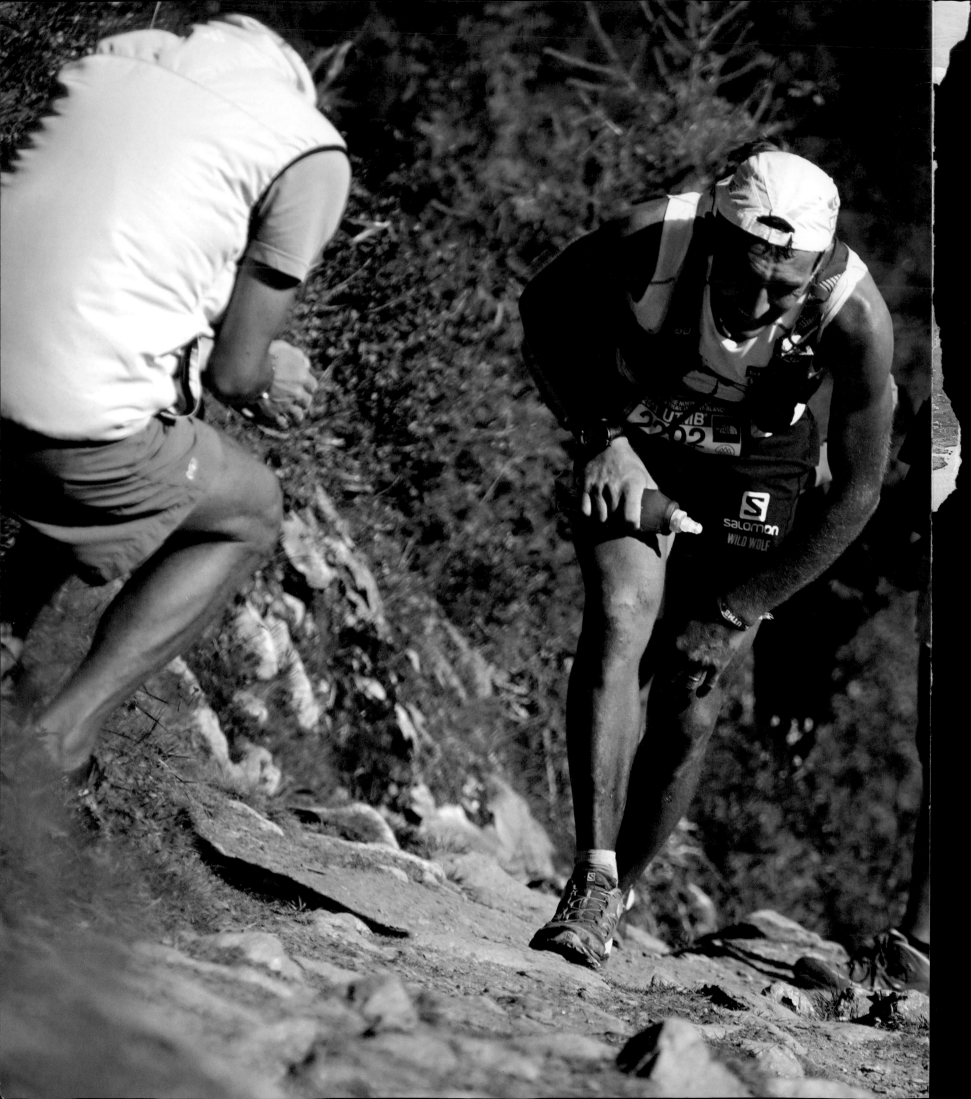

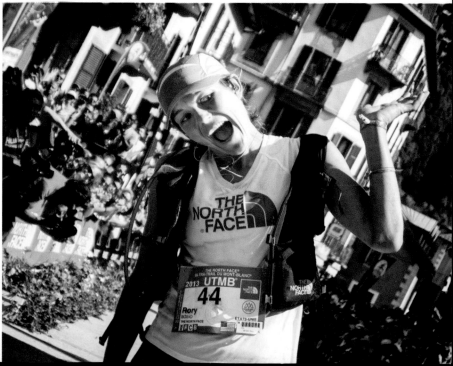

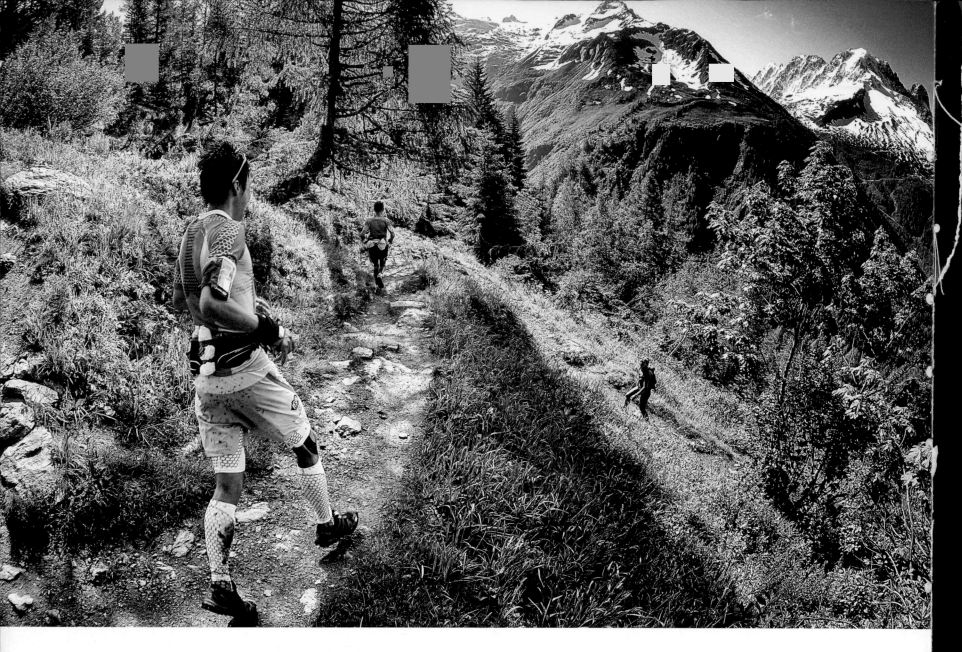

tough climb to the Croix du Bonhomme at 2,479 metres. The daunting challenge of a circular tour of Mont Blanc is under way.

Les Chapieux leads to the Col de la Seigne at 2,516 metres. The runners then follow the ridge of the Mont Favre, and they are now in Italy. Courmayeur provides a significant marker for the race, and what follows is a series of tough and relentless climbs: Refuge Bertone at 1,989 metres, Arnuva at 1,769 metres and then the highest point, the Grand Col Ferret at 2,537 metres.

Following the path down to Praz-de-Fort via La Fouly, the runners enter Switzerland. It's this journey from France, to Italy, to Switzerland and once again returning to France, that makes this race so special.

Champex d'en Bas leads to Bovine, Trient and Les Tseppes before descending to Vallorcine. Now the final leg through France follows, as the route crosses Argentière before finishing amongst the incredible spectacle and noise that Chamonix brings.

Hilary Sharp, a British International Mountain Leader based in Vallorcine, sums up her experience of completing the 2008 UTMB for Cicerone Guides: 'Then I was on tarmac, meaning there wasn't far to go now... Barriers alongside the road channelled us to the finish; it no longer

hurt and I knew exactly what to do. I'd been through it enough times in my dreams: keep running, get your poles in one hand, raise your other hand in victory and smile!'

UTMB has become one of the most exclusive and sought-after races in the ultra calendar. Year on year, demand to run has increased and today it is necessary to accumulate points on accredited ultra races worldwide, which are awarded ranking points (a sliding scale of one, two, three or four points) based on the difficulty of the course. Potential runners are required to have a minimum of nine points acquired from a maximum of three races. Even then, entry is not guaranteed; applications are received and a lottery draw chooses the lucky participants for the following year.

ABOVE: Single-track trails, switchback bends and fast running: all the elements that make UTMB such an iconic race.
OPPOSITE: Frenchman Sébastien Chaigneau, running through the night. His eyes are down; this is a time for concentration.

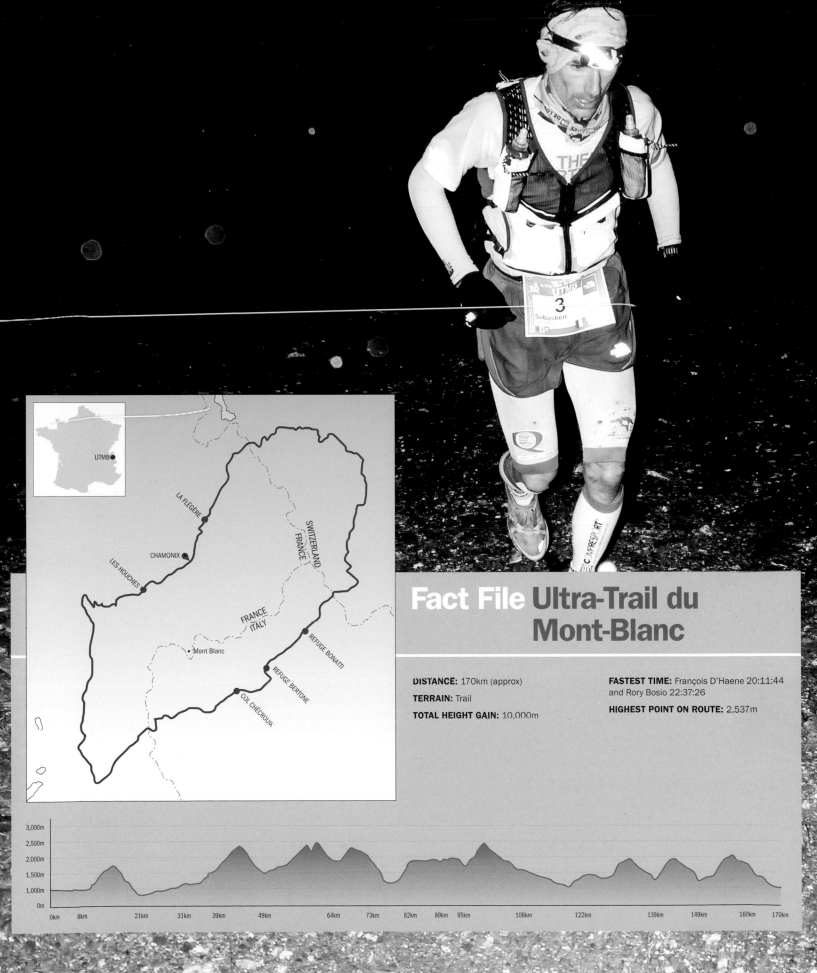

Fact File Ultra-Trail du Mont-Blanc

DISTANCE: 170km (approx)

TERRAIN: Trail

TOTAL HEIGHT GAIN: 10,000m

FASTEST TIME: François D'Haene 20:11:44 and Rory Bosio 22:37:26

HIGHEST POINT ON ROUTE: 2,537m

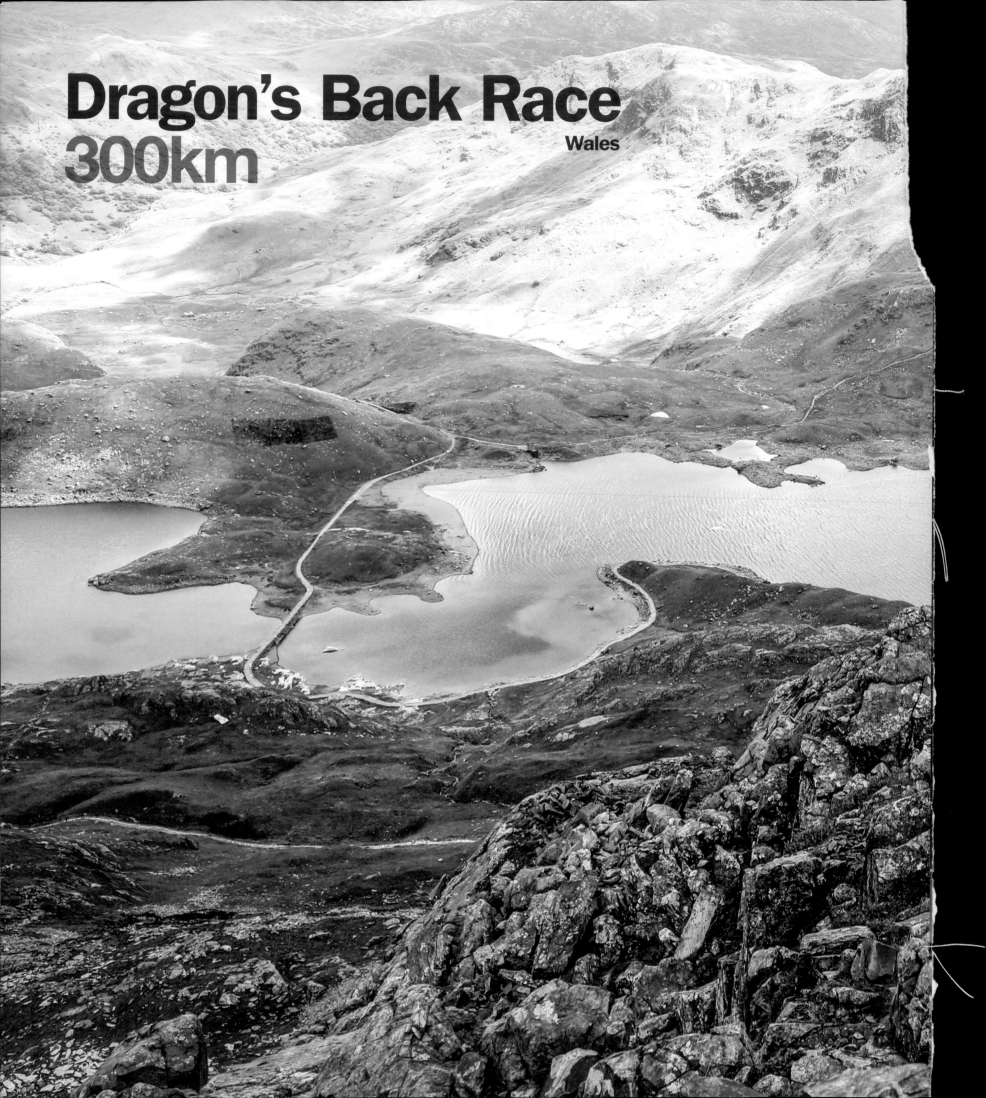

Dragon's Back Race
300km

Wales

The Dragon's Back Race is a simple race in concept. Start in the north of Wales at Conwy Castle, travel down the toughest mountainous spine of Wales over multiple days and then finish in the south at Carreg Cennen Castle. An incredible journey of 300 kilometres with 16,000 metres of vertical gain, all while navigating your own way via compass and map.

The first edition struck fear into the first participants and onlookers. The race was beyond tough, beyond challenging – a race so punishing that it only happened once. It became infamous, and just the mention of its name made the most experienced fell and mountain runner shake.

That is, until 2012.

Shane Ohly, an experienced mountain runner himself, revived the event and, sticking to the original format, a twenty-year hiatus was broken. Legendary mountain runner Steve Birkinshaw won the 2012 event outright, and 1992 champion Helene Whitaker returned and won the ladies' prize and placed fourth overall.

As *The Guardian* newspaper at the time reported, 'Five days, 200 miles, 8½ miles of ascent – the gruelling Dragon's Back Race, which started on Monday 3 September, crossed the length of Wales, from Conwy Castle in the north to Carreg Cennen Castle in the south. One of the world's most challenging races, it fills even the hardest runners with awe.'

The event had found a new client base, and the sport of ultra running was changing. Further, harder, more vertical, gnarlier – just mention the word 'toughest' and runners flock to sign up. The once-infamous reputation of the Dragon's Back Race was now a calling card.

Day one is arguably one of the best days in the mountains one could ever experience in the UK, as it takes in all of the Welsh 3,000s over a 49-kilometre route. The 3,000s are fifteen peaks in succession that total 3,823 feet (1,185 metres) of vertical gain and the infamous exposed arête of Crib Goch. It would make a great stand-alone race. So much so, a race already exists that takes in much of the day-one route – the V3K, one of the Skyrunning UK race series. However, participants in that race run for one day, stop, rest and then go home. No such mollycoddling on the Dragon's Back. This is just day one, and what follows are four lengthy and tortuous days that make the hardiest competitor question his or her sanity.

The race is arguably one of the toughest challenges available, not only in the UK but also worldwide. It is this that makes it so special. Welsh mountain terrain is very unique; unlike the Alps or Pyrenees, with mountains that soar thousands of metres high, Welsh mountains top out at just 1,000 metres. What makes it so tough is the relentless rollercoaster of highs and lows, with unpredictable and often boggy ground. Often off piste, the Welsh terrain is far removed from the groomed trails of, say, the UTMB in France.

Multiple days of relentless climbing and descending, harsh terrain, self-navigation, frequently poor visibility and daily distances well over 50 kilometres force each and every runner to question themselves: 'Can I do this?' Of course the weather plays a huge factor, and the runners' ability to navigate the fastest and most logical route is a key element of the race.

Only thirty people completed the 2012 edition. 300 applied for the 2015 running of the race, but only 144 were accepted due to strict entry criteria, of which 128 made the start line. Statistics show that only sixty-five completed the journey, a failure rate of 50 per cent.

Just like in the original race, when Helene Whitaker showed the men a thing or two, 2015 had all the potential for a repeat performance, with Jasmin Paris leading the way and placing second overall. She was closely followed by Beth Pascall (fourth overall) and Lizzie Wraith (sixth overall). Race victory went to Jim Mann, who showed everyone a clean pair of heels. Race director Shane Ohly touched on the ladies' performances at the awards ceremony: 'Despite the so-called

RIGHT: Wouter Hamelinck climbs through the mist.
PREVIOUS PAGE: Lizzie Wraith climbs up to the exposed ridge of Crib Goch.

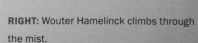

BELOW: Buttermere,
in the Lake District.

Fact File Lakeland 100 & 50

DISTANCE: 161km (approx)

TERRAIN: Trail

TOTAL HEIGHT GAIN: 6,856m

FASTEST TIME: Terry Conway 19:50:37
and Lizzie Wraith 24:15:06

HIGHEST POINT ON ROUTE: 670m (approx)

Bassenthwaite Lake

Derwentwater

Ullswater

Buttermere

Helvellyn

Great Gable

Scafell Pike

CONISTON

Coniston Water

Windermere

LAKELAND 100 & 50

But the technicality and challenges that the Mourne Mountains offer are not for everyone. Meek, who has raced for team GB and has placed top five at the iconic Comrades Marathon in South Africa, said post race, 'I really did push and race hard but the relentless ankle-twisting and gnarly terrain beat me down.'

The mountains of Northern Ireland may not have the height or elevation gain that the Alps or Pyrenees offer, but what they lack in height is more than compensated for in technicality and repeated rollercoaster climbing. Ask anyone who has run it: the Mourne Skyline MTR is no easy race. Lizzie Wraith summed it up after placing fourth in the 2015 edition of the race: 'I had completely wrong shoes today,' said Wraith. 'The descents were so slippery that I just couldn't push the pace. I am happy though!'

RIGHT: A runner climbs one of the many steep climbs that make this race so tough.

Fact File Mourne Skyline MTR

DISTANCE: 35km

TERRAIN: Trail

TOTAL HEIGHT GAIN: 3,370m

FASTEST TIME: Ian Bailey 3:51:22 and Stevie Kremer 4:24:25

HIGHEST POINT ON ROUTE: 850m

MOURNE SKYLINE MTR

NEWCASTLE START FINISH

CHECKPOINT 3

SLIEVE MEELMORE

CHECKPOINT 2/4

SLIEVE COMMEDAGH

SLIEVE MEELBEG

SLIEVE BEARNAGH

CHECKPOINT 1/5

SLIEVE DONARD

SLIEVE LOUGHSHANNAGH

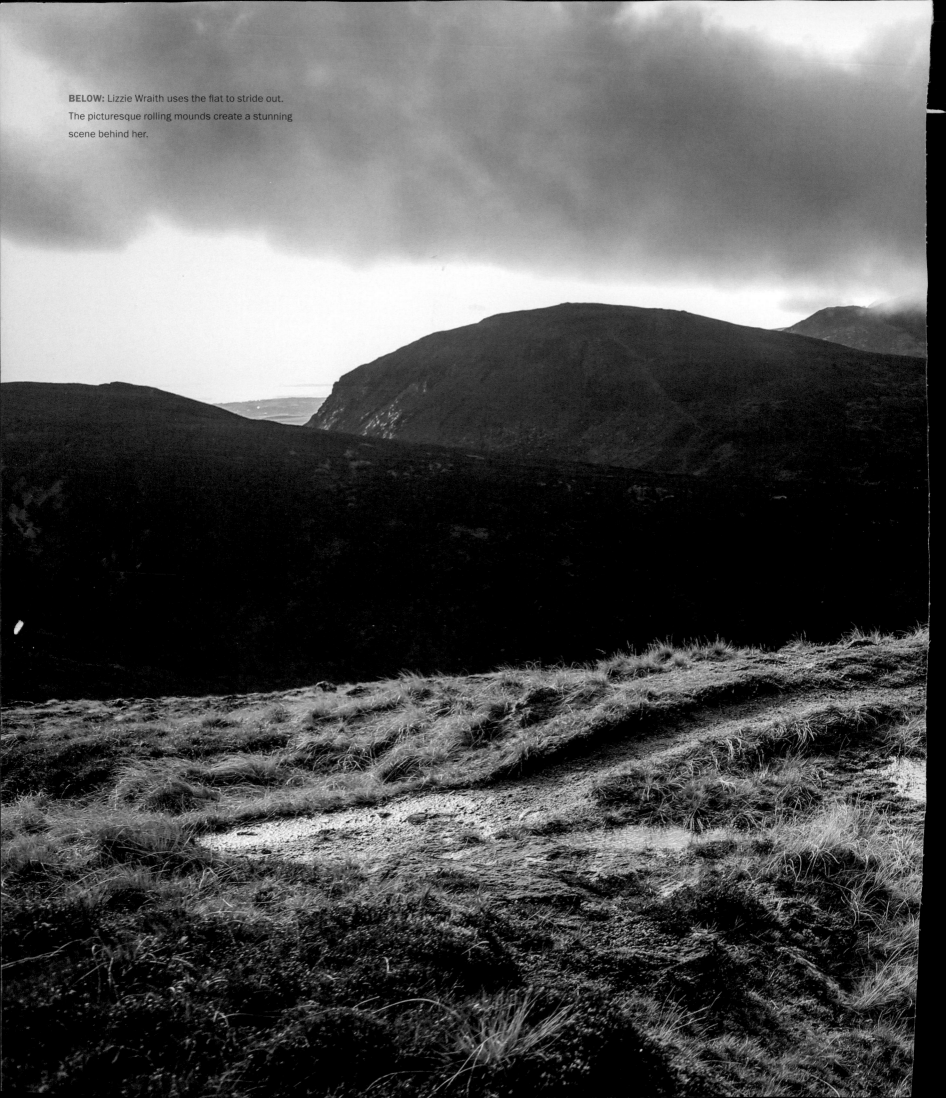

BELOW: Lizzie Wraith uses the flat to stride out. The picturesque rolling mounds create a stunning scene behind her.

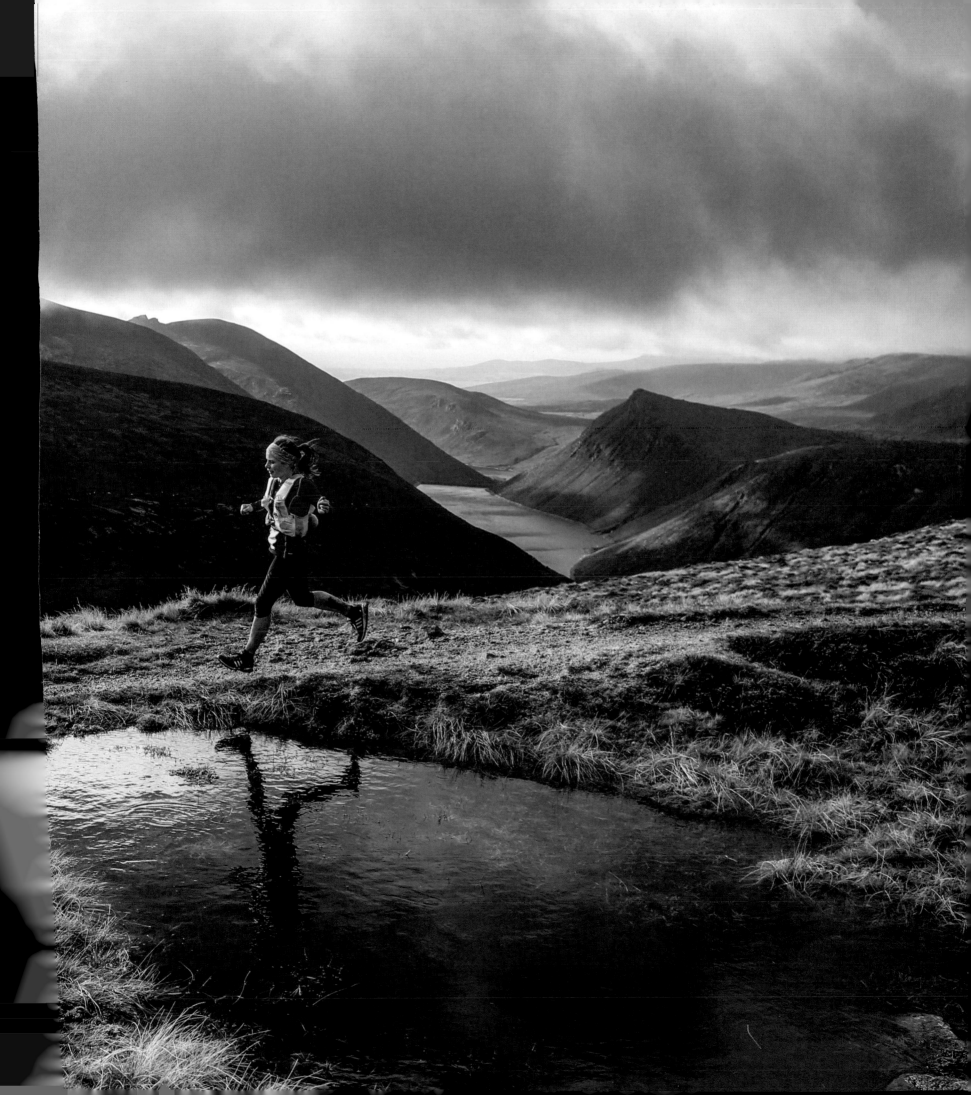

Tromsø SkyRace

45km

Norway

The terrain shifts from rutted track to rock and boulder fields. There are huge, irregular marbles of stone, at times covered in snow and at other times wet from rainfall. Traversing along a thin gully, it is essential to keep three points of contact at all times or be in danger of a serious fall. Welcome to the Tromsø SkyRace.

It's at the entrance of the highest point of the course that the race gets seriously technical, and for many this is the point where slow is by far better than risky. Deep breaths and one foot at a time – it's an intimidating route, and one where all one's faith is put in the stability of the rock. An angled piece of shining, slippery rock, completely irregular

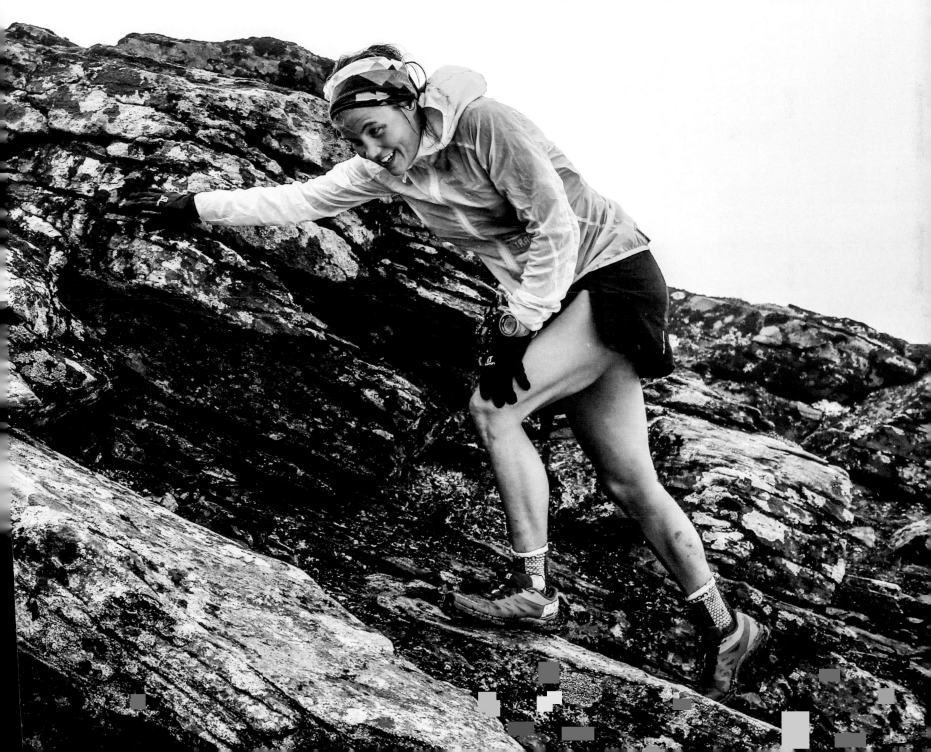

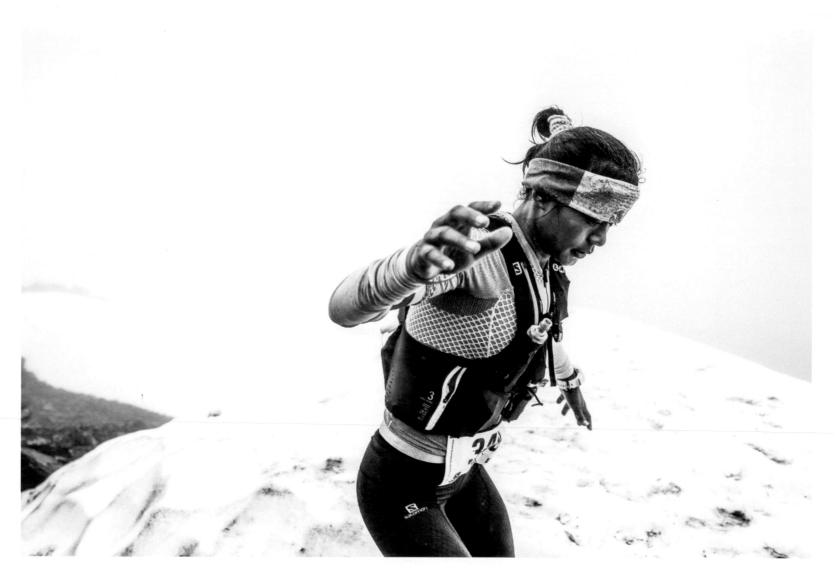

in shape, maybe 46 centimetres wide and at an angle of 30 degrees. Either side: nothing. One mistake here and it's fatal.

For race director Kilian Jornet, it's as if the danger does not exist. He can pop around a corner like a mountain goat at any time as he ensures the race is running smoothly. He looks at home, relaxed and confident on the terrain. He will have a rucksack on his back and in his hand a quiver of flags, making sure all the course markings are in place before the lead runners come through.

Right on Kilian's predicted time, the first runners arrive. At this point of the course they will have been running for several hours, with over 20 kilometres in their legs. Faces are drawn and eyes are almost bulging from the sockets as concentration levels are maintained as they work a route along the ridge to the end.

It is beyond impressive. Primal survival instincts are switched on and fear is switched off. The fluidity of movement makes the ridge traverse a new form of running – mountaineering ballet. On the other side of the summit, scree and snow welcome the runners as they drop to a crossing point on the course and the final push for home with another quad-busting, hands-on-knees climb.

In the 2015 edition the finish would finally come at just over 6 hours of running and climbing for the lead man, Jonathan Albon. Lead lady, Emelie Forsberg, came in at 7.09. But the race would continue on into the 24-hour day – darkness does not arrive here at this time of year. For all the runners, the chimes of midnight announced the course was closed; 111 runners had crossed the line.

The Tromsø SkyRace epitomizes the crossover between running and mountaineering. For sure it's skyrunning, but it's skyrunning with bells on, it's alpinism without the clutter. Perhaps we are seeing the start of a new sport, a more extreme version of what we have come to expect from races like Trofeo Kima and the Glen Coe Skyline?

ABOVE: Nepal running sensation, Mira Rai, crosses one of the many ice shoe sections on the course.
OPPOSITE: Eirik Haugsnes leads 2015 race winner, Jonathan Albon.

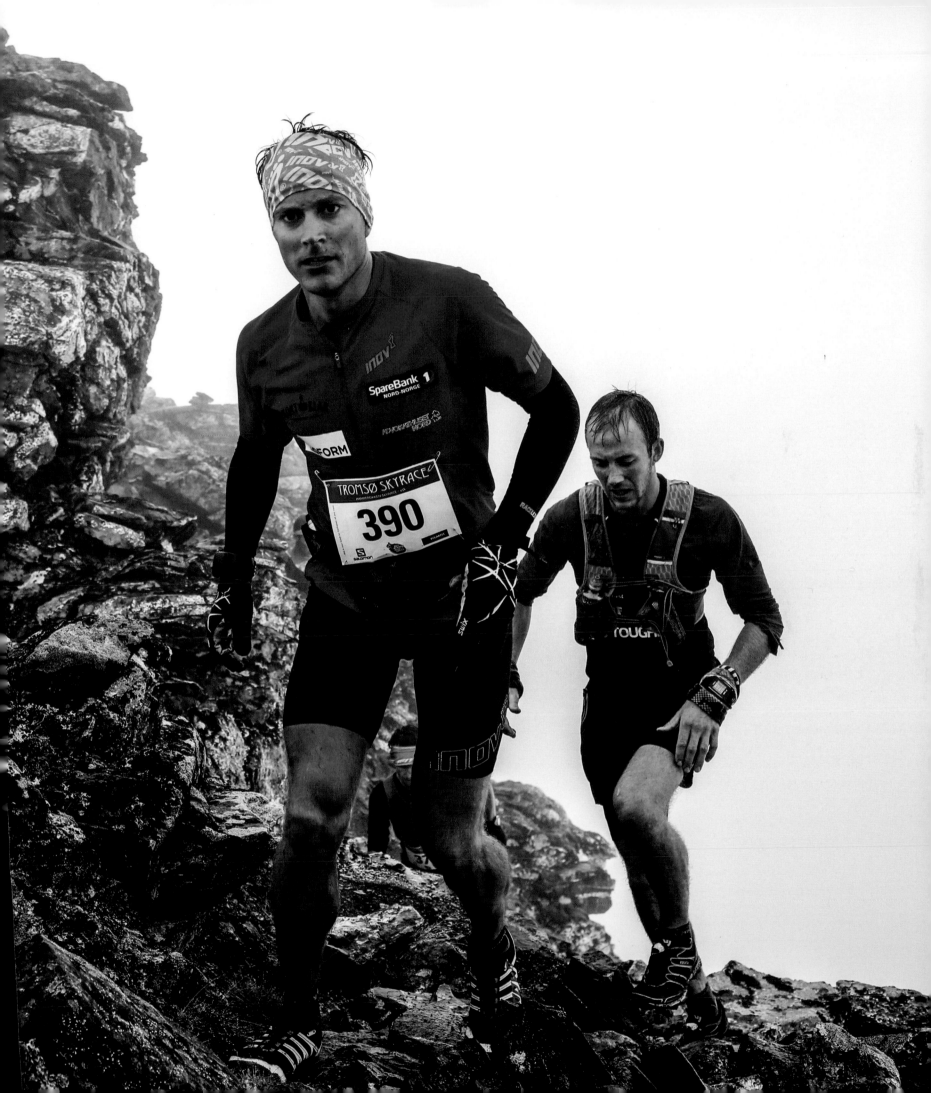

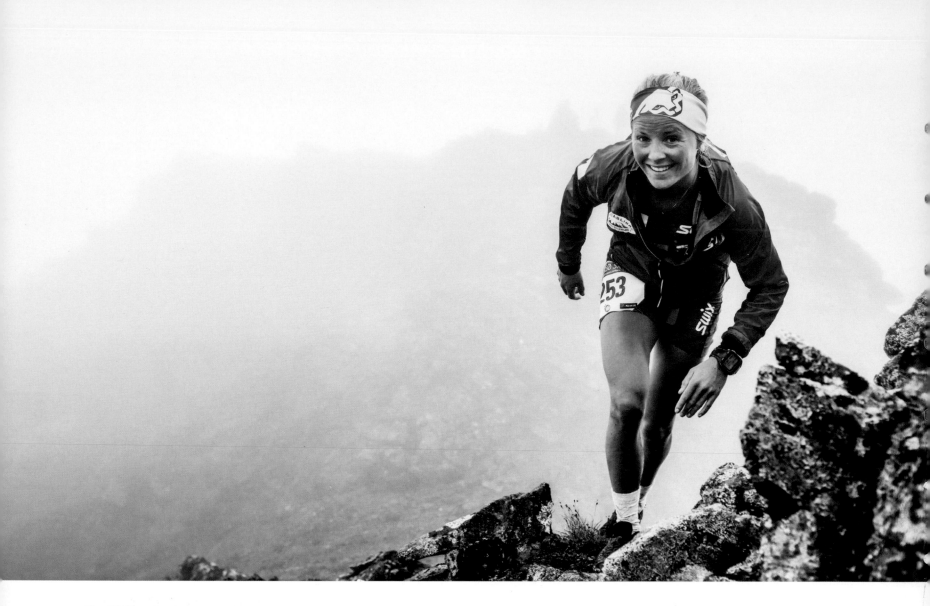

The 2015 race-winner Jonathan Albon describes the route in his own words: 'The Hamperokken ridge is difficult. For much of it I was using both my hands and feet for purchase. At one point on the razor-edge ridge we had to jump a gap from one rock to another. It was funny to see how our little contingent had gone from racing to simply traversing this dangerous section together. I found myself at the back of the group, the least experienced in this sort of scrambling, and twice found rocks tumbling down towards me from above. The last 50-metre ascent to the top was described by Kilian in the race briefing as grade-three scrambling. I'd describe it as "bloody scary".'

Purists would say that skyrunning may well finally be harking back to the glory days of the late 1980s or early 1990s, when Giacometti, Meraldi and Brunod pioneered a new sport on the slopes of Monte Rosa and Mont Blanc. One only has to look at the two race directors at the Tromsø SkyRace, Kilian Jornet and Emelie Forsberg, to understand how the sport of skyrunning may now be coming full circle back to its roots, the roots of a sport born on mountain slopes.

Kilian Jornet and his exploits have opened up the sport to a new audience, a new breed of skyrunner, and to that end the sport is growing, as are the courses.

'We cannot think of a better place than the mountains of Tromsø for a skyrace: a place to run between the sky and the Earth and to feel freedom,' Kilian says. 'You will run on technical ridges with the fjords on every side, and cross grass valleys in true wilderness. The course joins the two higher summits of the area, Tromsdalstinden and Hamperokken, in pure single-track and off-trail style.'

One thing is for sure, Tromsø is a special race. But be warned: this race is not for everyone. You need to ensure that you are prepared for the challenge that the Tromsø SkyRace will throw at you. It's a race that makes you feel alive by placing your head in the clouds and keeping your feet just barely on the ground.

ABOVE: Malene Haukøy scrambling over the jagged rocks on her way to the crossing of the Hamperokken.

OPPOSITE: Stunning wildflowers on this extraordinary route.

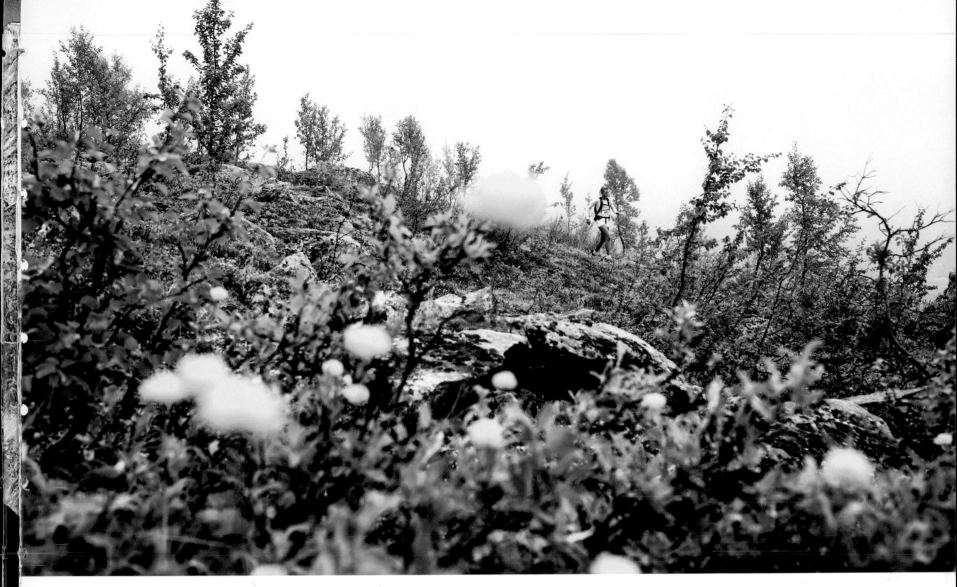

Fact File Tromsø SkyRace

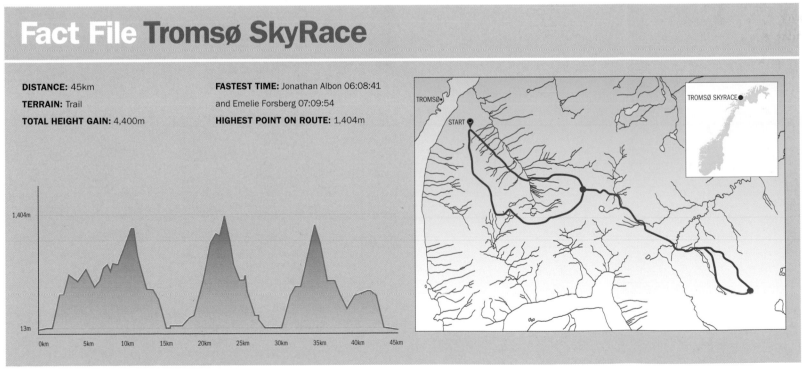

DISTANCE: 45km

TERRAIN: Trail

TOTAL HEIGHT GAIN: 4,400m

FASTEST TIME: Jonathan Albon 06:08:41
and Emelie Forsberg 07:09:54

HIGHEST POINT ON ROUTE: 1,404m

Tignousa (2,180 metres), the impressive Weisshorn Hotel (2,337 metres) is located on the right before the trail heads upwards, providing a stunning view of the five 4,000s.

The rockiest and arguably most technical sections of the race come through Barneuza, where single-track trail weaves a path through irregular and large, jagged rocks. At times the path disappears and the runners go off piste to navigate the fastest line.

The final 3 kilometres are steep, technical and downhill through forest and pastures that are often muddy and slippery. It is here that the race is often won. An ability to run fast and navigate these trails with tired legs is the difference between first and second, an ability that Kilian Jornet has displayed multiple times.

Pablo Vigil was an early pioneer of the race and he paved the way for US runners to take part, something that he is still heavily involved in. 'Having won Sierre–Zinal four consecutive times, it seems to have completely eclipsed most of my other running accolades. So, in a sense, it has been a great thing and again, in a positive way, the monkey on my back! Sierre–Zinal was the race that catapulted me onto a world stage. I am still involved with the race; yearly I help recruit top USA mountain runners.'

Sierre–Zinal has been a major force in the world of mountain running, not only from a race perspective but also from a runner's perspective. With the passing of the years, the race will continue to grow and with it, the experiences of runners and walkers will flourish.

For the elite runner, it is as Vigil describes: 'A surreal race. Beautiful and, of course, tough. The course favours a runner who is skilled, rounded, fast and strong, with an ability to climb and descend like a demon. If you want to show the world who you are in trail and mountain running, go to Sierre–Zinal and kick-ass... Or get your ass kicked!'

Run, don't walk: the five 4,000s are waiting.

Fact File Sierre–Zinal

DISTANCE: 31km

TERRAIN: Trail

TOTAL HEIGHT GAIN: 2,200m

FASTEST TIME: Jonathan Wyatt 02:29:12 and Anna Pichrtová 02:54:26

HIGHEST POINT ON ROUTE: 2,425m

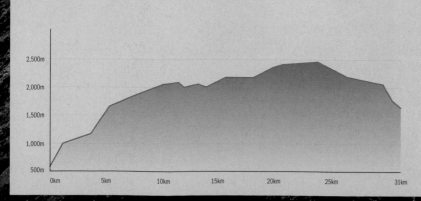

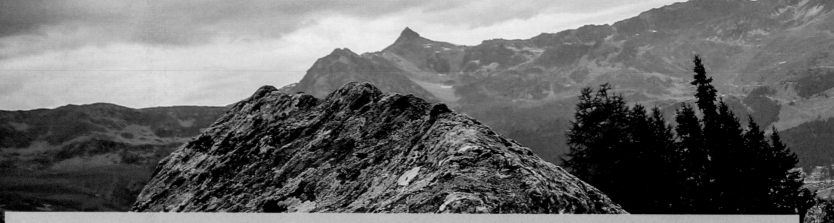

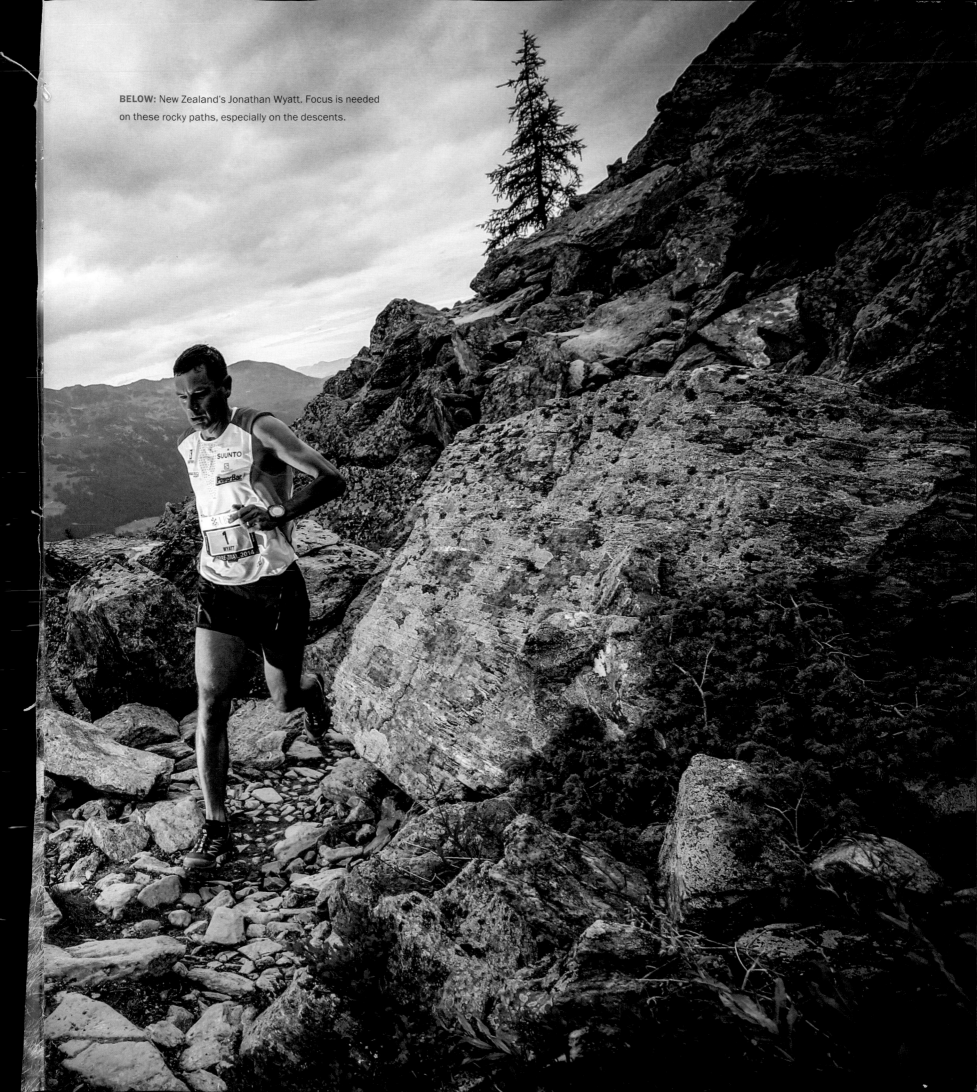

BELOW: New Zealand's Jonathan Wyatt. Focus is needed on these rocky paths, especially on the descents.

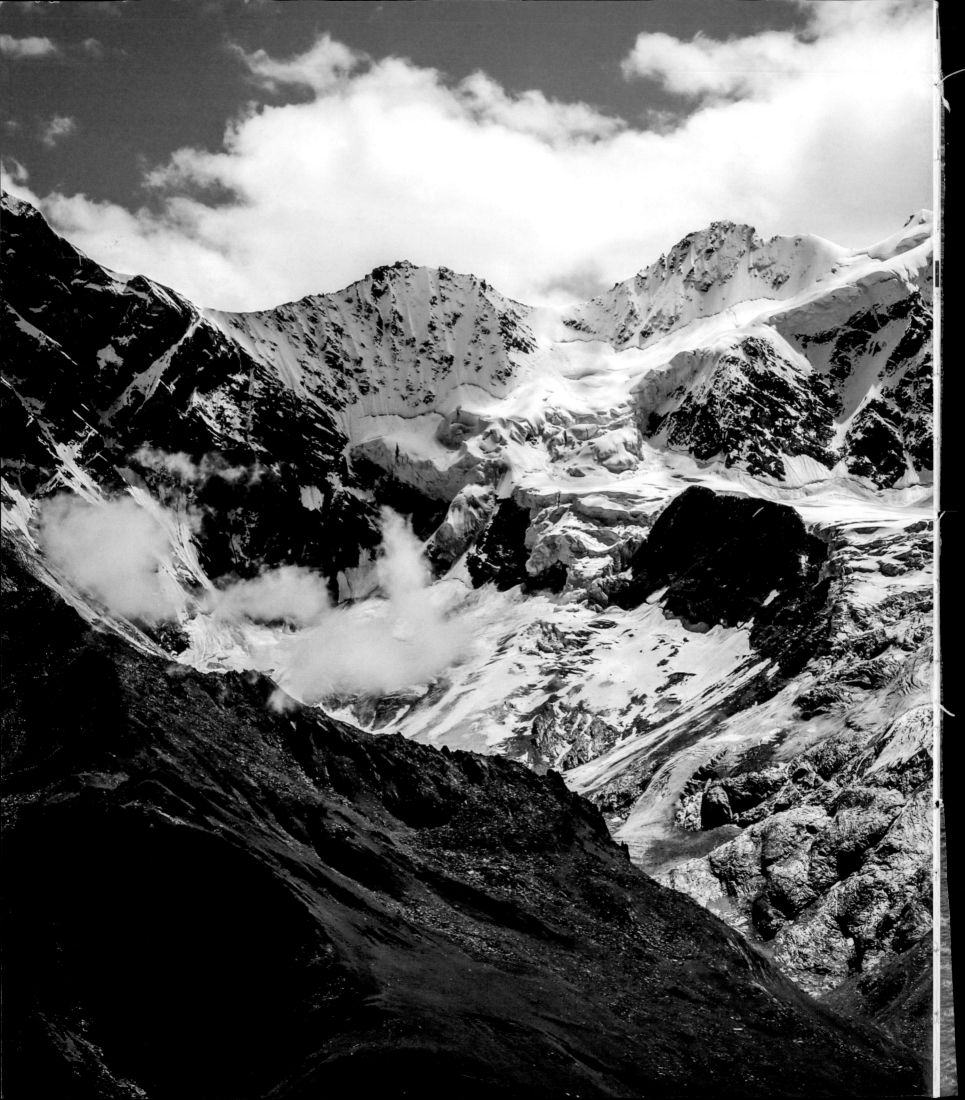

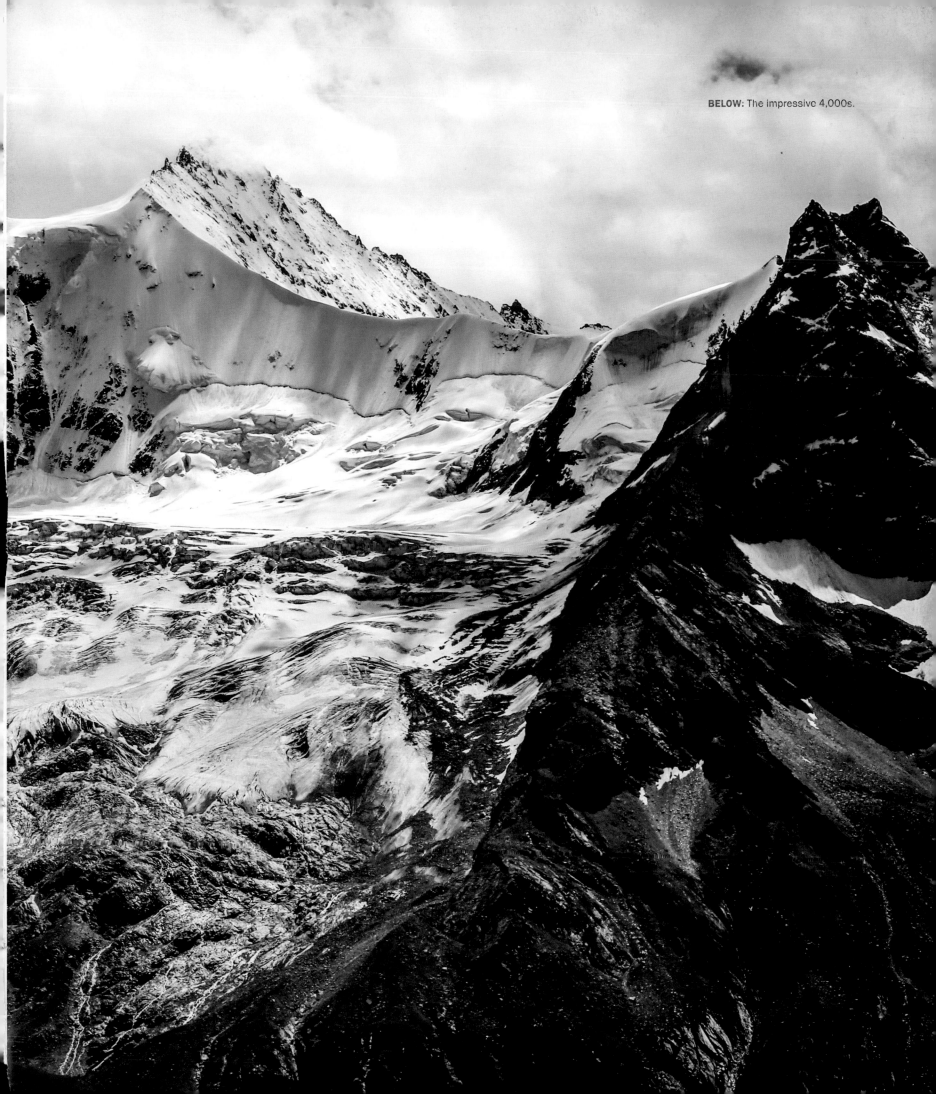

BELOW: The impressive 4,000s.

Matterhorn Ultraks
48km
Switzerland

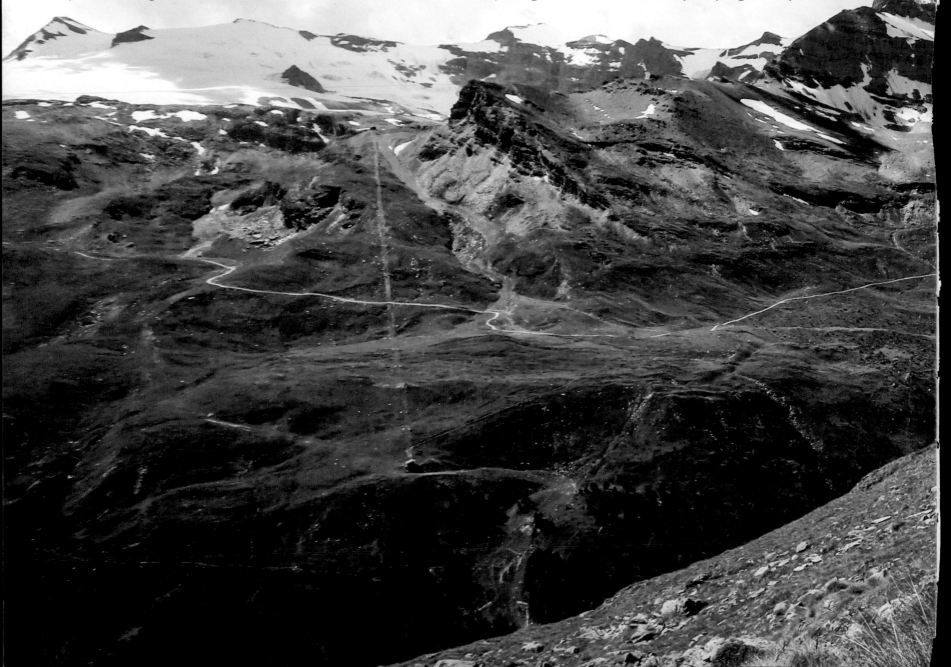

The stunning Matterhorn provides the backdrop for Switzerland's Matterhorn Ultraks race, a 48-kilometre skyrunning race with 3,600 metres of positive and negative gain. It's a magical race that provides a circular journey, starting and concluding in the picture-postcard mountain town of Zermatt. There is wild, expansive space, high mountains and the 3,130-metre Gornergrat, while the ever-present lone peak of the Matterhorn shadows the race and the runners with its majestic beauty.

Located 1,600 metres above sea level, Zermatt provides the focal point for this high-altitude race. It's a town of contrasts. Tourists flood in to trawl the streets, shop and snap 'selfies' while, in and amongst them, hardcore mountaineers head upwards with packs, ropes, crampons and ice axes.

Renowned for its tough opening kilometres, the Matterhorn Ultraks immediately heads to the sky, via Sunnegga at 2,260 metres all the way to the high point, Gornergrat, at 3,130 metres. It's a brutal 14 kilometres to open any race and, as such, those opening kilometres can be decisive in who crosses the finish line first.

Megan Kimmel from the USA ran hard from the gun in 2015, setting the pace against a world-class field. 'Anytime you get the rhythm in the

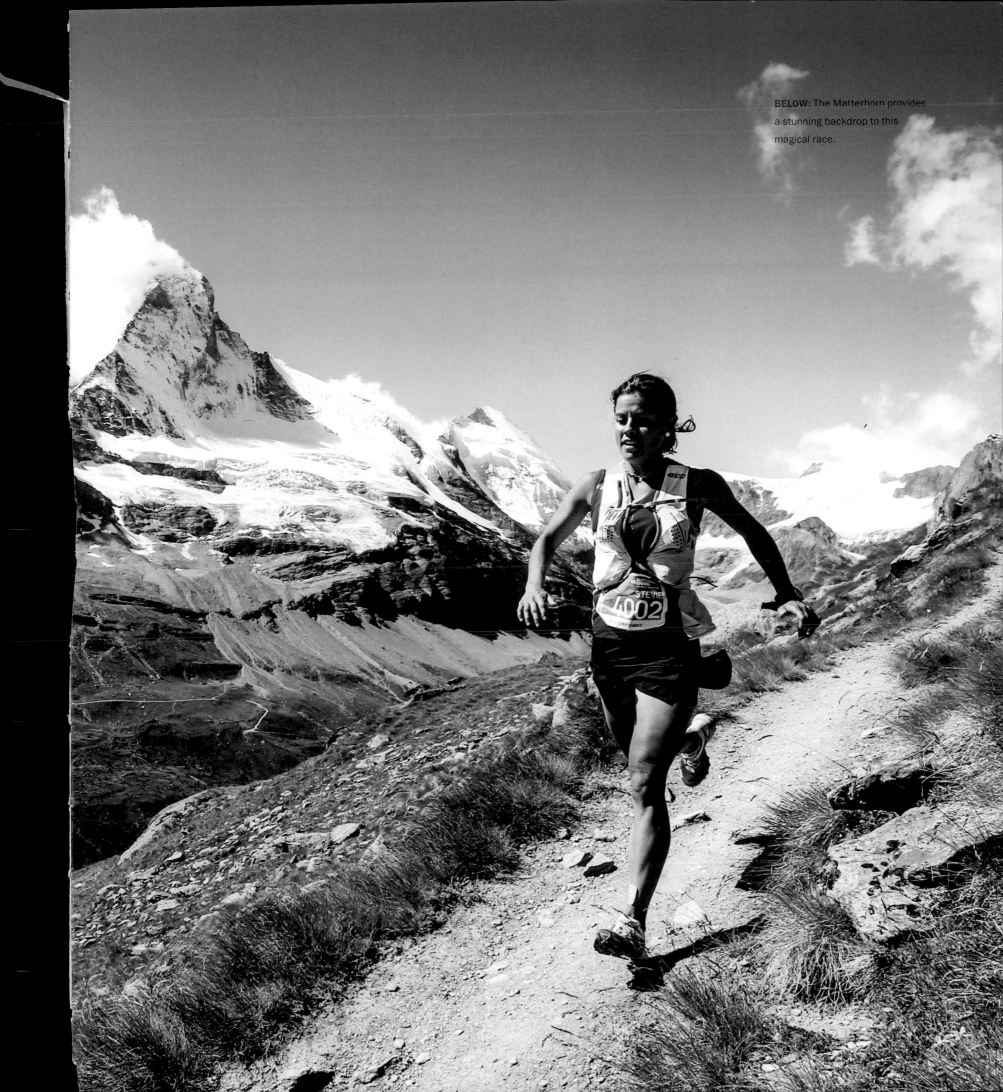

BELOW: The Matterhorn provides a stunning backdrop to this magical race.

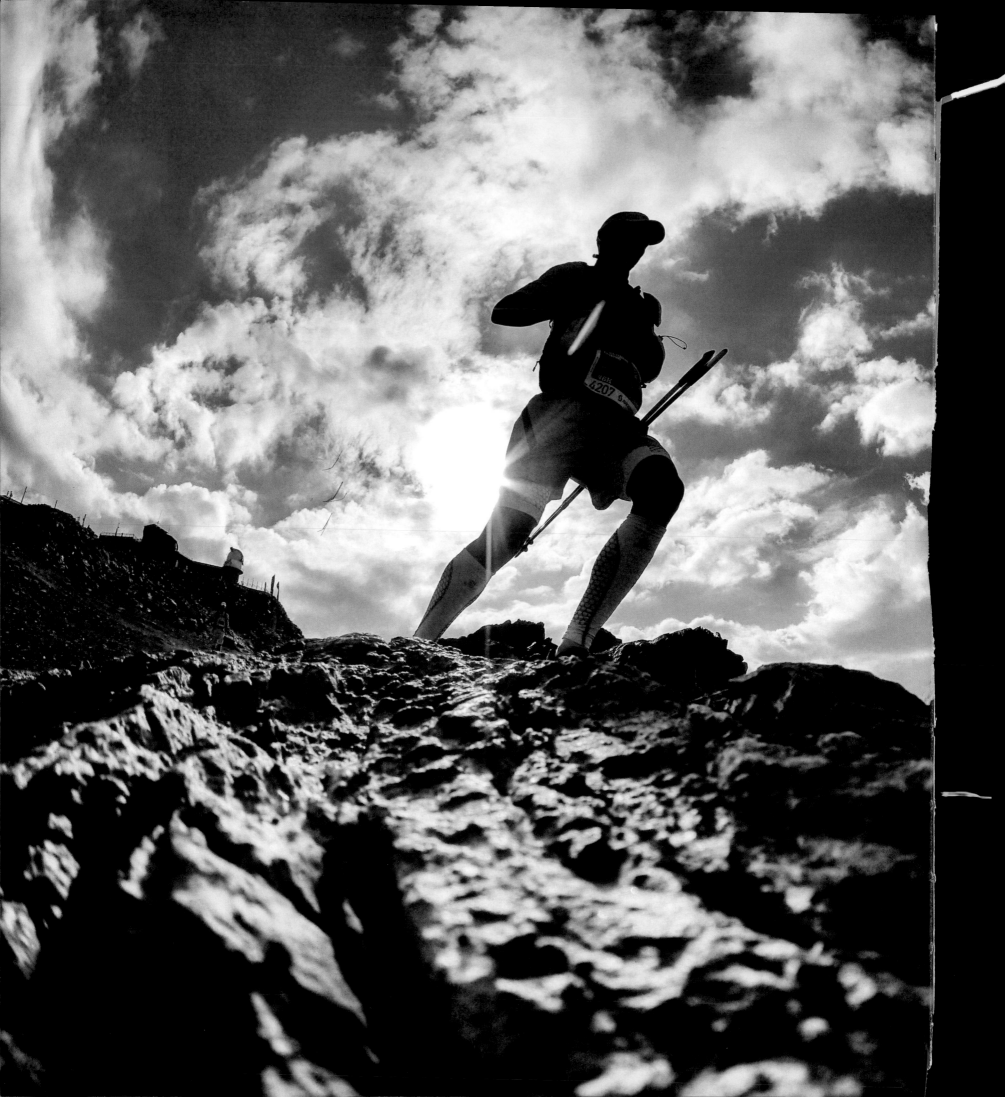

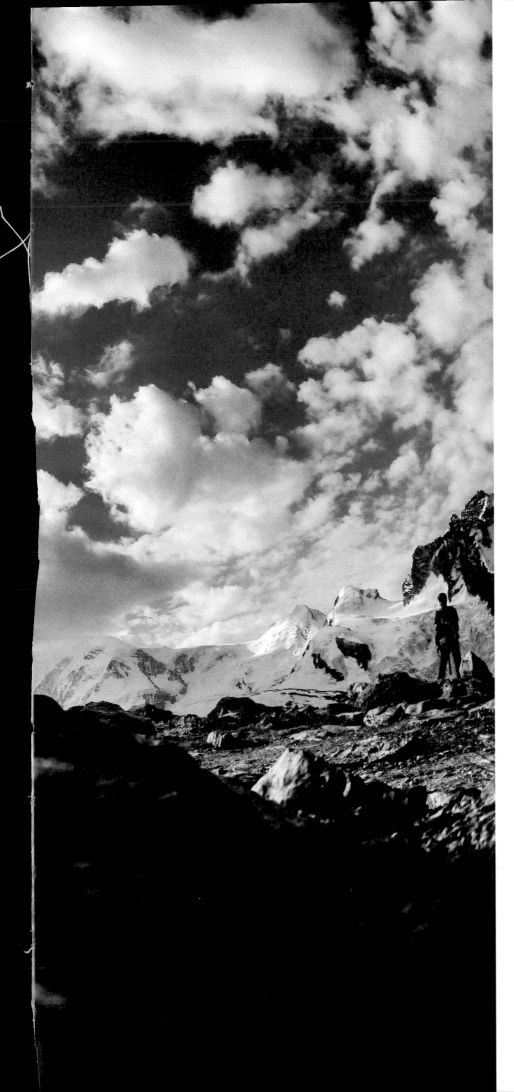

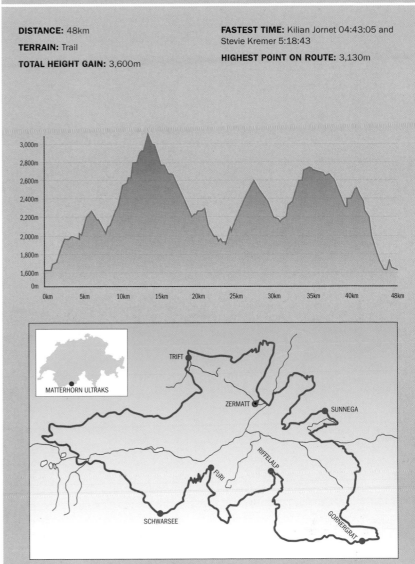

Fact File Matterhorn Ultraks

DISTANCE: 48km

TERRAIN: Trail

TOTAL HEIGHT GAIN: 3,600m

FASTEST TIME: Kilian Jornet 04:43:05 and Stevie Kremer 5:18:43

HIGHEST POINT ON ROUTE: 3,130m

❝ ANYTIME YOU GET THE RHYTHM in the up, the down, or the flat, the body is abruptly put into one of these other actions.'

Megan Kimmel

LEFT: The sun silhouettes a runner on a technical descent from the Gornergrat.

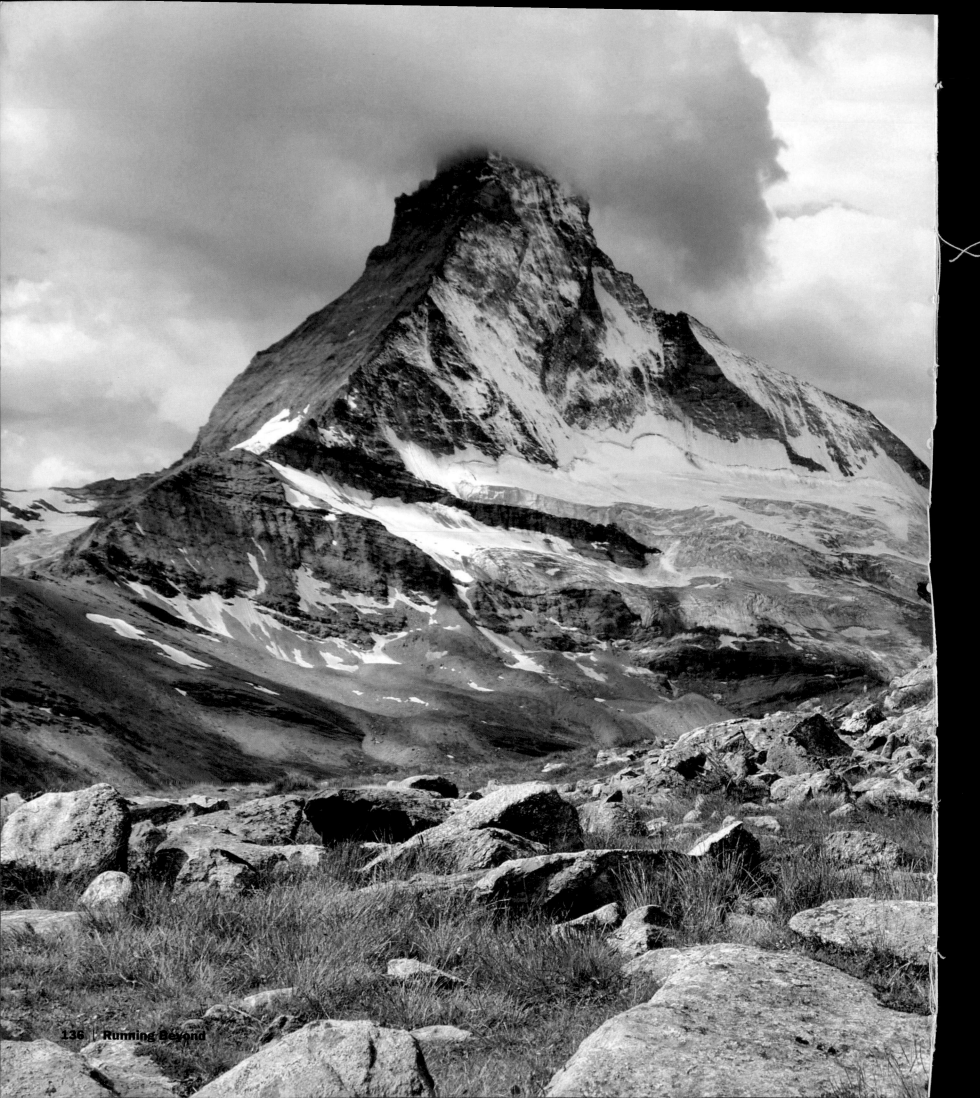

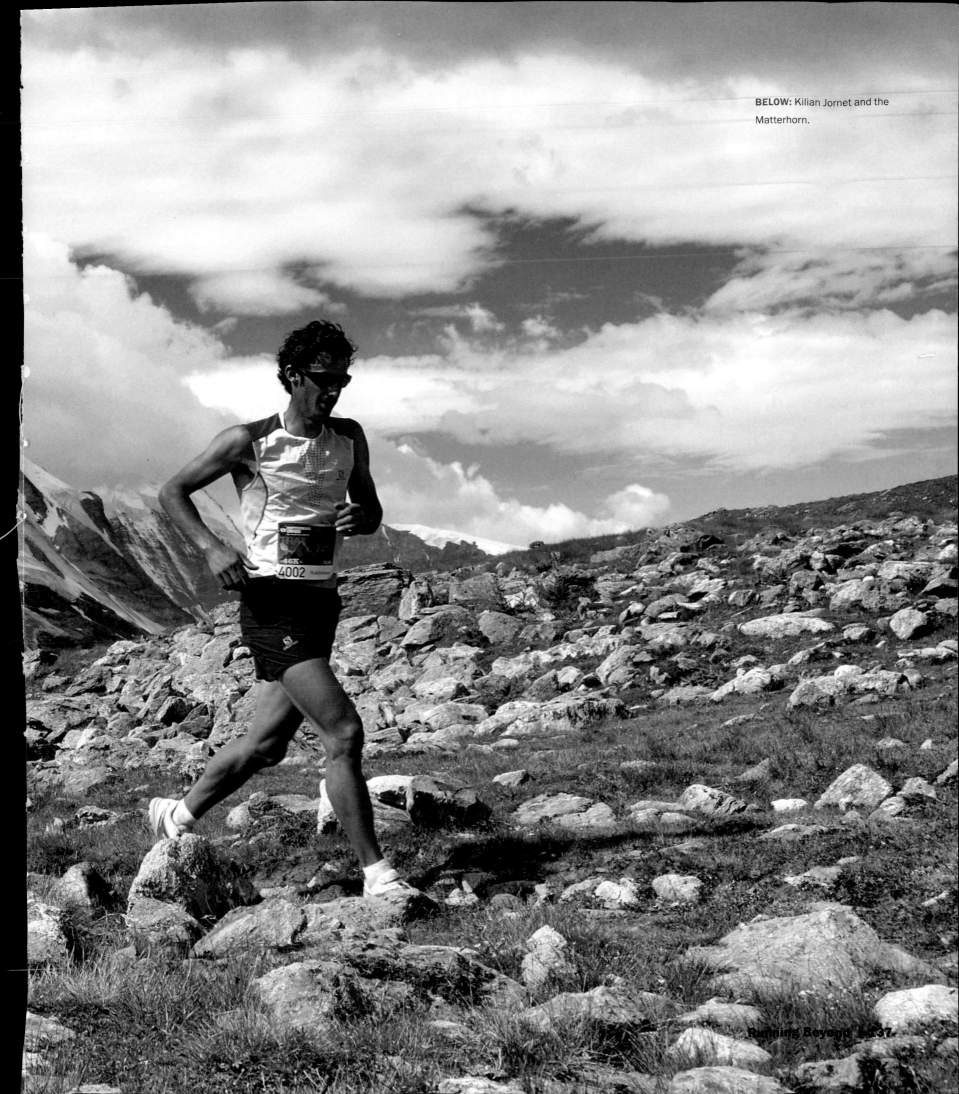

BELOW: Kilian Jornet and the Matterhorn.

Dolomites Skyrace and VK 22km

Italy

The ski town of Canazei and the incredible Dolomite mountains provide an amazing heart for a weekend of mountain running. The combination of the Friday Vertical Kilometer (VK), the Children's Race on Saturday and, of course, the gruelling SkyRace on Sunday, makes it a compulsory fixture on many an ultra, mountain, trail and skyrunner's calendar.

Canazei is surrounded by mountains, a little like a goldfish in a bowl that is surrounded by glass. Huge peaks tower over the valley and Canazei, as one would expect, personifies a typical mountain retreat: gift shops, restaurants, bars and of course a multitude of shops selling everything one could need for a mountain adventure. It is a picture-postcard place, and of course the people who live here understand the mountains innately. In winter they ski and in summer they climb, hike and run. It is out of this natural affinity for mountain life that a weekend of adrenaline-packed extreme running was born.

The Friday VK is run in timed groups of approximately twenty runners set off at 4-minute intervals. The objective is simple, but definitely not to be underestimated: travel from the valley at 1,450 metres altitude to the summit at Spiz (2,465 metres), covering 1,000 metres of vertical ascent as quickly as possible. At just over 2 kilometres in overall length, the Dolomites VK is one of the steepest on the circuit. The terrain underfoot also adds to the complexity; grass and woodland make up over 90 per cent of the course, and therefore grip is compromised. It's a race where many use climbing poles to aid the speediest ascent, and its quad-busting, lung-bursting action always leads to an incredible atmosphere as spectators line the route. The sound of cow bells, cheering and shouts of *'Forza!'* (meaning force, or strength) encourage everyone to find that little extra in the tank as sweat drips from the brow. The final kick is a sharp, left-hand turn, and then a vertical grass

RIGHT: Tadei Pivk, from Italy, uses one of the metal ropes to navigate this tricky corner.

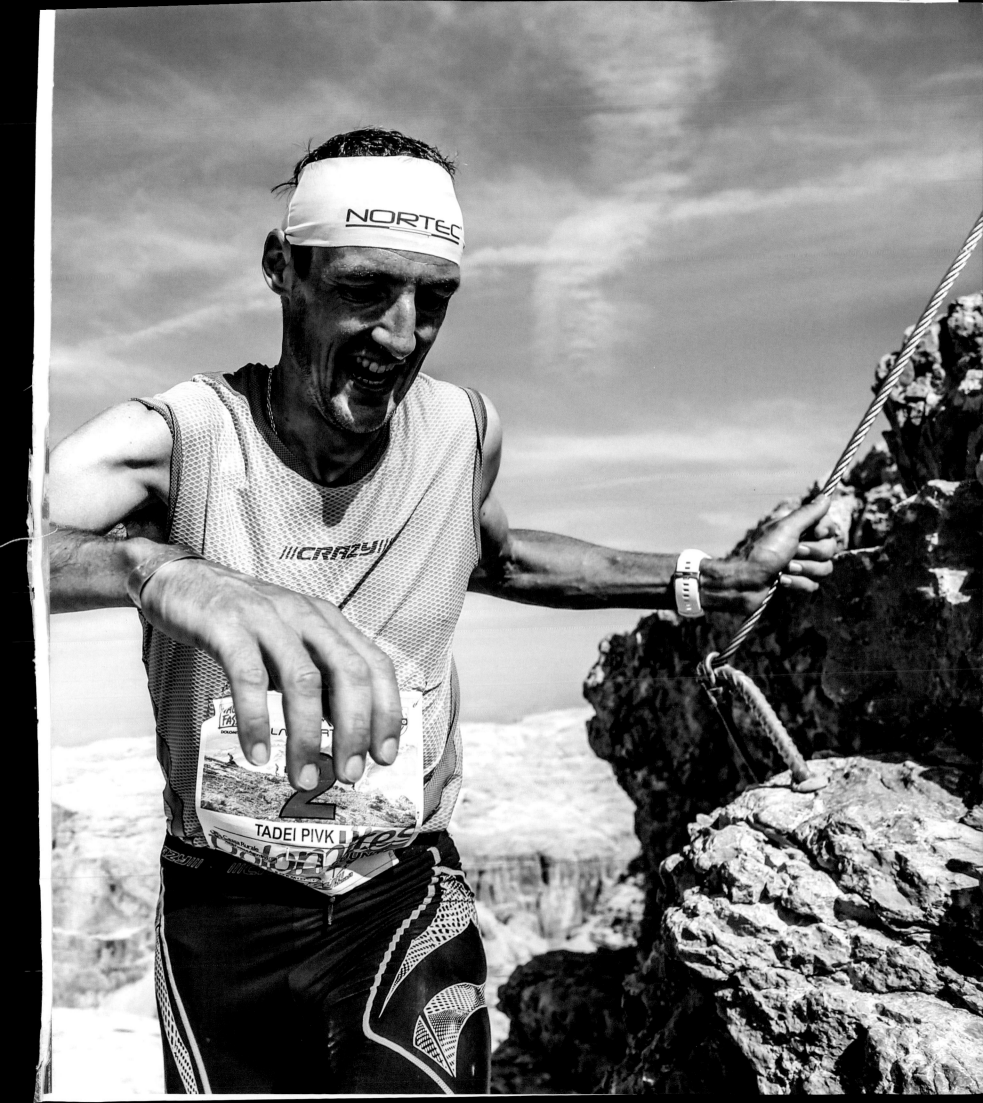

Tignousa (2,180 metres), the impressive Weisshorn Hotel (2,337 metres) is located on the right before the trail heads upwards, providing a stunning view of the five 4,000s.

The rockiest and arguably most technical sections of the race come through Barneuza, where single-track trail weaves a path through irregular and large, jagged rocks. At times the path disappears and the runners go off piste to navigate the fastest line.

The final 3 kilometres are steep, technical and downhill through forest and pastures that are often muddy and slippery. It is here that the race is often won. An ability to run fast and navigate these trails with tired legs is the difference between first and second, an ability that Kilian Jornet has displayed multiple times.

Pablo Vigil was an early pioneer of the race and he paved the way for US runners to take part, something that he is still heavily involved in. 'Having won Sierre–Zinal four consecutive times, it seems to have completely eclipsed most of my other running accolades. So, in a sense, it has been a great thing and again, in a positive way, the monkey on my back! Sierre–Zinal was the race that catapulted me onto a world stage. I am still involved with the race; yearly I help recruit top USA mountain runners.'

Sierre–Zinal has been a major force in the world of mountain running, not only from a race perspective but also from a runner's perspective. With the passing of the years, the race will continue to grow and with it, the experiences of runners and walkers will flourish.

For the elite runner, it is as Vigil describes: 'A surreal race. Beautiful and, of course, tough. The course favours a runner who is skilled, rounded, fast and strong, with an ability to climb and descend like a demon. If you want to show the world who you are in trail and mountain running, go to Sierre–Zinal and kick-ass... Or get your ass kicked!'

Run, don't walk: the five 4,000s are waiting.

Fact File Sierre–Zinal

DISTANCE: 31km

TERRAIN: Trail

TOTAL HEIGHT GAIN: 2,200m

FASTEST TIME: Jonathan Wyatt 02:29:12 and Anna Pichrtová 02:54:26

HIGHEST POINT ON ROUTE: 2,425m

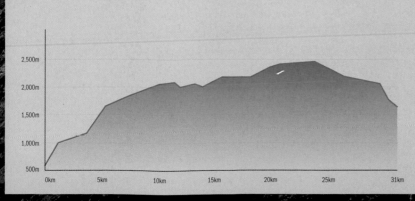

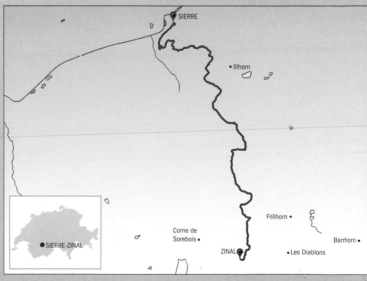

SIERRE

Illhorn

Frilihorn

Barrhorn

Corne de Sorebois

ZINAL

Les Diablons

SIERRE-ZINAL

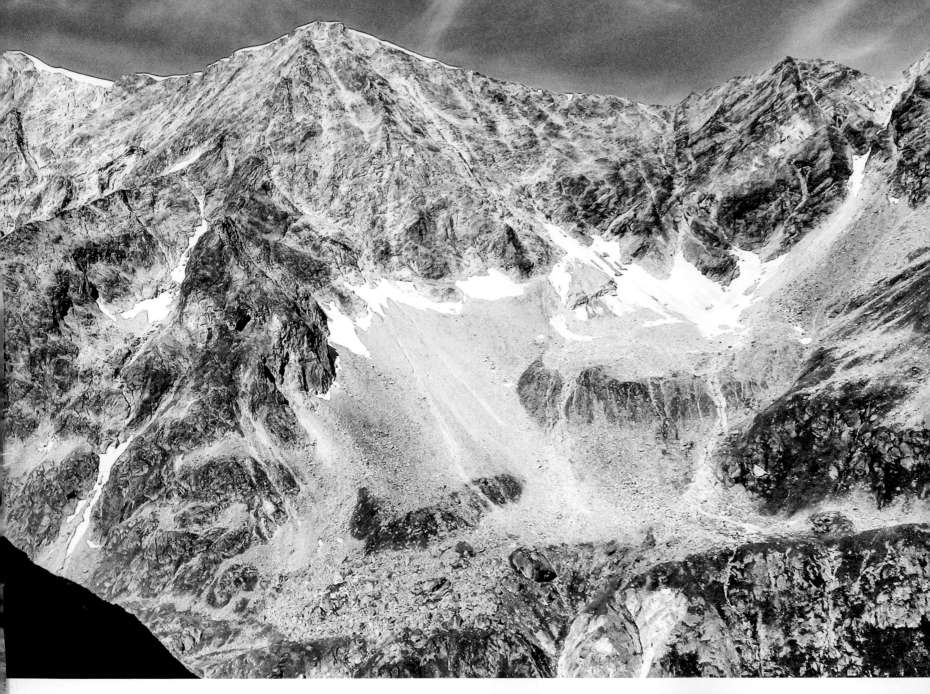

ABOVE LEFT: Stevie Kremer from the USA.
ABOVE RIGHT: Linda Doke from South Africa soaks in the stunning mountain scenery.
RIGHT: Pablo Vigil.

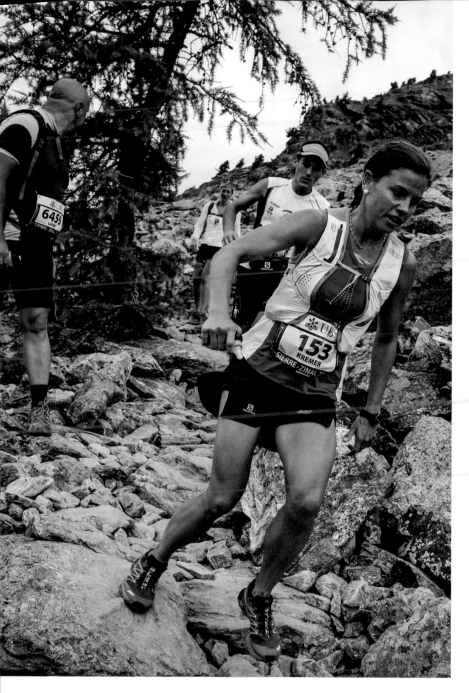
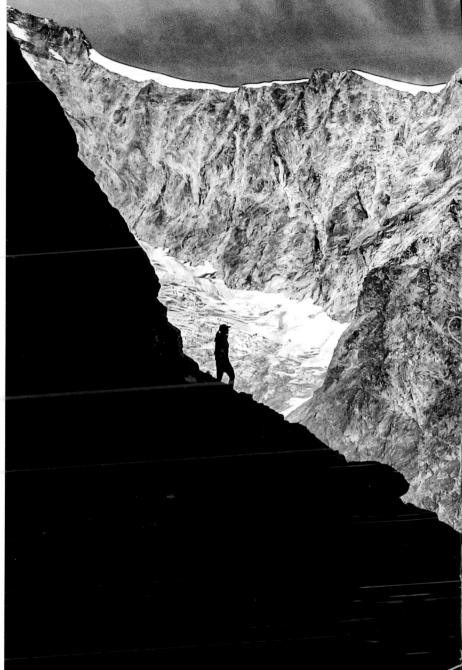

The creation of Jean-Claude Pont, the race has two departures that provide an opportunity for all to participate, runners and tourists (walkers) alike. The tourists start at 5am to allow them enough time to reach the cut-off time of 4pm. The runners start 4½ hours later, and they are ranked according to various categories.

Starting in Sierre (585 metres), a long and relentless climb makes up over half of the opening kilometre's total elevation gain of 2,200 metres. The highest point of the race comes at Nava, which is at 2,425 metres.

Over the years the race has had some notable stars. Pablo Vigil had four consecutive victories from 1979 to 1982; Jonathan Wyatt from New Zealand set the male course record at 2:29:12 in 2003; and in recent years, mountain-running stars Kilian Jornet (2009, 2010, 2014 and 2015) and Marco De Gasperi (2008, 2011 and 2012) have won the race.

Anna Pichrtová (now Strakova) from the former Czechoslovakia has an incredible set of palmares in mountain running. She has won Mount Washington Road Race six times, Mount Kinabalu Climbathon five times and Sierre–Zinal four times, in the process setting the course record of 2:54:26, which still stands today.

'Sierre–Zinal is a beautiful mountain race with an incredible history,' she says. 'Over the years, it has been a benchmark race with an incredibly high-quality field of male and female runners. To win four times and set a course record obviously provides great pleasure. I still think back to the opening 8 kilometres and the relentless climbing. It's quite a start for any race.'

Climbing 1,300 metres in 8 kilometres at a gradient of 34 per cent, the pasture of Ponchette at 1,870 metres provides some rest after such a brutal start. Chandolin (2,000 metres) is preceded by good trails with less climbing, allowing runners to stretch their legs and gain some pace after the harsh start.

Irregular, undulating slopes of broken trail follow for 10 kilometres to Nava (2,425 metres), the highest point of the race. Running through

Fact File Tromsø SkyRace

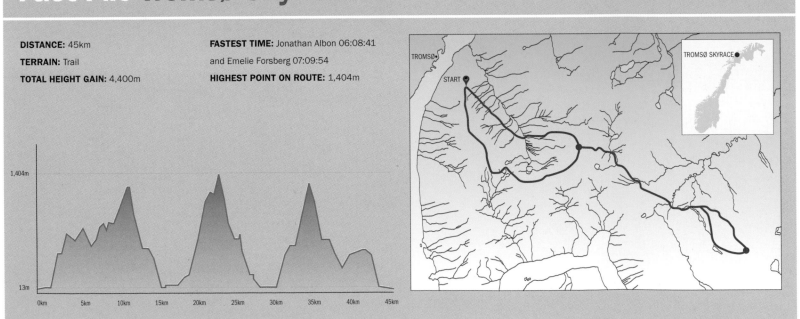

DISTANCE: 45km

TERRAIN: Trail

TOTAL HEIGHT GAIN: 4,400m

FASTEST TIME: Jonathan Albon 06:08:41
and Emelie Forsberg 07:09:54

HIGHEST POINT ON ROUTE: 1,404m

TROMSØ•

START

TROMSØ SKYRACE•

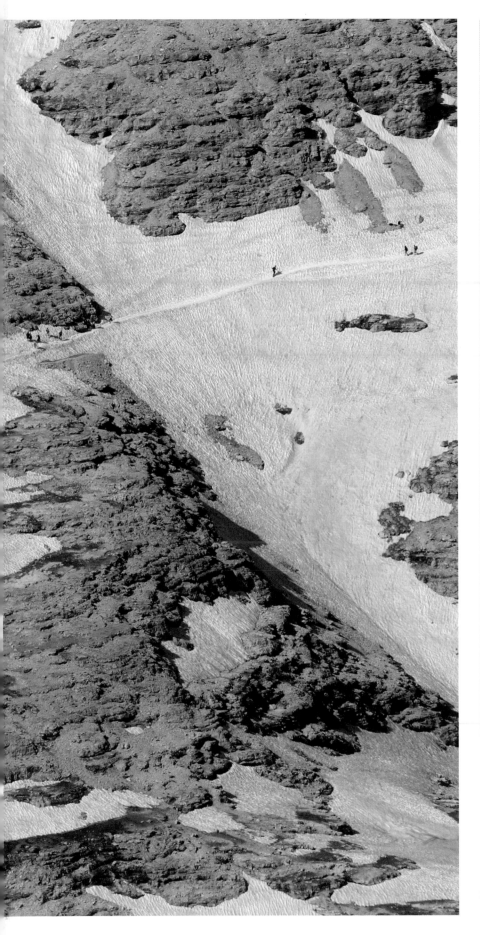

Fact File **Dolomites Skyrace**

DISTANCE: 22km

TERRAIN: Trail

TOTAL HEIGHT GAIN: 1750m

FASTEST TIME: Kilian Jornet 02:00:11 and Megan Kimmel 02:25:57

HIGHEST POINT ON ROUTE: 9,152m

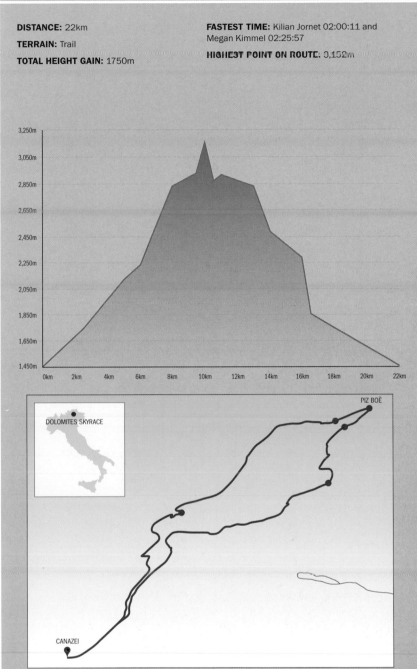

LEFT: Conditions vary year on year; the 2014 edition had many snow crossings.

Limone Extreme
23km
Italy

Lake Garda, situated east of Milan and west of Venice, has long been a destination as a holiday resort. Limone sul Garda, as the name suggests, sits on the lake's edge on the northwest side, flanked by sheer mountains. The heart of the old town is the little harbour, the old Port Porto (now Porto Vecchio). Narrow lanes lined with tourist shops wind in and along the shore, with a plethora of streets that go up the slopes behind it. To the south is the more modern part of Limone that includes a waterfront promenade, and it is here that the start and finish of the Limone Extreme race takes place.

The steep, aggressive mountains don't require too much imagination when it comes to designing a race – their dominance over the skyline almost entices the endurance runner to them. Skyrunning legend Fabio Meraldi has been instrumental in creating two races here: first, a vertical kilometre that travels from the lake, 1,000 metres directly up and undertaken during darkness, and second, a SkyRace of 23 kilometres and 2,000 metres of elevation that leaves the town behind to follow lakeside paths to the north of the harbour, on a circular route through the mountains and back to the shore.

BELOW: Runners cross one of the narrow ridges of single-track trail, high in the mountains above Lake Garda and the seaside resort of Limone.

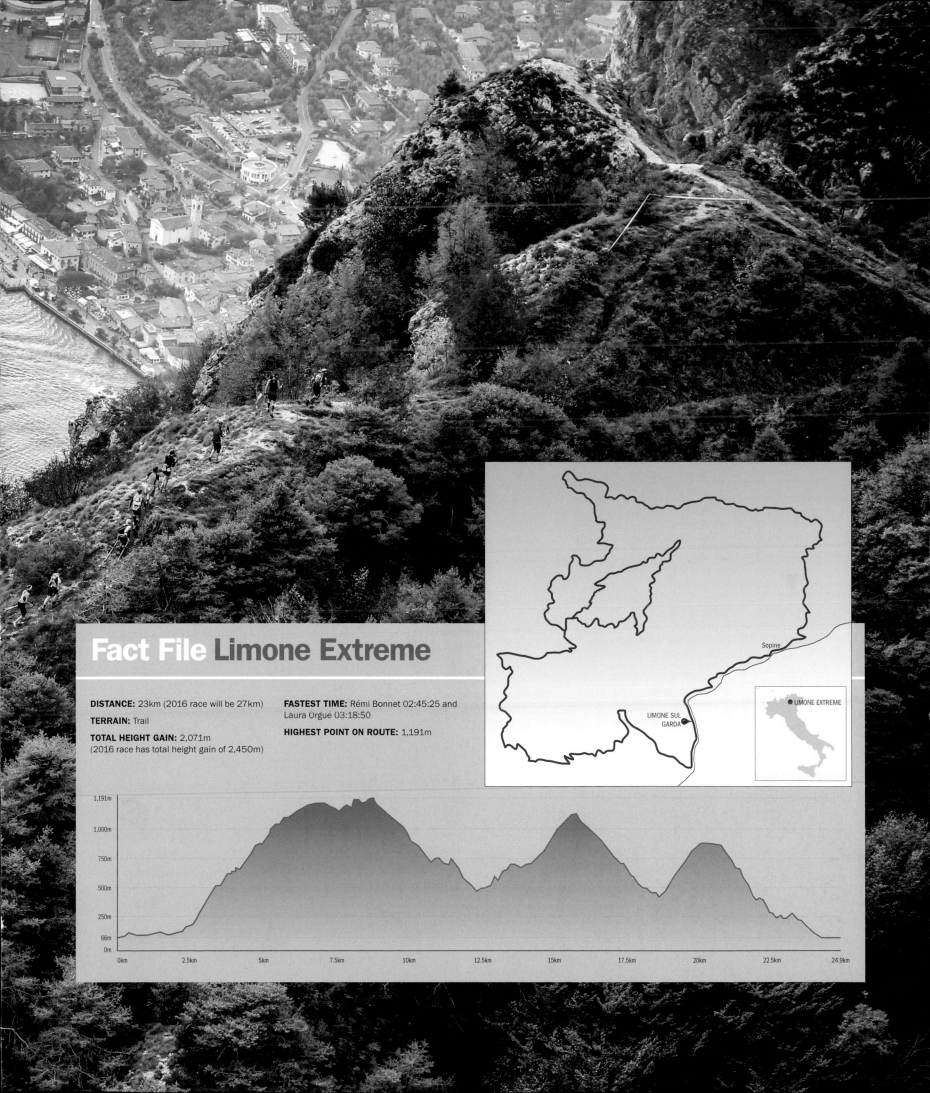

Fact File Limone Extreme

DISTANCE: 23km (2016 race will be 27km)

TERRAIN: Trail

TOTAL HEIGHT GAIN: 2,071m
(2016 race has total height gain of 2,450m)

FASTEST TIME: Rémi Bonnet 02:45:25 and
Laura Orgué 03:18:50

HIGHEST POINT ON ROUTE: 1,191m

Sopine

LIMONE SUL
GARDA

LIMONE EXTREME

Meraldi's exploits are legendary within endurance running. He passed his mountain-guide training at the age of twenty. Not only a runner, he participated in mountain tours, ski mountaineering and pioneered the early days of skyrunning with ISF president, Marino Giacometti. Four European titles and nine Italian titles, amongst other cups and medals, are listed in his record of achievements, and he also won the iconic Pierra Menta ten times and the Sellaronda Skimarathon six times. However, it is his world records of speed ascending high mountains that have gained him his iconic place in the sport of mountain running, his most notable on Aconcagua. He was a natural mountain runner with strong legs, huge lungs and no fear.

The course at Limone is a wonderful one. It is the essence of pure mountain running, providing an anticlockwise loop of adrenaline-packed trails that weave up and down exposed ridges, zigzag up walls of rock and then pass through lush forests of dense, green woodland.

Leaving Lungolago Marconi next to Lake Garda, a 2-kilometre stretch of narrow path leads through the streets of Limone. It passes scattered hotels, peaceful terraces, lemon groves and little secluded beaches before crossing the main coastal road and heading up into the impressive mountains at Reamòl. A breathtaking, rugged ascent leads to Punto Larici, proceeds to Passo Rocchetta and reaches the crest of Monte Carone at 1,621 metres above sea level.

Jonathan Albon, racing in his first skyrunning race, had this to say on his experience: 'It's one of the shortest skyrunning races in the series, but it is also known as one of the more technical and I found it quite frankly terrifying in some places; on many sections, one misplaced footstep would result in you hurtling down to a certain death!'

The second part of the race, with its continuous change in gradients, takes athletes from Bocca dei Fortini at 1,200 metres to Monte Traversole (1,441 metres) and Corna Vecchia (1,415 metres). The course slopes down to Dalco at 842 metres before the steep descent to the finish line in Limone.

Survive Albon did, and in the process he placed 14th overall, an impressive result. 'The elevation profile was quite impressive – within the first 5 kilometres (2 kilometres of which was in the relatively flat town), the course rocketed up over 1,000 metres. After this baptism of fire, the route continued to undulate, climbing higher and higher on cliff-side passes and forestry tracks before a tremendous descent back to Limone and the finish.'

RIGHT: Rémi Bonnet runs the swichbacks on his way to victory in 2015.

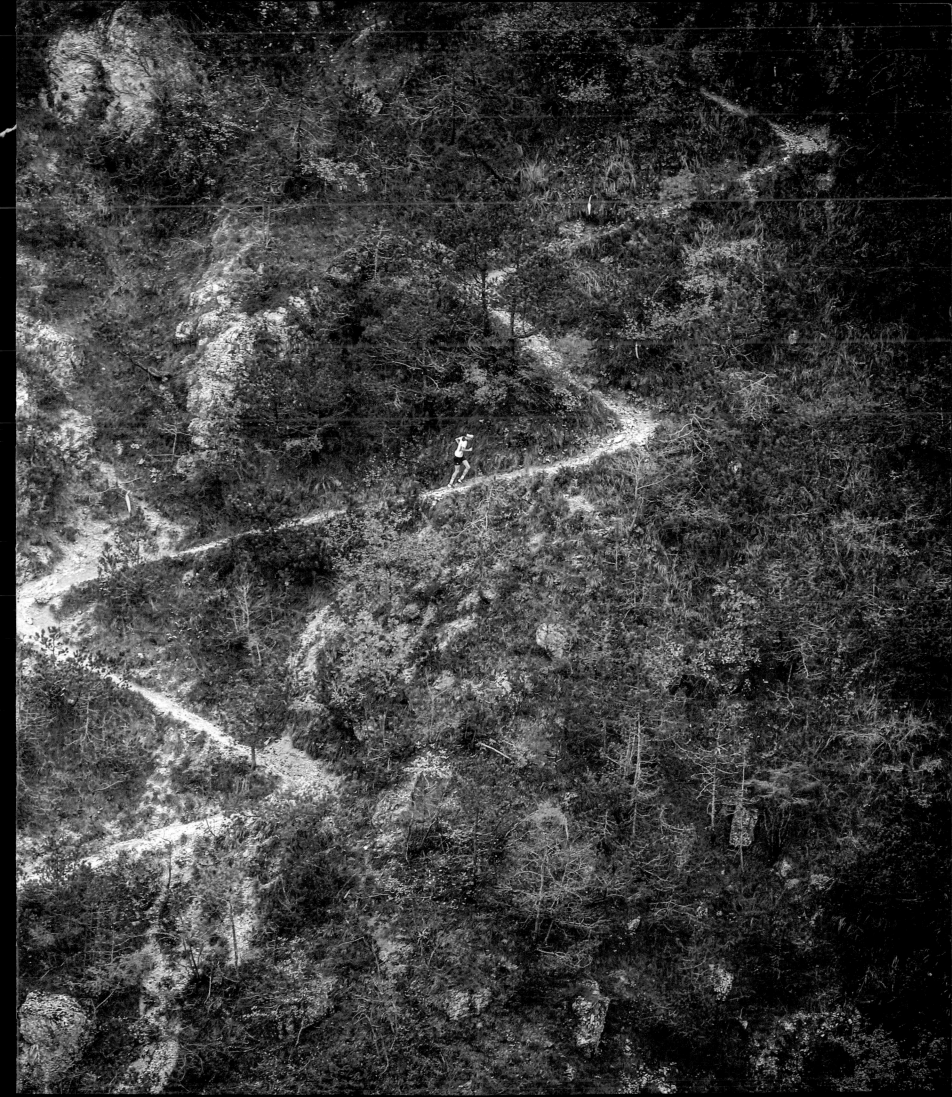

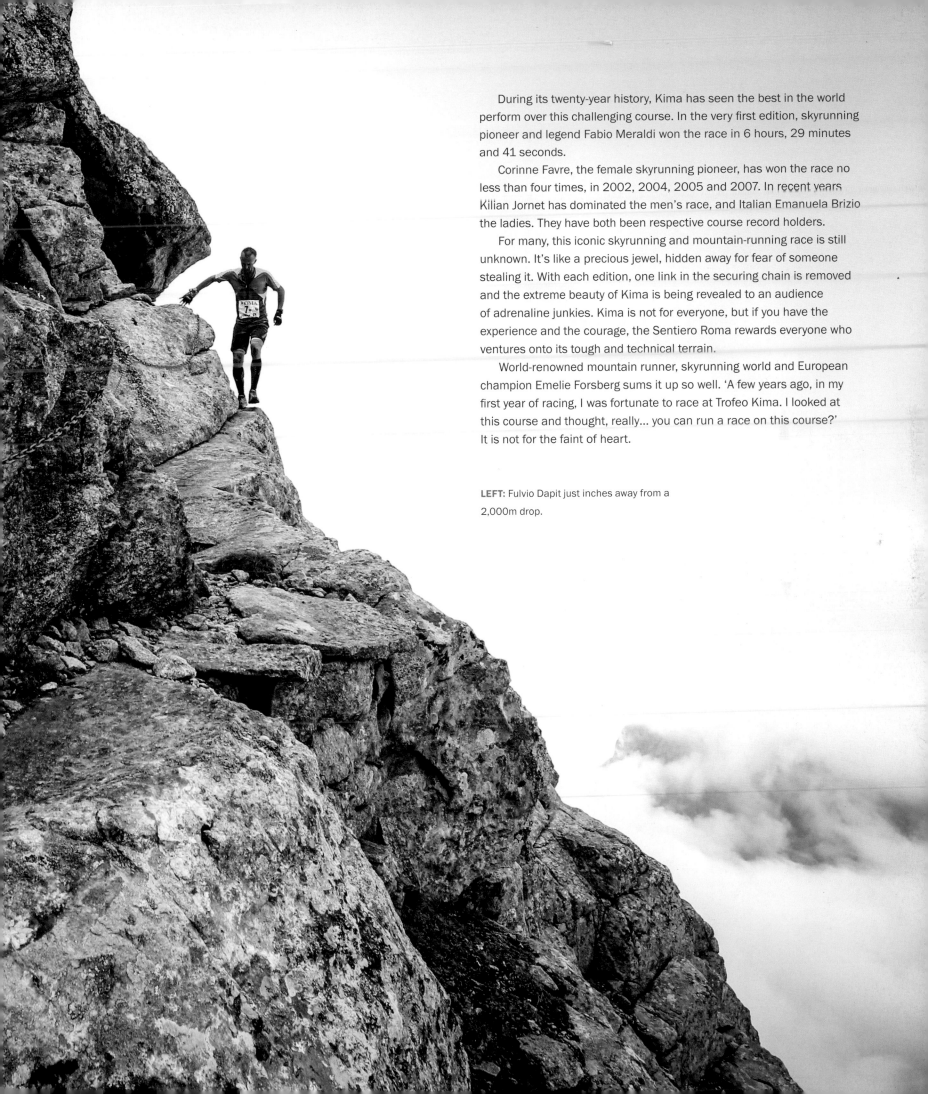

During its twenty-year history, Kima has seen the best in the world perform over this challenging course. In the very first edition, skyrunning pioneer and legend Fabio Meraldi won the race in 6 hours, 29 minutes and 41 seconds.

Corinne Favre, the female skyrunning pioneer, has won the race no less than four times, in 2002, 2004, 2005 and 2007. In recent years Kilian Jornet has dominated the men's race, and Italian Emanuela Brizio the ladies. They have both been respective course record holders.

For many, this iconic skyrunning and mountain-running race is still unknown. It's like a precious jewel, hidden away for fear of someone stealing it. With each edition, one link in the securing chain is removed and the extreme beauty of Kima is being revealed to an audience of adrenaline junkies. Kima is not for everyone, but if you have the experience and the courage, the Sentiero Roma rewards everyone who ventures onto its tough and technical terrain.

World-renowned mountain runner, skyrunning world and European champion Emelie Forsberg sums it up so well. 'A few years ago, in my first year of racing, I was fortunate to race at Trofeo Kima. I looked at this course and thought, really... you can run a race on this course?' It is not for the faint of heart.

LEFT: Fulvio Dapit just inches away from a 2,000m drop.

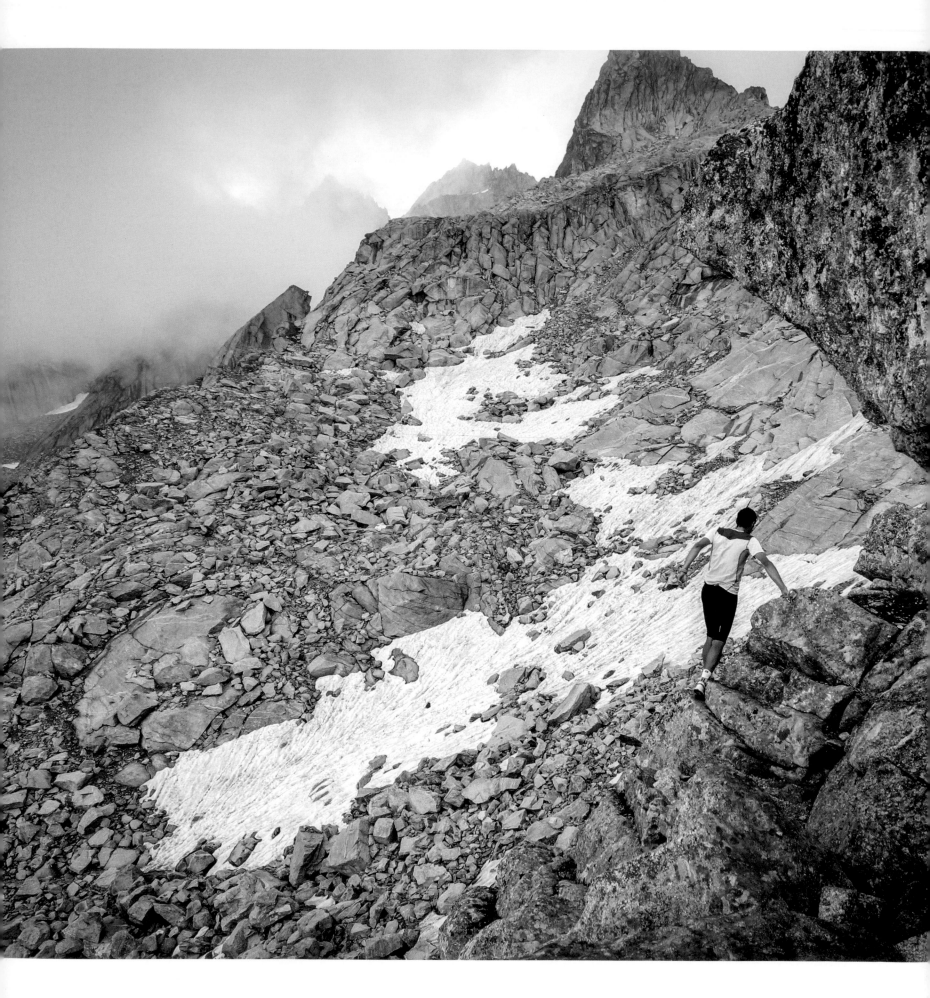

ABOVE: ISF President, Marino Giacometti.
LEFT: Kilian Jornet.

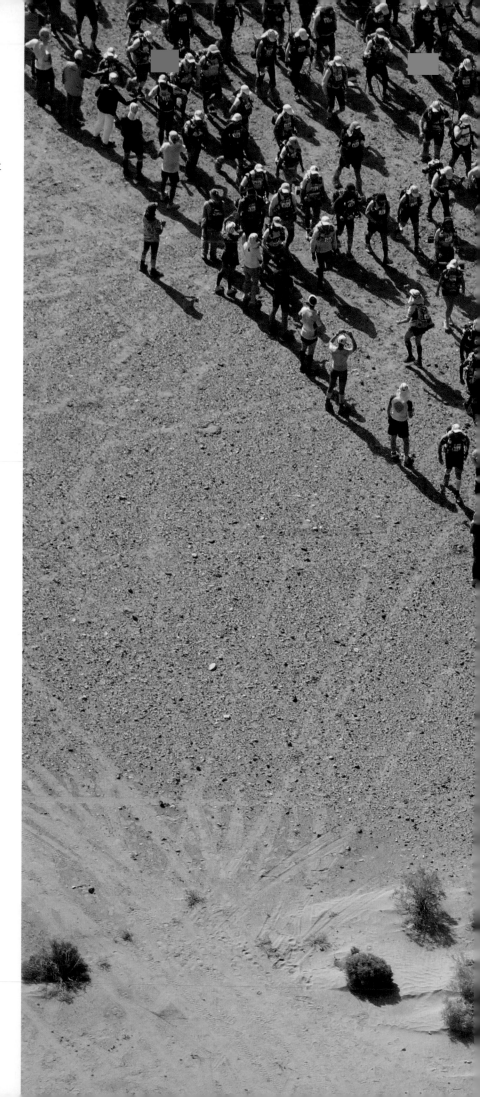

Described by race founder Patrick Bauer as 'the greatest show on Earth', one has to agree that his comparisons to a circus are apt. The Marathon des Sables, or MDS as it is affectionately known, really is a large, circus-like operation on a scale that is second to none. Volunteers number 130 to supervise the race, 430 general staff support the race and 300 local Berbers man the bivouac. All-terrain vehicles number 120, and there are eight 'MDS' planes, twenty-five buses, four dromedaries, one incinerator lorry, five quad bikes and two helicopters to keep the show on the road. Add to this fifty-two medical staff, plus journalists and photographers, and you really do have the 'Cirque du Sahara'. It's quite special.

A race with a history, the Marathon des Sables dates back to 1984, when Patrick Bauer, aged twenty-eight, ventured into the Sahara to traverse solo a 350-kilometre journey with a pack weighing 35 kilograms. It was the ultimate self-sufficient expedition and lasted twelve days.

Inspired by the experience, in 1986 the first edition was created. Just twenty-three pioneers embarked on what must have felt like one of the ultimate expeditions. Who would have thought that those formative years would have laid the foundations for what is, without question, the father of multi-day racing? The race has had many memorable moments – from the Gulf War impacting on the race in 1991, to the tenth anniversary edition in 1995. In 1996 Mohamad Ahansal participated for the first time, and in 1997 Mohamad's brother, Lahcen Ahansal, won his first race, one of many. The two Moroccan brothers have in many ways become the face of the MDS.

Despite the hardships of the Sahara and the lack of infrastructure, Bauer and the MDS team have been instrumental in testing and pushing the boundaries of what is possible in a remote environment. In 2000 they introduced the internet to the Sahara, and in 2013 they introduced solar power. Sandstorms, wind and, believe it or not, flooding in 2009 have all caused disruption to the race, but in the spirit of Bauer's original pioneering journey, a solution is always found. The race really has paved the way for ultra running and, in doing so, for many participants it has provided that first inspirational journey that has set many a runner on a lifelong quest to run further and in more extreme conditions.

Elisabet Barnes, the 2015 ladies' champion, has immersed herself in the MDS experience. 'On the two occasions that I have done the MDS, it has been a life-changing experience. Not necessarily the race in isolation, but the whole process, from signing up until completing. The simplicity of life and going back to basics helps you reconnect with what really is important in life. Multi-day racing is becoming increasingly popular and there are many fantastic races out there, but the MDS will always remain a very special race to me. Part of the appeal is the complexity of the race. To do well you must be a good runner, but so many other factors

RIGHT: Like a herd of wildebeest, the runners resemble animals in migration.
PREVIOUS PAGE: Multiple MDS champion, Mohamad Ahansal, runs his own path away from the masses.

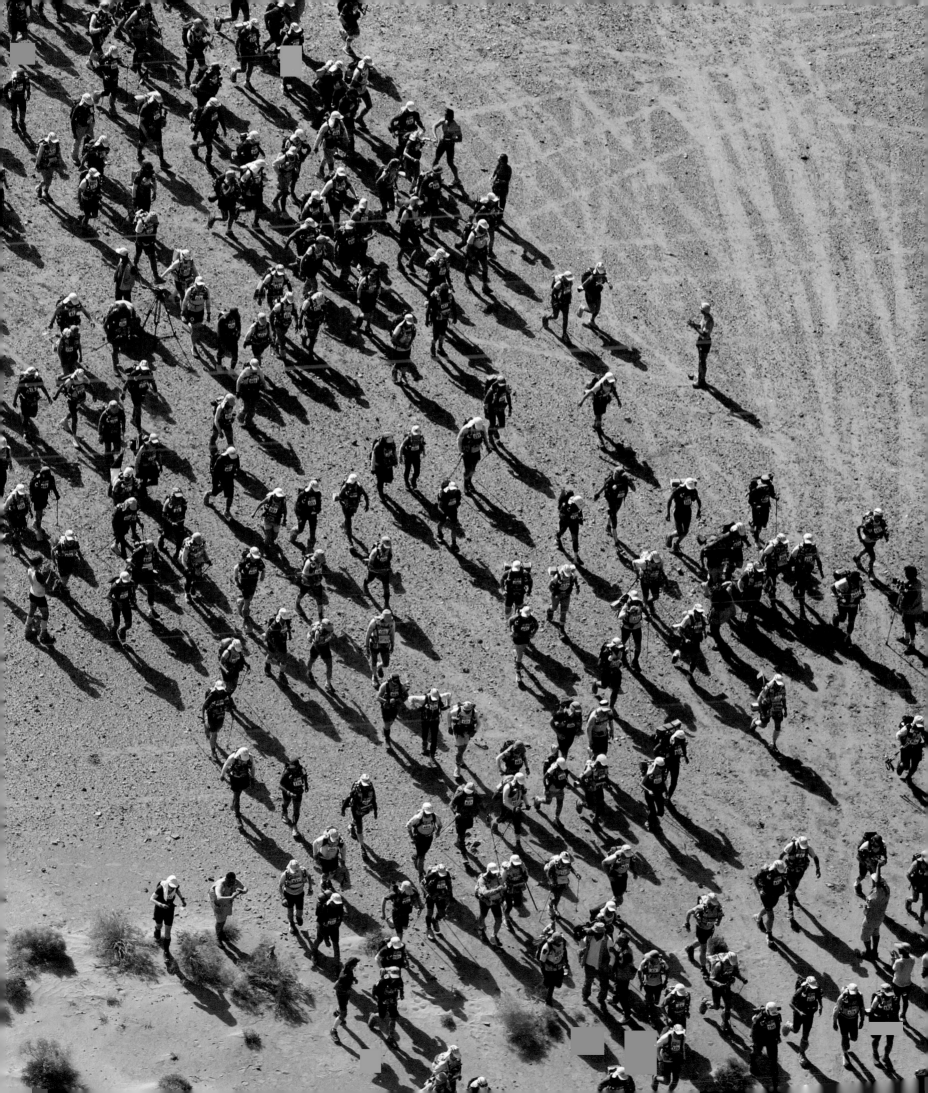

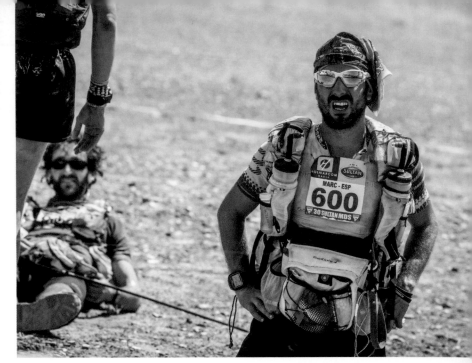

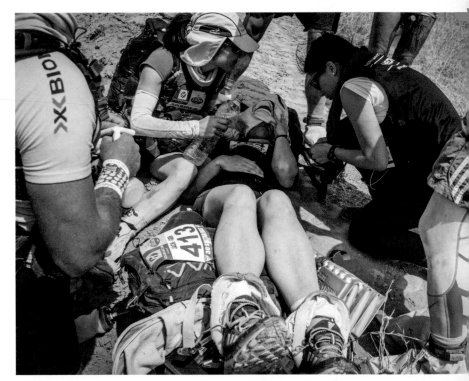

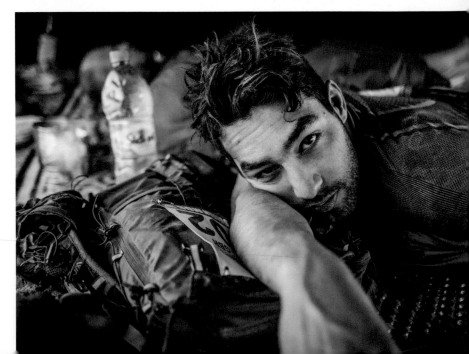

come into play, which makes for a very interesting week where your race strategy can make or break you. You must respect the heat and harsh conditions of the desert or you can quickly be in trouble.'

The Marathon des Sables has been called the toughest race in the world. The combination of daily self-sufficiency, restricted rations, restricted water and bivouac life certainly make it a life-changing journey, and for many it may well be the toughest.

2014 ladies' champion Nikki Kimball, from the USA, sums it up well: 'It's no easy race if you are pushing at the front. But it's as easy or as hard as you want it to be. The cut-offs are generous and that provides so many with an opportunity, which is great. But if you are looking to be at the front, you have to be fit, dedicated and focused. It's not the hardest race I have done, but it is also not the easiest.'

Each year the course changes, although inevitably the race still visits familiar ground that has been covered in earlier editions. Bauer loves the Sahara and, as one edition of the race finishes, he starts to plan the next. Dividing his time between France, Spain and Morocco, the desert and MDS have become a lifelong passion.

'[It's] the cocktail of the desert, running and the self-sufficiency,' explained Bauer after the 2015 edition. 'Nobody at the beginning

ABOVE: Sir Ranulph Fiennes, the legendary British explorer.
OPPOSITE: Magic moments. Top left – Worn-out feet – the Sahara takes its toll. The heat and sand are a tough combination; Top right – Two runners collapse at the end of the race. They have done it, and it has taken everything that they had; Middle left – Everything is rationed in the race, and a runner must have a special card clicked to make sure that they do not exceed what is allowed; Middle right – Exhausted and dehydrated, a runner receives immediate medical care on the route from one of the many medics, one of the reasons why Marathon des Sables is so safe; Bottom left – Cooking one's own food and carrying everything means that compromises must be made, and thinking 'outside the box' can save valuable weight. Here, a runner uses a bottle cut in half for a bowl; Bottom right – Only three things to do in the Sahara: run, eat and rest. A runner drained after the long day.

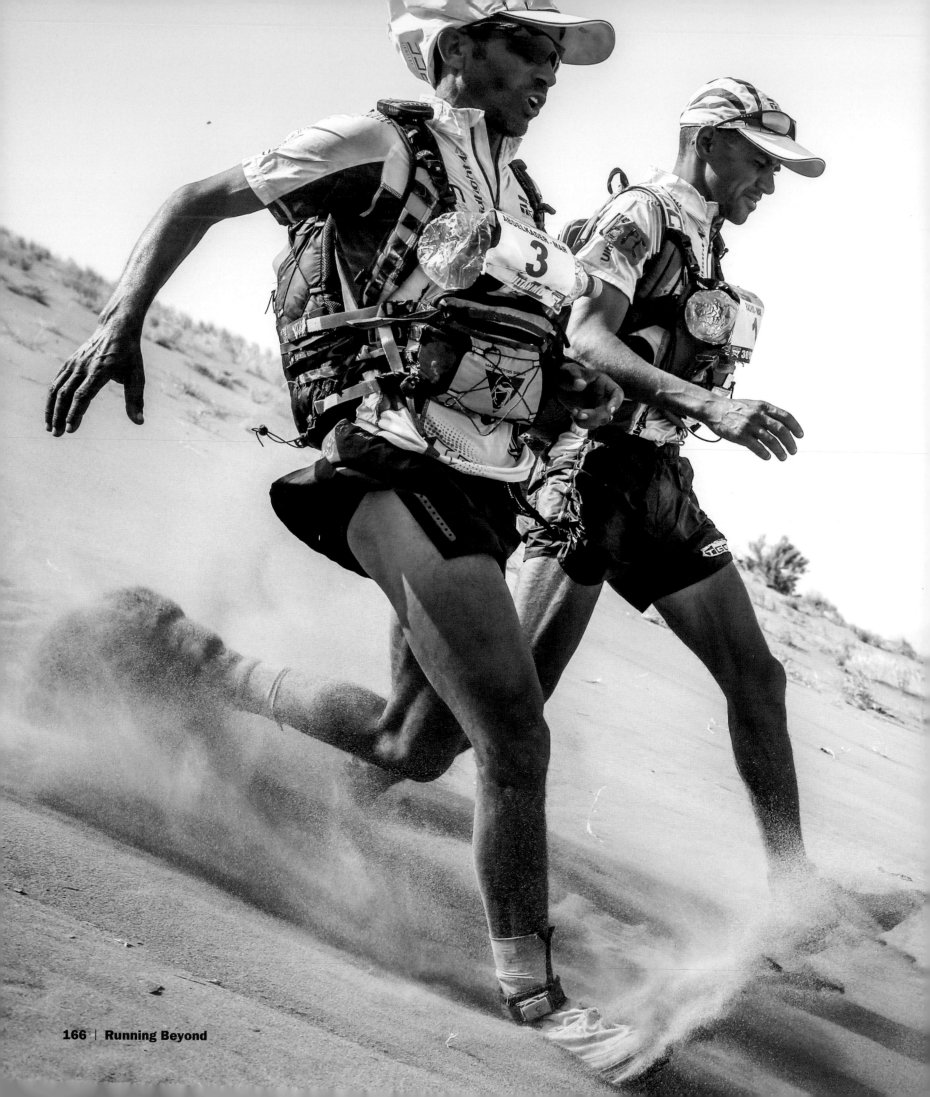

thought it would be possible to run with a pack. The expedition was an extra bonus. You need to manage everything: calories, water, clothing, rest, etc. When a race is over, I start immediately on the next year. I have a passion and I think about it all the time. I want to be more strategic with my long-term vision; I like to look three years ahead.'

The race provides an extraordinary experience, and it is this that attracts so many runners back, year after year. 'We share values with participants and it creates a bond,' says Bauer. 'Some say "never again", and then two years later we see them returning. We all strive for equilibrium, to balance the experience and we all strive for positive thoughts. If we have them, then we can share beautiful things.'

The route may change and daily distances may vary, but there is a comfort in the MDS format. The race takes place over six days, there is always a long day and always a marathon day, but either side of this, distances are flexible. Participants carry all that they need for the duration of the journey: food, clothes, a sleeping bag, any mandatory kit as specified by the race, and optional luxuries such as an MP3 player. The race provides a shelter for the night (a bivouac), which is shared with seven other runners, and a water allowance is provided each day.

'I had a very light sleeping bag,' says Nikki Kimball. 'If you are racing and want to be competitive, then weight is everything. You must go as light as possible. I didn't have a sleeping pad, no luxuries, and no creature comforts. If you want to "complete" it makes sense to have a few comforts, but don't go crazy – remember, you have to carry everything.'

Over the years, the race has increased in distance, typically settling at 250 kilometres. The long day in particular has on occasion got longer, as in 2015 when runners had to complete almost 90 kilometres. As the infrastructure of the race grows and accessibility for vehicles increases, it's easier for the race to expand. 'Water has always been a key issue at MDS,' Bauer explains. 'We now have great water supplies. In the past this was not the case. But we all have short memories. We forget the hardships.'

The UK's Danny Kendall has raced Marathon des Sables and is the highest-ranked Briton in the race. When asked about water in the Sahara, he says, 'Water is the one thing that is provided during the race and dehydration is one of THE biggest risks in the desert. It's a good idea to drink at regular intervals, take small and regular sips. Everyone will loose a lot of salt and the organization provide salt tablets daily to ensure you can replace electrolytes; make sure you take them.'

Every year makes new demands, but one thing is for sure: at the end of the journey, no matter how broken a runner is, no matter how sore their feet may be through blisters, the elation of the finish line is something to behold. In our busy lives full of stress, computers, mobile phones and creature comforts, MDS provides something special in its minimalist approach. It takes you back to basic instincts – to survival. Lives have been changed at Marathon des Sables. The race still appears on the bucket list of many a runner.

'You must not start off too quickly on the first day,' warns Jo Meek, who placed second in the 2013 race. 'Remember, you will be excited, you have waited for this day for a long time. When you are finally released into the Sahara, it is very easy to run too quickly and too hard with adrenaline. Start slowly and ease into the race. The long day for many is the ultimate day, so always keep this in mind and try to keep something back. Don't be worried about walking. With the exception of the top runners, everyone walks at MDS, so practise this and get comfortable with it.'

To endure the journey, to survive on rationed food and water, to share a bivouac with seven souls – it all reaffirms that you are living. From first to last, the sand of the Sahara never leaves your socks and shoes and, just like those distant memories of your formative years at school, MDS will stay with you to the grave. In many cases, the person who leaves the desert is not the same person who entered.

LEFT: It's always head to head at the front of the race.

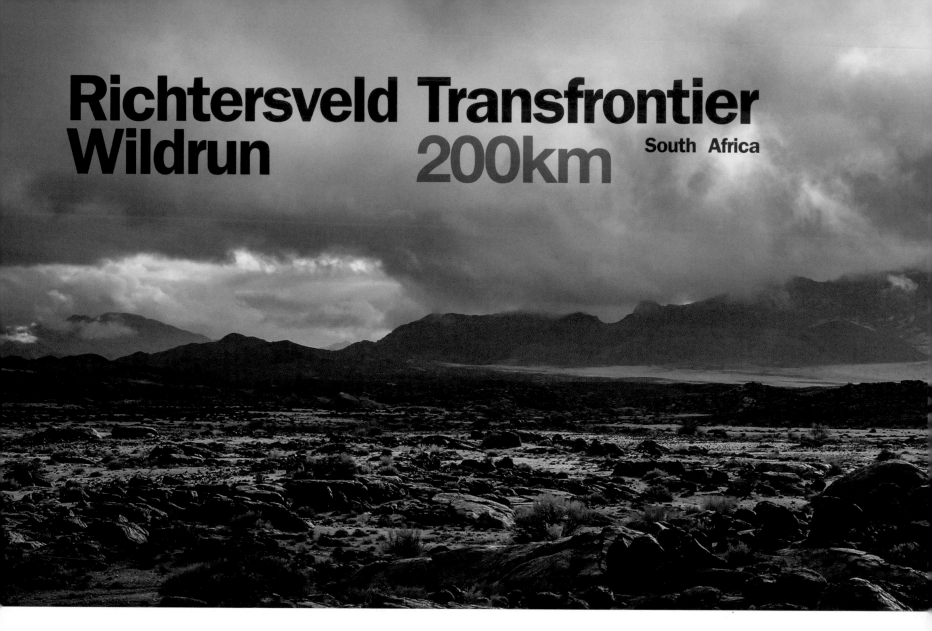

Richtersveld Transfrontier Wildrun

200km South Africa

Placing one foot in front of the other as a method of transport takes us back to our roots, back to our basic instincts: the simple act of running. At its heart it's about being in the wild, surviving and fulfilling a primal need to cover ground in search of food and a place to sleep.

Situated in the remote Richtersveld Transfrontier Park in the most northwestern part of South Africa, the Richtersveld Transfrontier Wildrun ticks all the boxes as a location for a wild adventure that harks back to our primal needs.

Navigating via GPS over five days, participants cover 200 kilometres through this remote and isolated wilderness on a circular route that starts and finishes on the Orange river at Sendelingsdrift. On day four, the race crosses over into Namibia for the ultimate transfrontier experience. A supported race, base camp each day is leap-frogged to ensure that runners have the maximum comfort. Small individual tents are provided to ensure a good night's rest. It is a run through time, through millions of years of history in an ever-changing landscape that challenges not only the legs and lungs, but also the eyes and mind.

The Richtersveld Transfrontier Park includes the oldest desert in the world and is home to an abundance of flora, wildlife, nomadic tribes, sulphur springs, archaeological sites, the stunning Tatasberg boulders and the iconic Fish River Canyon, the second largest in the world behind the Grand Canyon. No two days are the same in this remote, rugged wilderness, and in addition to an ever-changing terrain, weather conditions offer a challenge. Hot days are followed by cool nights. It rarely rains here, maybe once or twice a year, but when it does, you need to be prepared; it's almost biblical.

Weathered by water, rain and volcanic activity, the park is a geological masterpiece of natural sculptures. Imagine running through a gallery of Henry Moore or William Blake's finest work; it is a vision of what a mountain desert wilderness should look like through the eyes of an artist. Mountain summits, deep canyons and the massive granite boulders of the Tatasberg make the Wildrun a running playground through one of the most beautifully challenging environments you will ever see.

ABOVE: The wild and gritty Richtersveld.

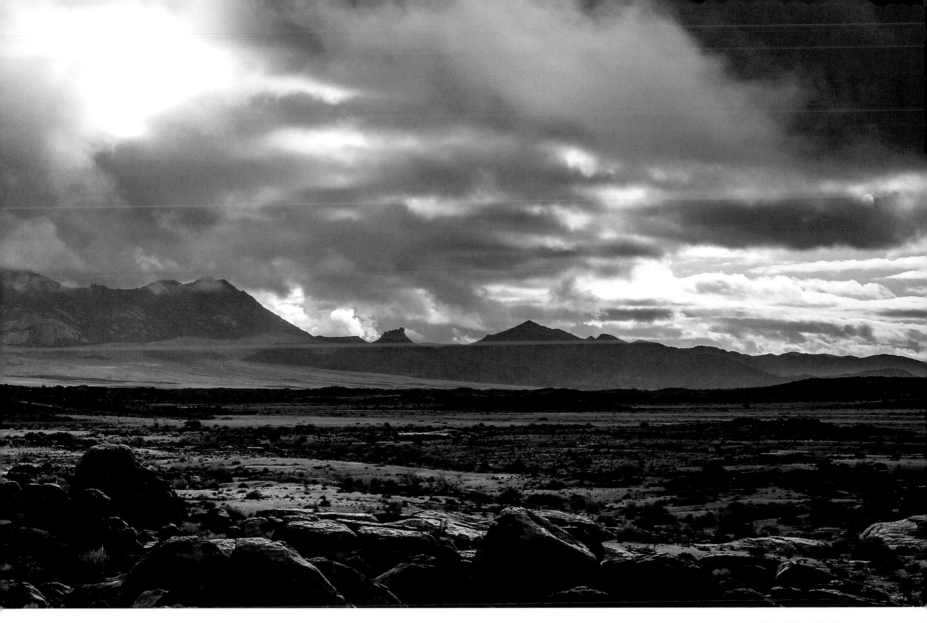

Fact File Richtersveld

DISTANCE: 200km

TERRAIN: Trail

TOTAL HEIGHT GAIN: 3,400–3,612m
(route dependent)

FASTEST TIME: Bernard Rukadza 15.20.46
and Katya Soggot 15:26:57

HIGHEST POINT ON ROUTE: 833m (approx)

Please note: this profile charts the total height gain of each day.

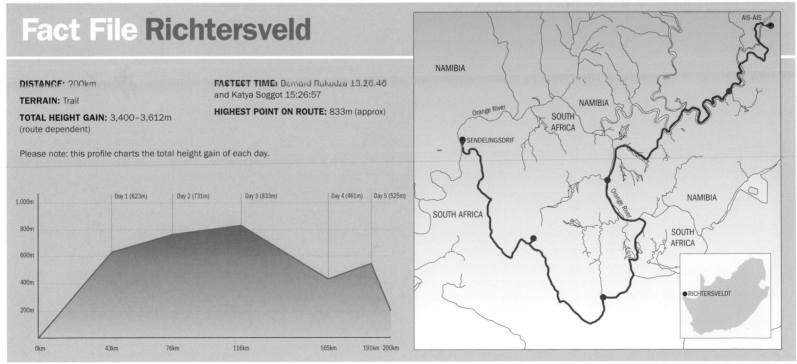

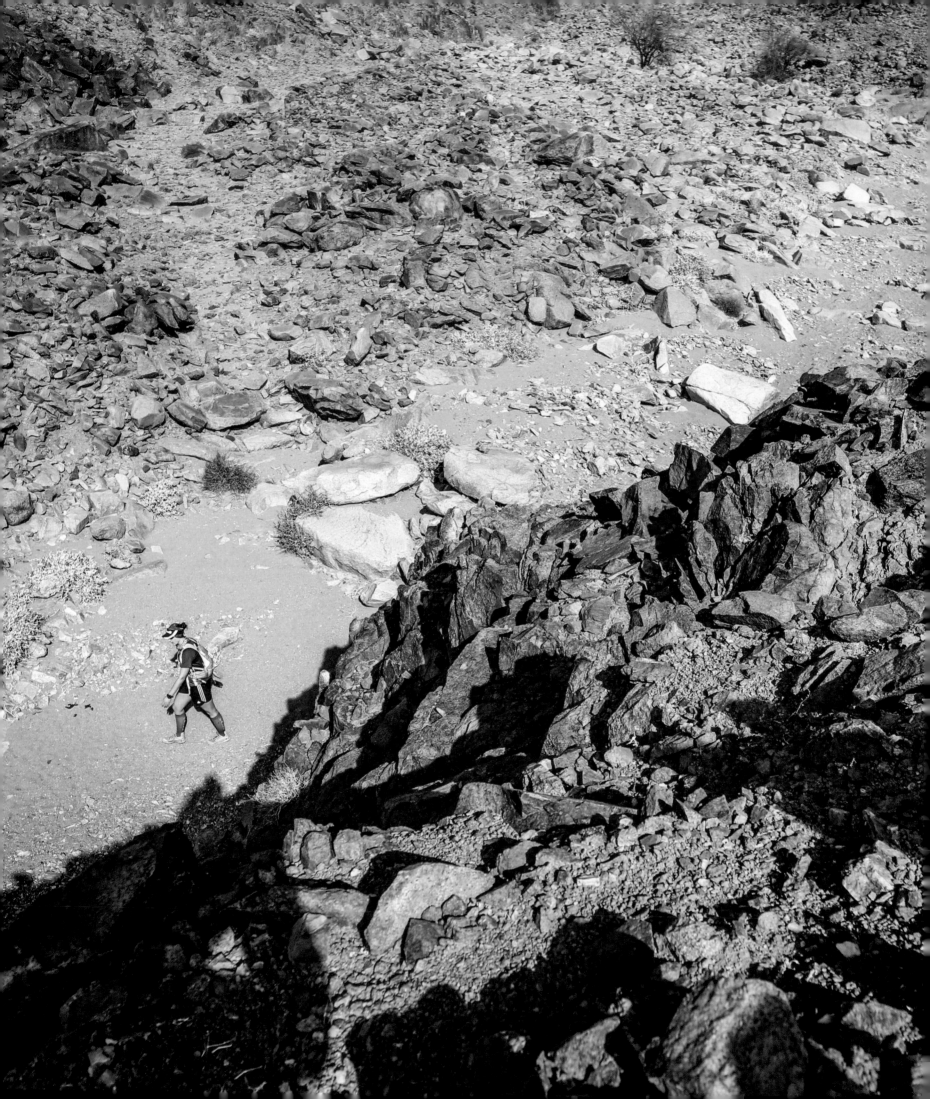

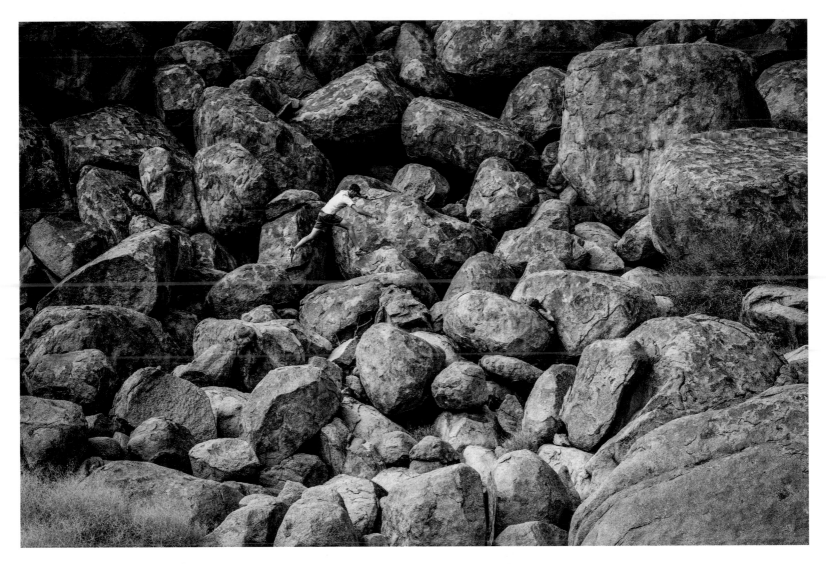

Few people have witnessed this remote place, and that is what makes it so special. It's a low-key race and intentionally so – the Richtersveld Transfrontier Park is a tough environment. Competitor Mark Matt sums it up well: 'This is a great sprawling adventure of a run in a remote and magical desert wilderness, backed up by superb organization, hospitality and good energy all round. The Wildrun team are to be commended for their ability to send runners into the deep heart of a wild and remote mountainous desert and to fire them in the furnace of true desert running.'

The idea for the race came about in 2006 when Wildrunner race-director Owen Middleton visited the area for the first time. Working in conjunction with park manager Nick de Goede and Roland Vorwerk from Boundless South Africa, a dream became a reality in 2014 with the first edition of the race.

The Richtersveld Transfrontier Wildrun makes us ask a fundamental question: why do we run? It also provides an opportunity to visit a remarkable natural wonder that is so seldom visited or seen. It makes one hark back to a time of simplicity, of being at one with the environment, isolated from the modern-day clutter of technology. Out here it's possible to create a primal bond, being at one not only with

‘ **THE WILDRUN TEAM ARE TO BE COMMENDED** for their ability to send runners into the deep heart of a wild and remote mountainous desert and to fire them in the furnace of true desert running.'

Mark Matt, competitor

ABOVE: The amazing Tatasberg Boulders.
OPPOSITE: Stunning canyons are walled by steep and jagged rock.

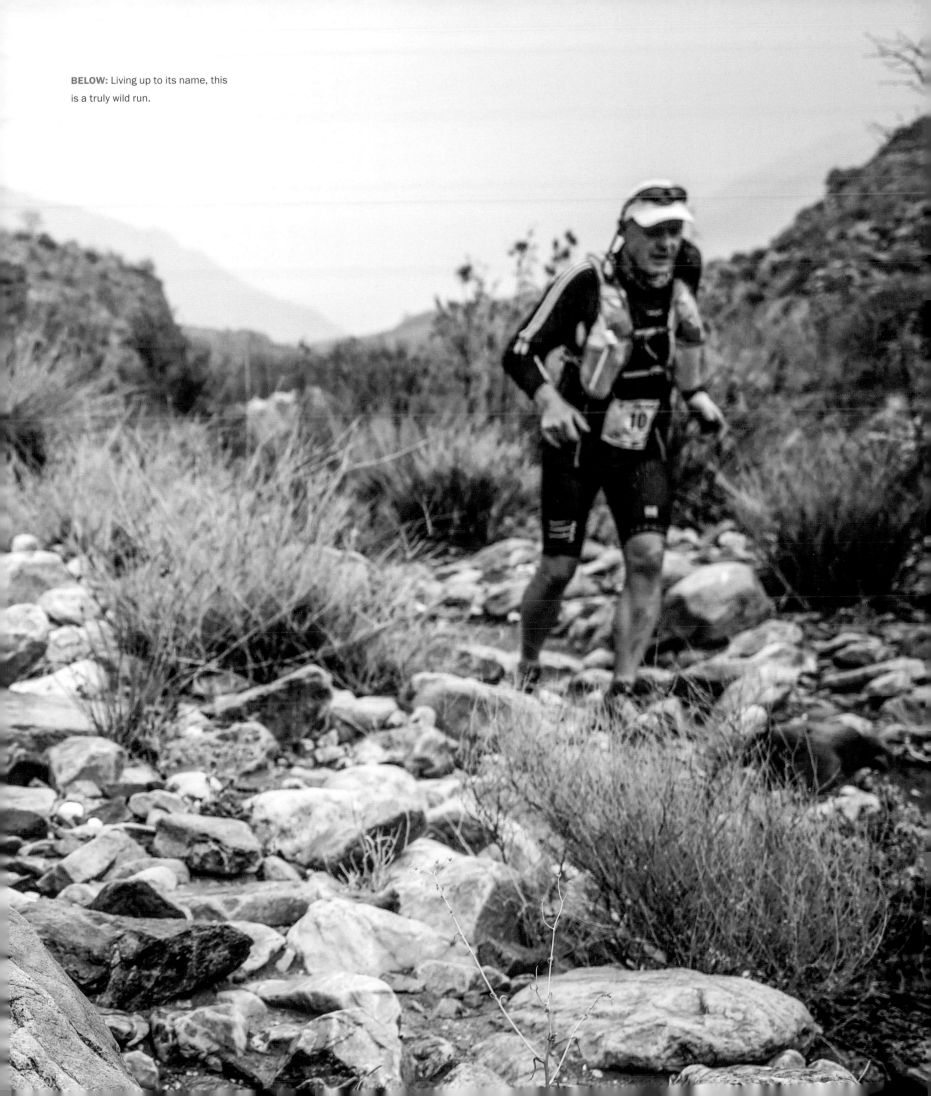

BELOW: Living up to its name, this is a truly wild run.

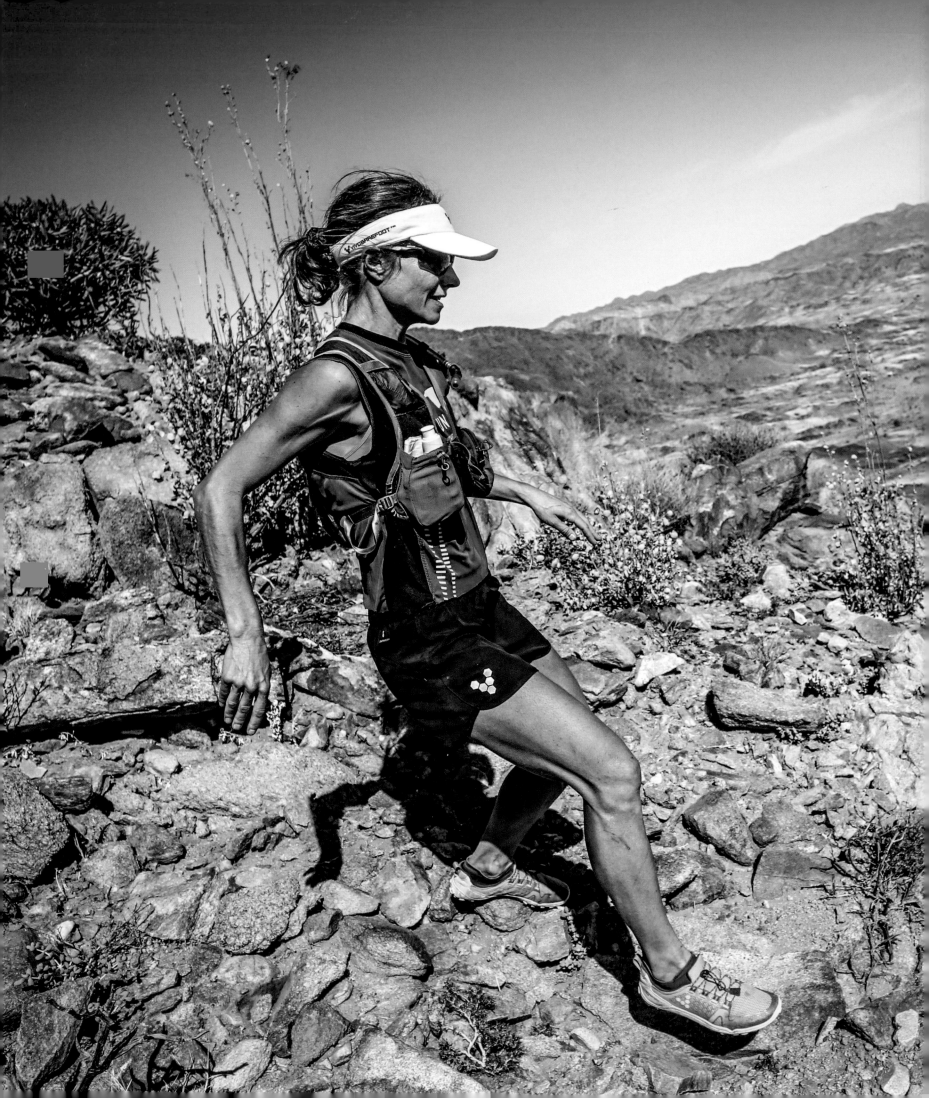

nature but also with fellow competitors as stories and experiences are shared each night around camp fires under incredible African skies.

Carien du Plessis participated in the 2015 edition of the race, and her experience was a profound one. 'The Richtersveld looks desolate from afar, but up close it is a rich landscape with amazing rock formations, plants and animals. The run was across these landscapes (a variety of sand, loose and often sharp stones, jeep tracks and succulents and thorny bushes), quite a way off the beaten track, and challenging enough to shake any average person out of their comfort zone, on each of the four days.

'I had to learn how to use a GPS pretty quickly, but once I figured it out, things were fine. The days were a real runners' retreat, because we were out of mobile-phone range for most of the time. Yummy meals are homecooked for you and the tents are pitched, so all you have to concentrate on is running and staying roughly in one piece.'

'Escape' is a word used extensively when talking about running. It's a metaphor that encompasses so much: an escape from work, an escape from day-to-day life, and so on. But do we ever really find that escape? Here, in Africa, it is possible. The Wildrun provides the rawest and most organic experience on the trails.

To not slow down, look around and soak in and embrace what is around you would be very foolish. To win without embracing the experience and splendour of this environment would ultimately mean that you have lost. Remove the blinkers, kick back, enjoy the experience and you may well find that your racing experience is enhanced by the removal of performance pressure.

LEFT: Katya Soggot from South Africa runs down one of the many technical trails on her way to victory in 2015.

Iznik Ultra
136km Turkey

Iznik, formerly known as Nicea, is situated on Lake Iznik in the province of Bursa, some 2½ hours away from Istanbul. Renowned for its olive trees and beautiful ceramics that have adorned many of the key mosques in Istanbul, much of its past is still visible today.

Founded in 4 BC by King Antigonus I Monophthalmus of Macedonia, Nicea was an important centre in Roman and Byzantine times and has been a witness to key moments in the history of the Ottoman Empire. Using the lake as a backdrop, the 80-kilometre and 139-kilometre Iznik Ultra races essentially cover half or the whole of the lake as the race route. The first 60 kilometres or so include tough climbs and quad-breaking descents, while the final 60 kilometres after the village of Soloz hug the lake with the odd deviation and are predominately flat.

Turkey is not known for ultra running. Despite its geographical location, its history and the multicultural influences placed upon it, ultra is still a sport for the few. Even running is a minority sport. Caner Odabaşoğlu decided to create an event in Turkey that would place it on the ultra map, and in doing so established an event that sits on many an ultra-runner's 'must do' list.

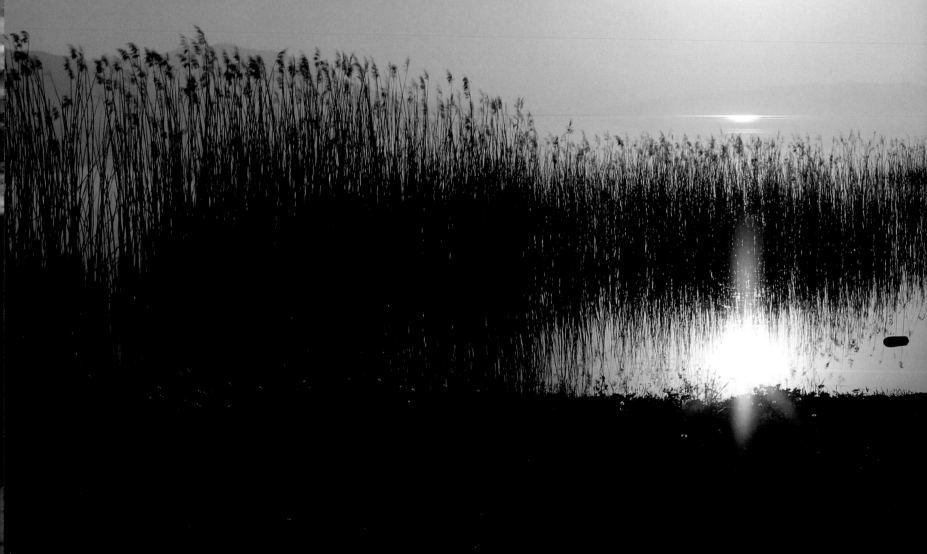

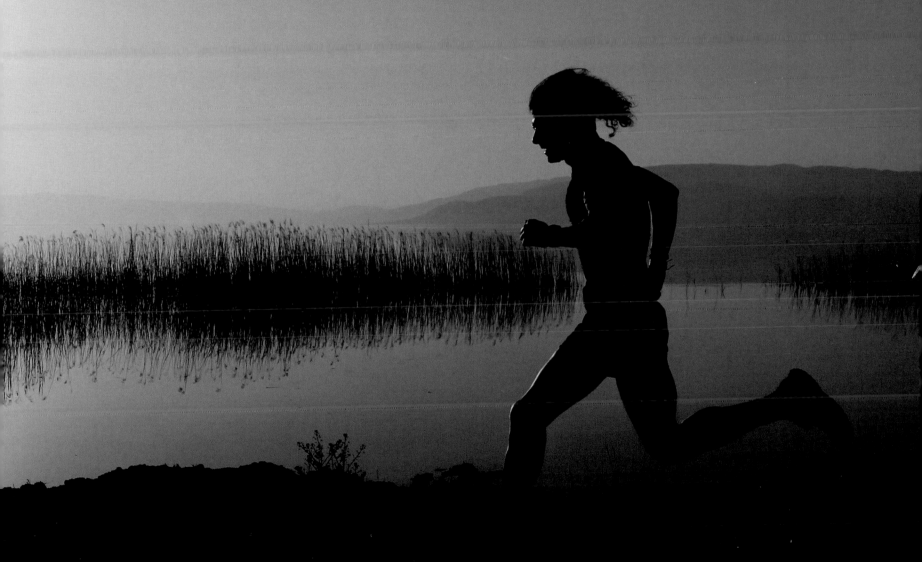

‘ SOON WE WERE ON OUR WAY INTO THE DARKNESS
OF IZNIK. Within a few metres I was on my own, so
I sped up to follow someone, as my worst fear was
getting lost in the dark.’

Zoe Salt, UK runner

BELOW: Depa runs beside the lake as a day
comes to an end.

ABOVE: The trails of Iznik and Turkey provide a 360-degree experience, with so many locals providing colour along the route.
OPPOSITE: Benoît Laval, France.

Predominately trail, less than 20 per cent of the course is road and these sections are purely used as a transition from one section of trail to the next. The feet are led across rocky, rutted, muddy and often slippery terrain, and the course boasts climbs that are tough and demand pacing, particularly if running the longer event. Run too hard, too early and the remaining kilometres after Soloz, although flat, are very tough.

Starting at midnight, the 136-kilometre race is the Iznik Ultra flagship race. Zoe Salt, a runner from the UK who placed third female at the 2013 edition of the Marathon des Sables, took part in the 2015 edition of the race. She said of her experience, 'Soon we were on our way into the darkness of Iznik. Within a few metres I was on my own, so I sped up to follow someone, as my worst fear was getting lost in the dark. It turned out that this was another of my unnecessary stresses as there were markers every 50-ish metres – foolproof even for me!'

Darkness has an ability to hide obstacles and challenging terrain. Salt picks up the story: 'We ran through miles and miles of olive groves and trees full of blossom. It was so quiet. Then, bam! I was confronted with what in the dark seemed to be a near-vertical climb. Had I packed climbing shoes or rope?'

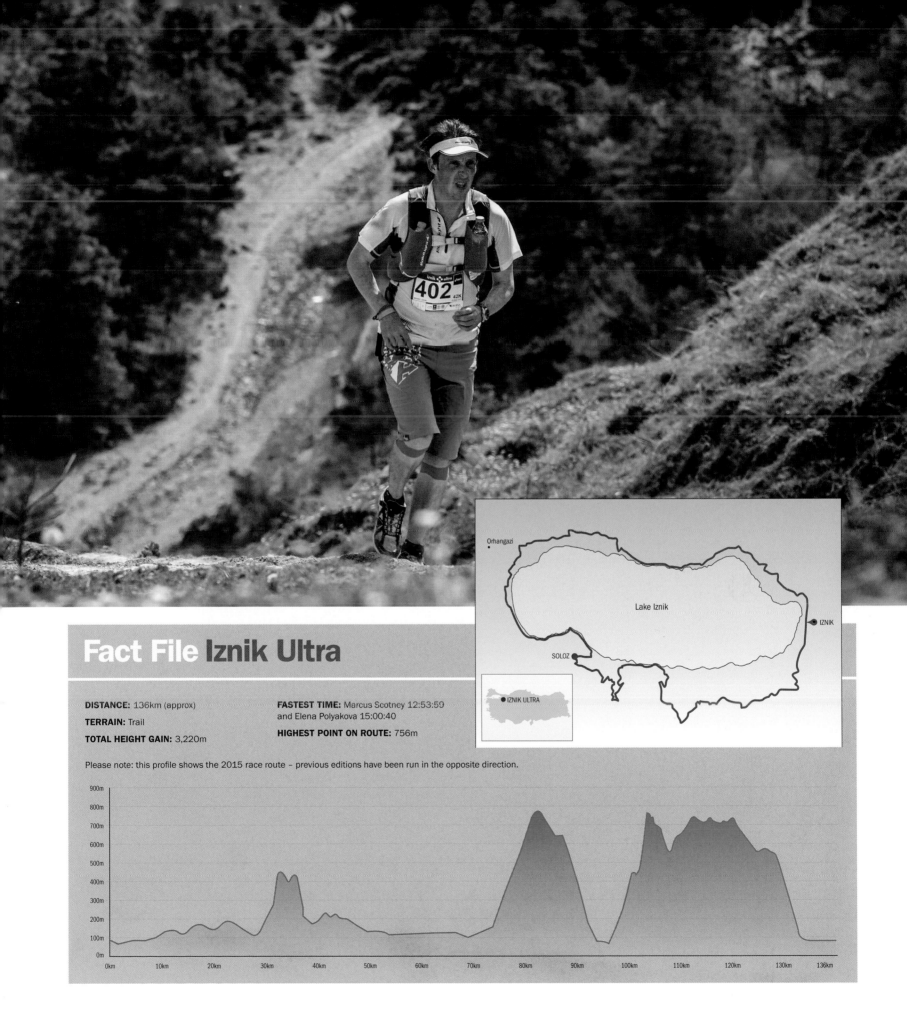

Fact File Iznik Ultra

DISTANCE: 136km (approx)

TERRAIN: Trail

TOTAL HEIGHT GAIN: 3,220m

FASTEST TIME: Marcus Scotney 12:53:59 and Elena Polyakova 15:00:40

HIGHEST POINT ON ROUTE: 756m

Please note: this profile shows the 2015 race route – previous editions have been run in the opposite direction.

Donnie Campbell, a personal trainer from Scotland, won the race overall and his story was a lonely one. 'I was planning to stay with the lead pack for the first half of the race and then make a break, but after two or three kilometres I started pulling away. I wasn't even pushing it, it was just a comfortable pace for me. I was on my own for most of the time, so it ended up being quite a lonely race.'

Dawn eventually arrives, and with it the wonderful call to prayer. The sun rises over the hills, bathing the landscape in beautiful colours, although from the halfway point the most picturesque part of the race is still to come. The rolling hills offer views of distant, snow-capped mountains. In the foreground is a lake, its surrounding fields and minarets marking each village and town.

A lover of mountains, Campbell found the early flat sections of the race tough mentally, but in the latter stages, more challenging terrain suited his style. 'The course was relatively flat; I'm used to more mountainous races so my legs felt a bit sore around 100 kilometres, but once I hit some hills my legs felt fresh.'

It's downhill to the finish, but dense forest hides the town and on several occasions runners are given false hope of the finish line, as it appears like a mirage amongst the foliage. Iznik finally comes into sight, and the final kilometres are on the road to the makeshift finish at the lakeside.

Iznik's proximity to Istanbul provides a perfect opportunity to combine running and sightseeing in one trip. Istanbul is busy, noisy and chaotic but amongst all this impact on the senses, it is a place of great beauty. Within the old town, one has the ability to absorb history on each street and every corner.

The Iznik Ultra is not only about ultra running. It is about motivating a population to see the benefits of what ultra running can bring. The Turkish people are incredibly accommodating, friendly and warm. They embrace a sport that they know nothing about and welcome it with open arms. The appreciation, the applause and the accolades that the local communities provide throughout the race are second to none. Iznik relaxes the mind and body and fulfils running ambitions, making Turkey and the Iznik Ultra a perfect running experience.

BELOW: Sunset on Lake Iznik.

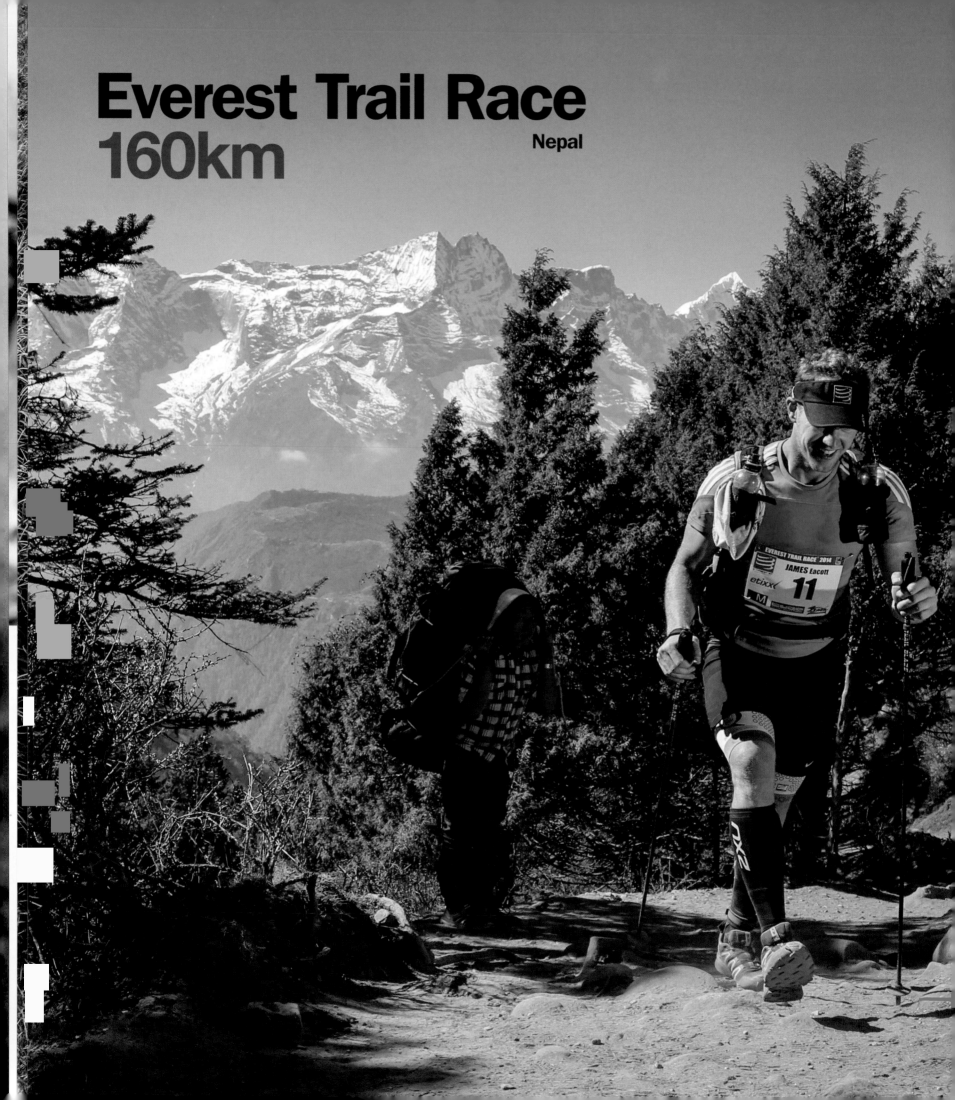

Everest Trail Race
160km
Nepal

'TRAVEL IS THE DISCOVERY OF TRUTH; an affirmation of the promise that humankind is far more beautiful than it is flawed. With each trip comes a new optimism that where there is despair and hardship, there are ideas and people just waiting to be energized, to be empowered, to make a difference for good.'

Dan Thompson, author

Sir Edmund Hillary and Tenzing Norgay are the stuff of legend: real superheroes for the modern era. They had the 'right stuff' – that innate quality of the stiff upper lip and the ability to 'take it on the chin'. Fifty-plus years ago, clad in wool and leather boots, they departed Kathmandu on what is now considered one of the most iconic journeys ever taken: a journey that would take the duo and a British expedition step by step, stride by stride from Kathmandu to Everest Base Camp; a journey to climb the highest mountain in the world.

To follow in the footsteps of these pioneers and retrace the 1953 journey is beyond running. It's a life-affirming and life-changing experience, and one that the Everest Trail Race provides.

Kathmandu is just the most incredible place. The noise, the colour, the people, the cars and the dust; it assaults the senses. Nothing can really prepare you for the poverty, beauty and generosity of the Nepalese people. Kathmandu is a gateway to another world.

Departing Kathmandu, the road to Jiri is a twisting and gut-wrenching series of bends and miles. At an altitude of 1,905 metres, base camp one is warmed by the glow of yellow tents. As the sun lowers behind the surrounding mountains, anticipation of the journey ahead is high. Sherpas and porters prepare dinner, one prepares for the first night under canvas and, suddenly, the journey ahead feels very real.

The Everest Trail Race (ETR) follows the route of Hillary and Tenzing from Jiri all the way to Tengboche and then turns around and heads back to Lukla, thus facilitating an easy and manageable exit point to fly back to Kathmandu. At 160 kilometres in distance, an experienced ultra runner may well think the race to be easy. Think again. The combination of relentless climbing, long descents, technical terrain and high altitude makes the ETR, mile for mile, one of the toughest races of its type.

LEFT: James Eacott climbs to Tengboche as a porter looks on.
NEXT PAGE: Another world.

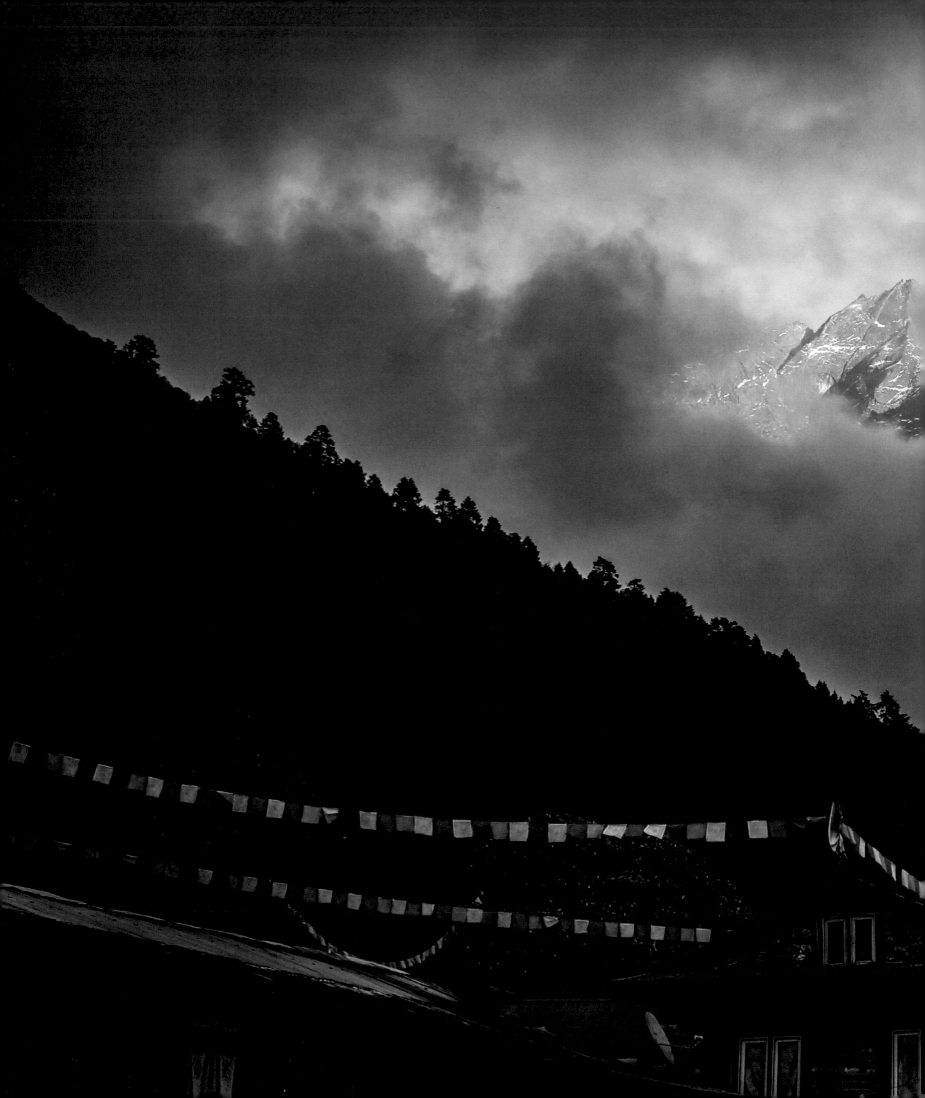

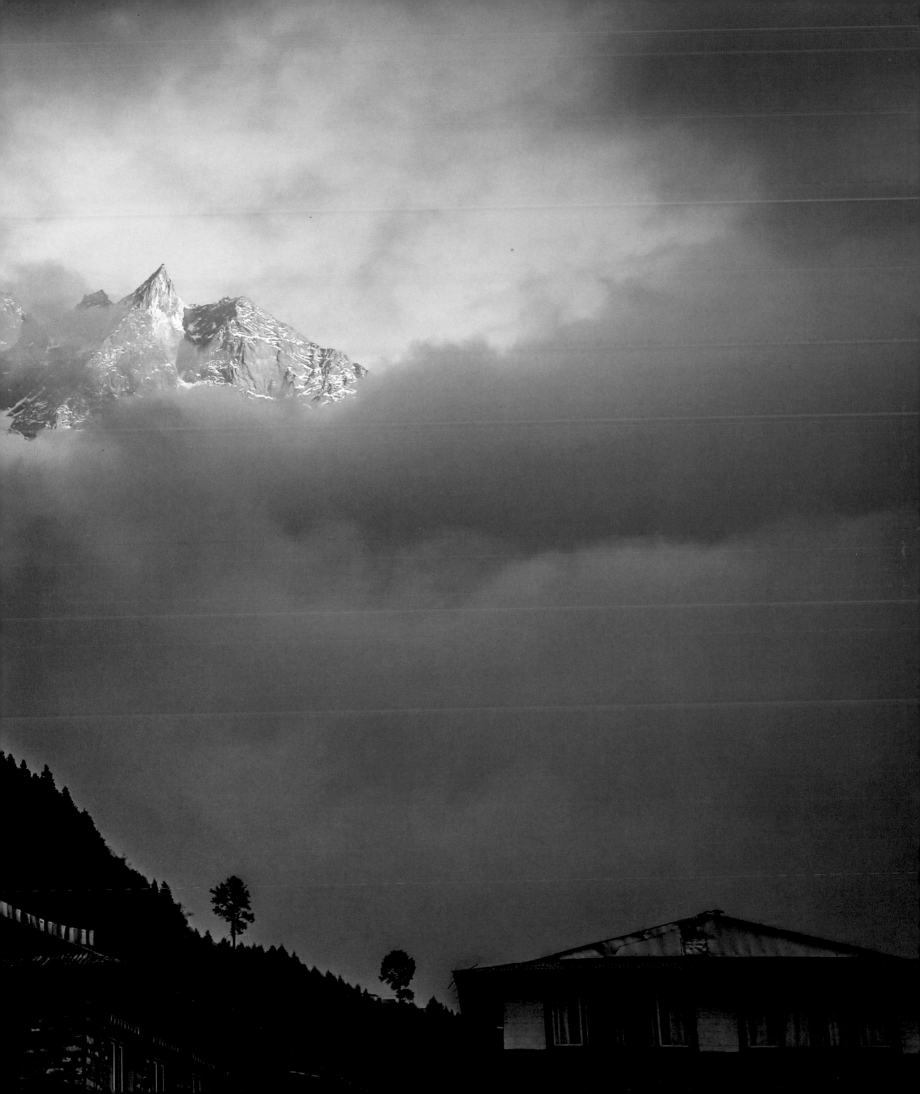

Broken down into manageable chunks, the race is divided into six stages with daily distances of approximately 22, 28, 30, 31, 20 and 22 kilometres. Altitude gain starts at 3,000 metres and builds to 6,000 metres. The race is a journey to widen one's eyes as well as one's lungs, the visual splendour of the Himalayas being beyond words. The mountains, trails and people arguably provide one of the most stunning backdrops to any race on the planet. When running, it's easy to become stuck in the routine of relentless forward motion – then something stirs, you look up and, as your jaw hits the floor, the visual splendour takes what little breath remains away; you are left gasping, breathless at the beauty.

The trekking route, on which the race travels, is the motorway of Nepal. We are the tourists in the midst of a constant stream of heavy-goods vehicles surrounding us in the form of porters, mules or yaks. Porters transport goods and services up and down this trail motorway daily, an important lifeline to the whole community. For £10 a day, they will carry 30 kilograms on their backs, covering high altitudes and long distances with the ease of mountain goats. Experienced porters have been known to carry up to 120 kilograms per day – it is beyond belief, but here this is normal. No roads exist, and the only method of transporting any goods along the trail is by porter, yak or mule. Large eyes, dried dirt and wide-open, welcoming smiles; the Nepalese people really are the salt of the Earth. Living in a harsh, demanding and remote environment, they have adapted to the surroundings and have found a peace and humility that we can all learn from.

Day one to Bhandar eases runners into the race, with around 3,700 metres of vertical gain and descent and approximately 21 kilometres in distance. The mind is released and the legs and lungs try to follow. The sound of horns from local villagers announce that the race is under way.

Bhandar to Jase Bhanjyang on day two is arguably considered the toughest of the race. It is a brute of epic proportions, and leaves every runner questioning the journey ahead and the possibility of completion. Deviating from Hillary and Tenzing's route, the ETR does

BELOW: Two-time champion and course record-holder, Anna Comet.
RIGHT: Locals make the race a unique experience.

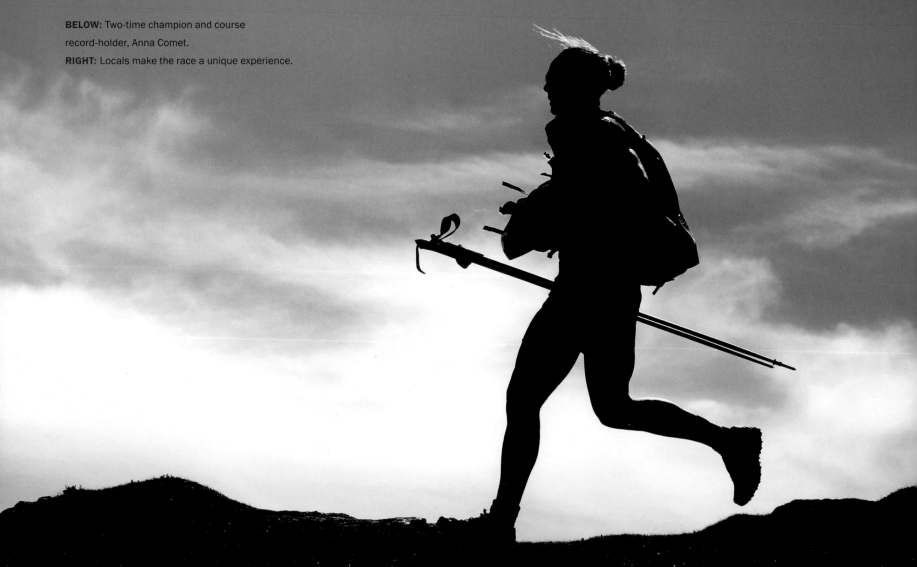

Fact File Everest Trail Race

DISTANCE: 160km

TERRAIN: Trail

TOTAL HEIGHT GAIN: 10,400m

FASTEST TIME: David Ruiz Gomez 20:11:17 and Fernanda Maciel 26:00:29

HIGHEST POINT ON ROUTE: 6,600m

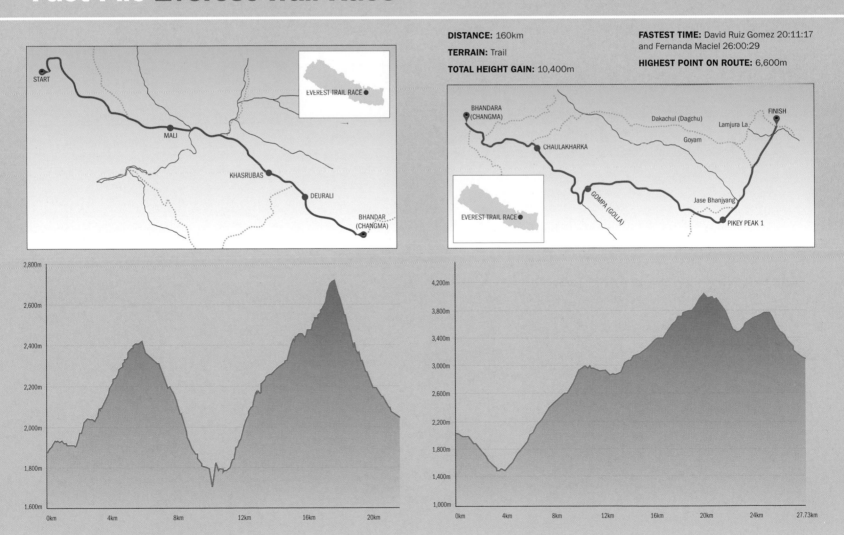

* Left-hand map and profile refer to stage one; right-hand map and profile refer to stage two.

not circumnavigate Pikey Peak at just over 4,000 metres, but goes over it. As one runner said, 'It would certainly appear that day one really had been just an *hors d'oeuvre* and the race would miss the *entrée* and go straight into the main course, ready or not!'

Like any good meal, you can sometimes be a little overwhelmed by the plate in front of you. Pikey Peak is just such an indulgence. It is a climbing journey that makes a vertical kilometre look like a small hill-rep. Front runners can anticipate 2-plus hours of relentless climbing, while the remainder of the field can spend 4, 5, 6 hours and maybe longer negotiating the steep slopes of these Himalayan foothills. From the summit, each step of pain is rewarded with a wonderful vista of the Himalayan range. In the distance are Everest, Lhotse and Ama Dablam, dwarfing this 4,000-metre peak with their 7,000-metre splendour.

Kharikhola, a monastery perched atop a mountain, provides an incredible end to day three. Ultra runners have often discussed and tried to explain out-of-body experiences while running. It's not something one can pinpoint – like a mirage they come and go, leaving one to question one's sanity. Kharikhola may well provide such stimulus. 'Is that real?' one may ask, as the final steps arrive and the day's finish banner awaits, along with some profound realizations. As Dan Thompson writes so beautifully in *Following Whispers: Walking on the Rooftop of the World in Nepal's Himalayas*, 'Travel is the discovery of truth; an affirmation of the promise that humankind is far more beautiful than it is flawed. With each trip comes a new optimism that where there is despair and hardship, there are ideas and people just waiting to be energized, to be empowered, to make a difference for good.'

The trail changes and suddenly more trekkers, more porters, more mules and yaks populate the route to Lukla and beyond. Dropping down and climbing up, the trail switches and twists and as you turn a bend at Kari La, the mountains hit you through the mist. They are no longer distant peaks but massive, snow-covered monsters that make you realize how completely insignificant you are.

Lukla is the gateway to Everest base camp and the mountains in this region. A small airport provides access to the trails and mountains from Kathmandu. Like Namche Bazaar further down the trail, Lukla is an important hub for supplies. The camp for day four is located through the town, nestled in a valley. Runners are now in the heart of the tourist trek to the high mountains.

Tengboche, the finish line of day five, offers a panorama that brings a tear to the eye. Everest, Lhotse and Ama Dablam feel in touching distance and the finish line frames them beautifully, like a classic painting. Relief, a whirlwind of emotions and an outpouring of tears

RIGHT: Jose Delgado, from Spain, runs from Tengboche back to Lukla on the last day of the race.

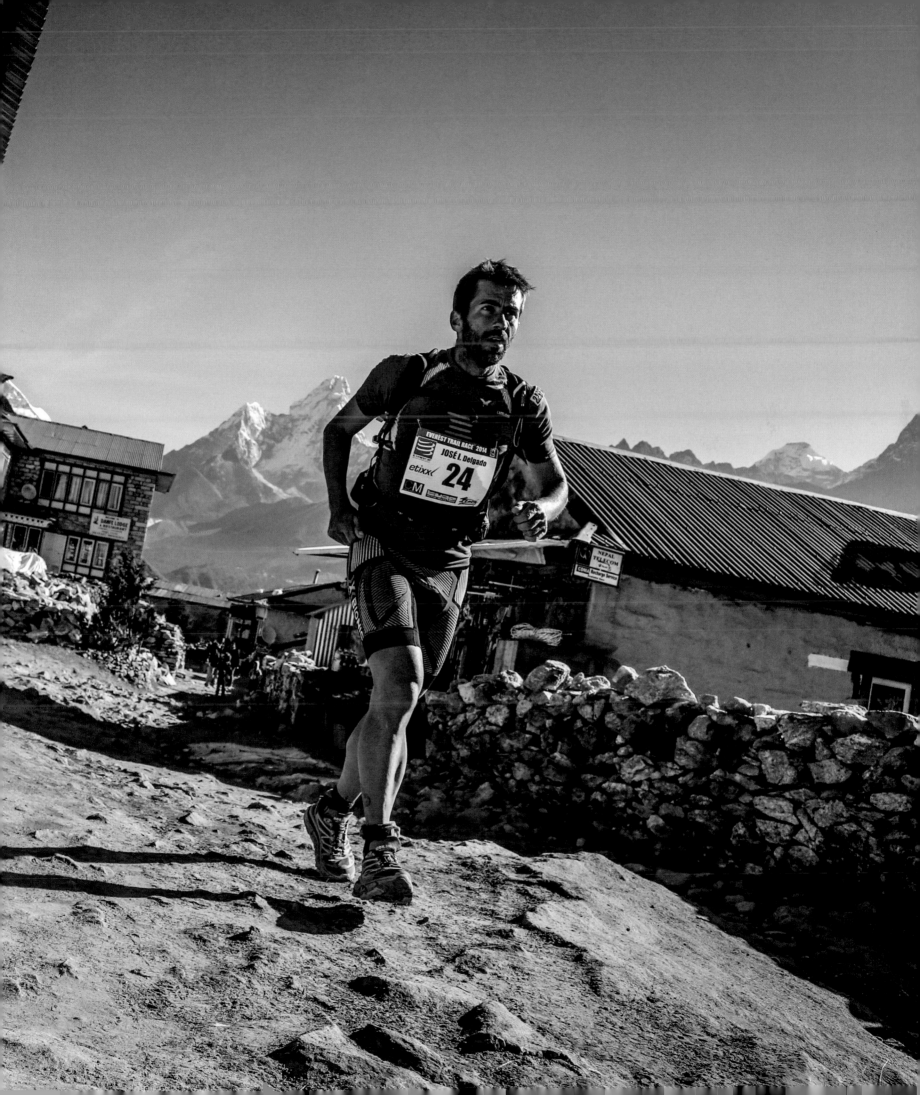

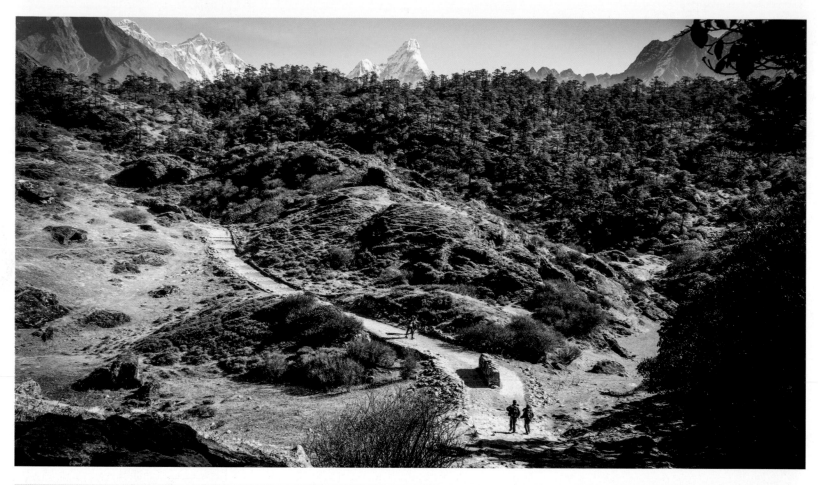

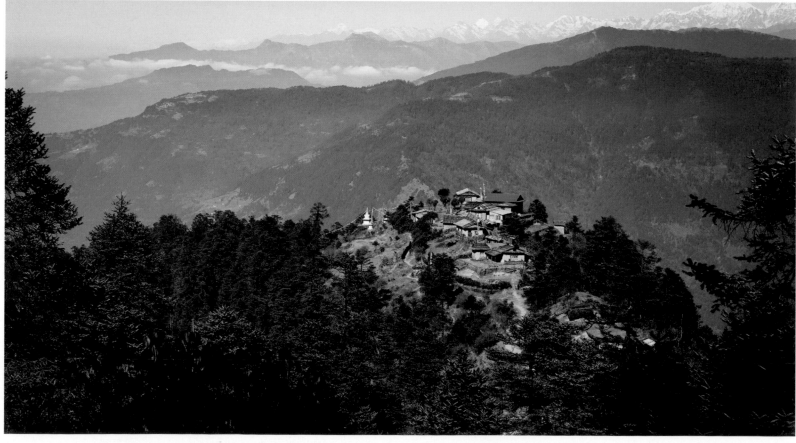

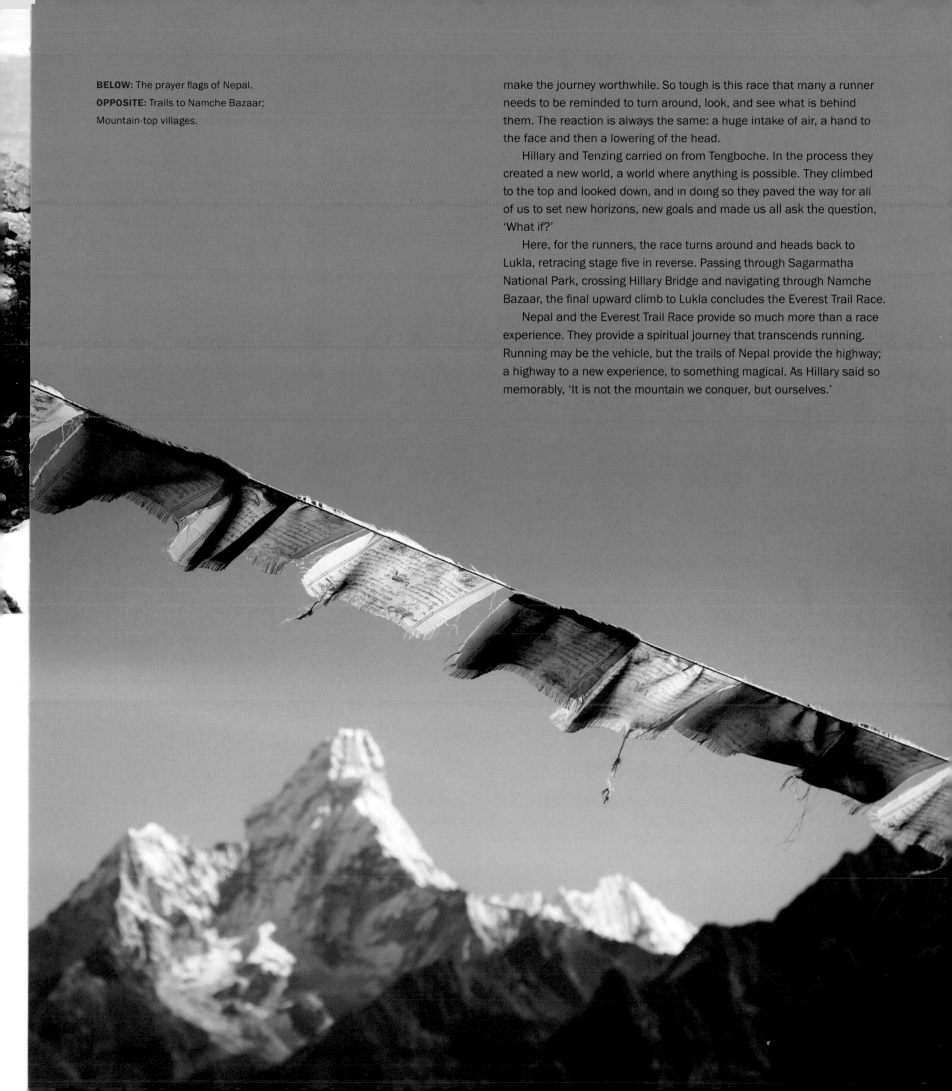

BELOW: The prayer flags of Nepal.
OPPOSITE: Trails to Namche Bazaar;
Mountain-top villages.

make the journey worthwhile. So tough is this race that many a runner needs to be reminded to turn around, look, and see what is behind them. The reaction is always the same: a huge intake of air, a hand to the face and then a lowering of the head.

Hillary and Tenzing carried on from Tengboche. In the process they created a new world, a world where anything is possible. They climbed to the top and looked down, and in doing so they paved the way for all of us to set new horizons, new goals and made us all ask the question, 'What if?'

Here, for the runners, the race turns around and heads back to Lukla, retracing stage five in reverse. Passing through Sagarmatha National Park, crossing Hillary Bridge and navigating through Namche Bazaar, the final upward climb to Lukla concludes the Everest Trail Race.

Nepal and the Everest Trail Race provide so much more than a race experience. They provide a spiritual journey that transcends running. Running may be the vehicle, but the trails of Nepal provide the highway; a highway to a new experience, to something magical. As Hillary said so memorably, 'It is not the mountain we conquer, but ourselves.'

Run the Rut
50km USA

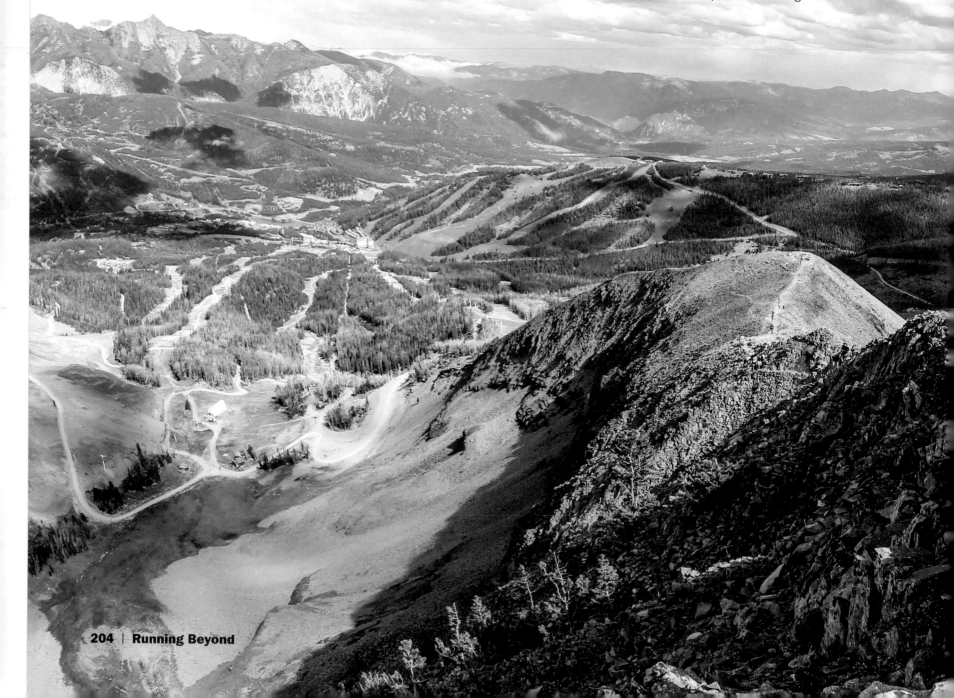

Big Sky, Montana, hosts the Run the Rut weekend of racing – three days, three races and three incredible experiences. Big Sky, a ski resort, is located between the wonderful town of Bozeman and the iconic Yellowstone Park. If ever a race existed that you should combine with a holiday experience, this is it.

Bozeman is a pristine town that in some ways portrays the American dream, with row upon row of neat stores that are colour-co-ordinated and stylistically harmonious to ensure visual serenity. In many ways this

is contradicted by the brash size of the vehicles that cruise the streets; huge monsters of chrome and colour. The airport is located less than 20 minutes out of town, making it a great place to start a journey in Montana.

Big Sky sits between Bozeman and Yellowstone Park and the isolated Lone Peak mountain provides a stunning backdrop for the Run the Rut races of VK (vertical kilometre), Sky and Ultra. The advantages of using a ski resort as a race hub are clear to see. Facilities such as restaurants, hotels and shops are on tap, and the racing has a custom-

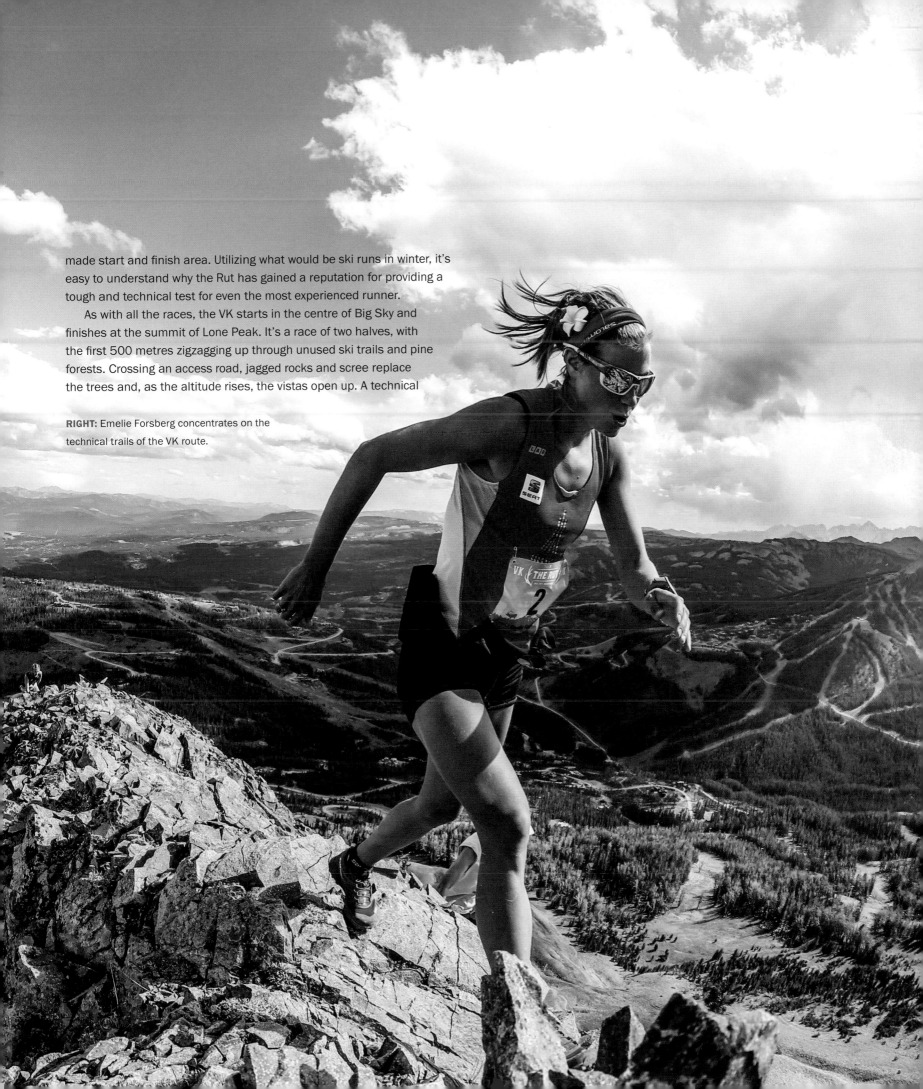

made start and finish area. Utilizing what would be ski runs in winter, it's easy to understand why the Rut has gained a reputation for providing a tough and technical test for even the most experienced runner.

As with all the races, the VK starts in the centre of Big Sky and finishes at the summit of Lone Peak. It's a race of two halves, with the first 500 metres zigzagging up through unused ski trails and pine forests. Crossing an access road, jagged rocks and scree replace the trees and, as the altitude rises, the vistas open up. A technical

RIGHT: Emelie Forsberg concentrates on the technical trails of the VK route.

'❝ **THE RESPONSIBILITY FALLS ON THE RACE PARTICIPANT** to be aware of your surroundings and other runners. This is a true mountain course, so please treat it with the respect it deserves.'

Mike Foote, Race Director

BELOW: Climbing to Lone Peak.

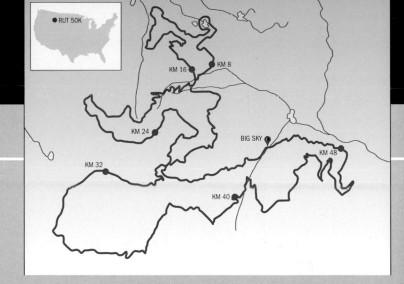

Fact File Run the Rut

DISTANCE: 50km

TERRAIN: Trail/road

TOTAL HEIGHT GAIN: 3,200m

FASTEST TIME: Kilian Jornet 05:09:31 and Emelie Forsberg 06:25:44

HIGHEST POINT ON ROUTE: 3,403m

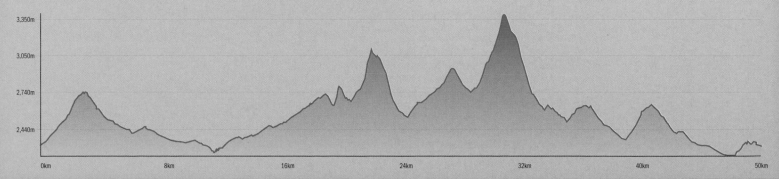

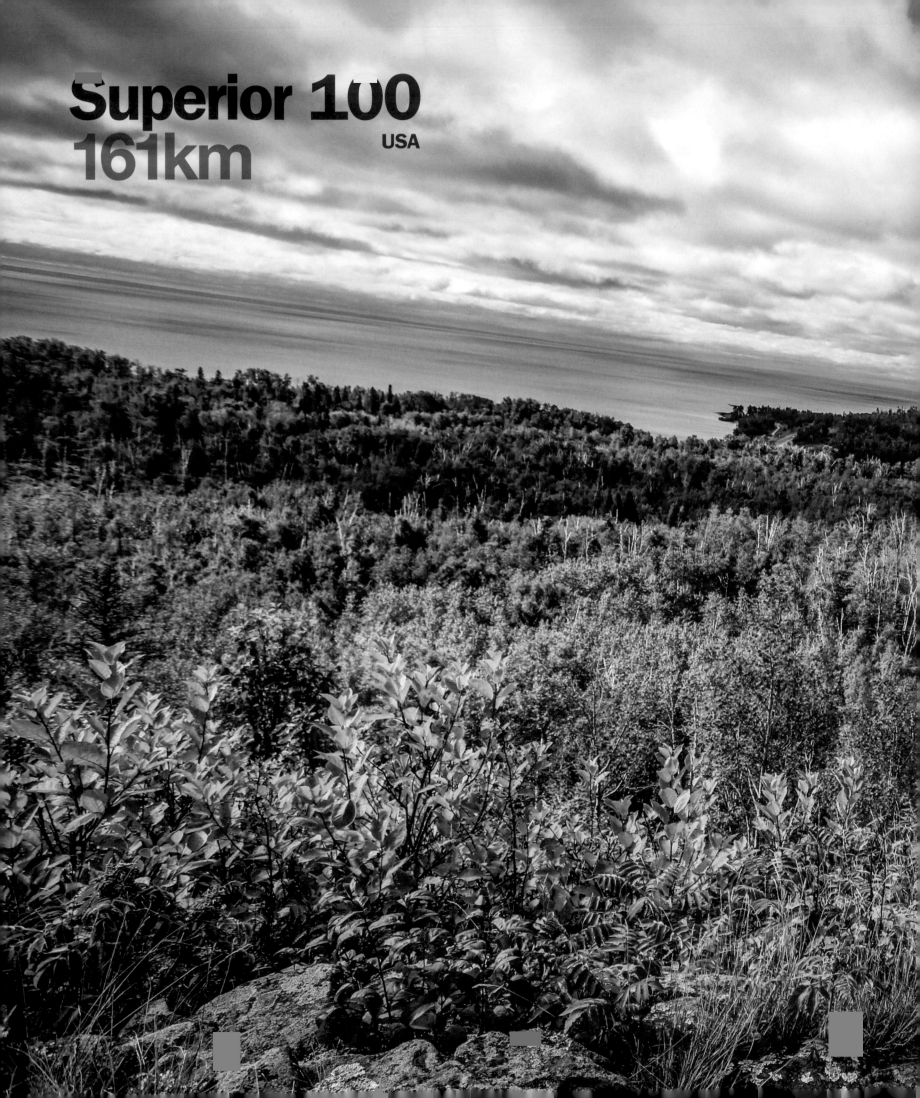

Superior 100
161km
USA

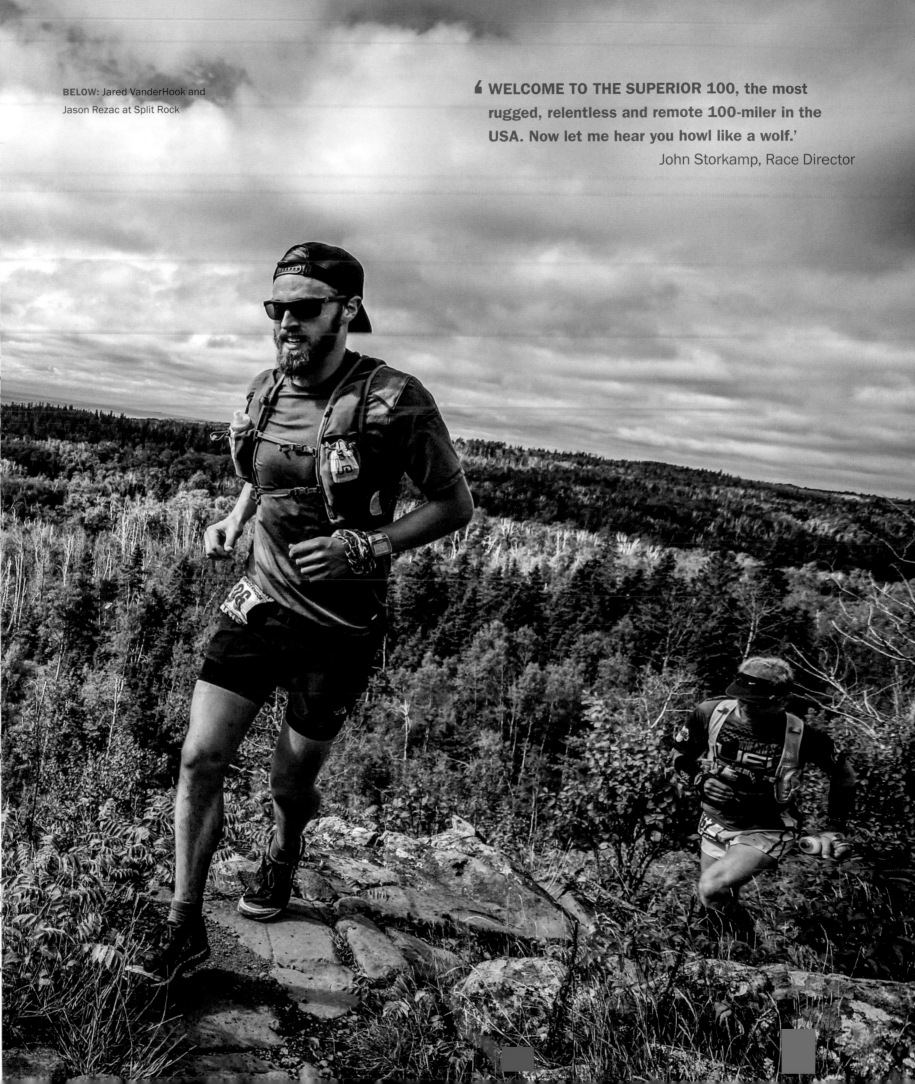

is one such human being who il
Running with a smile, whenever
and aid stations he repeats, 'Th
supporting.' You've got to love th
the fatigue, despite sore legs an
never slips, his positivity never v

Brutal and relentless, Super
terrain, variable weather and, ot
are not things that should be ta
twice before, in 2011 and 2010
win at Superior; would 2014 be
iconic Western States earlier in
On the trails of the Superior Hik
and eventually made his move v
Buckle in hand, the victory was

'It was a tough day and nigh
afterwards. 'I just had to keep b
then when the time came, I kne
not to look back. I was running s
together. I am really happy with
second. Of course, the support
team make it very special.'

Another evocative viewpoint
exhale; the warmth of my breath
headlamp as I climb up Carlton F
like bouldering on legs that have
hours. I dig my trekking poles in,
night sky, trying to take some of
over the last few hours my left le
of stretching will loosen it, but qu

Only one man and one lady
Superior 100 provides many an
a collective gathering of many ir
create one wonderful whole. Ea
warrior who achieves greatness
Storkamp told them all that the
did; it does. As competitor Roby
the world simply by putting on a
creating an envelope for greatn

RIGHT, TOP TO BOTTOM: Bob Geren
Cameron just before Crosby Manitou
Leslie Semler at Carlton Peak; April A
Split Rock.
OPPOSITE: Dylan Armajani above Be
NEXT PAGE: Jameson Nass at Carlto

BELOW: Jared VanderHook and
Jason Rezac at Split Rock

❝ WELCOME TO THE SUPERIOR 100, the most
rugged, relentless and remote 100-miler in the
USA. Now let me hear you howl like a wolf.'
John Storkamp, Race Director

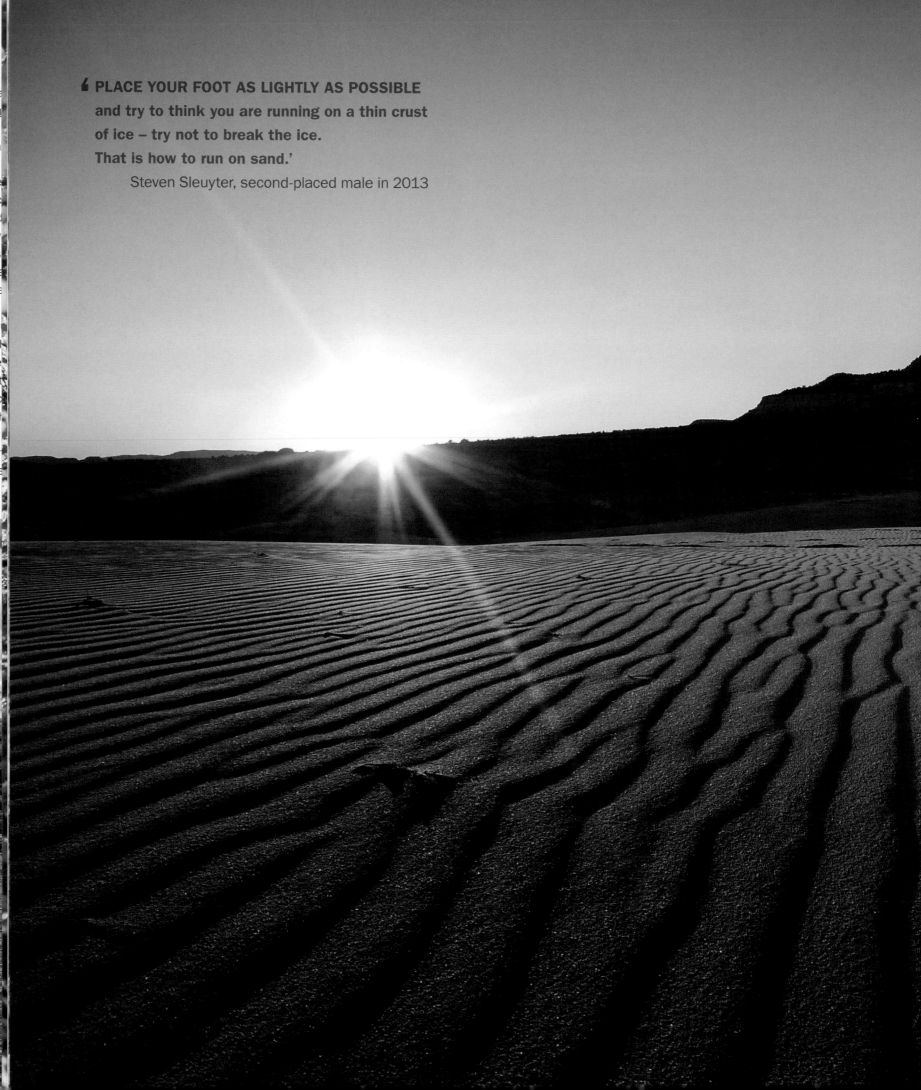

Two black, spiral earrings, a
huge artistic print and carg[...]
rock star. He greets you with a [...]
to have you here, man.' Storka[...]
100, and as a runner himself, [...]
Modest in his approach, he we[...]
arrive for packet pickup (collec[...]
Superior 100, the most rugged[...]
USA. Now let me hear you how[...]

The response is loud and s[...]
runners' initiation with an impa[...]
161 kilometres along the Supe[...]
the ridgeline overlooking Lake [...]
Mountains. It's gnarly, tough, r[...]

Storkamp has a twinkle in [...]
Cheri provide is tough, and the[...]
to achieve and, as he says, no[...]
be on the journey with a chanc[...]
the finish or not, lives will be c[...]
the task and the responsibility [...]
children; if possible he will nur[...]

Running brings people toge[...]
boundaries, crosses countries [...]

❛ PLACE YOUR FOOT AS LIGHTLY AS POSSIBLE
and try to think you are running on a thin crust
of ice – try not to break the ice.
That is how to run on sand.'
Steven Sleuyter, second-placed male in 2013

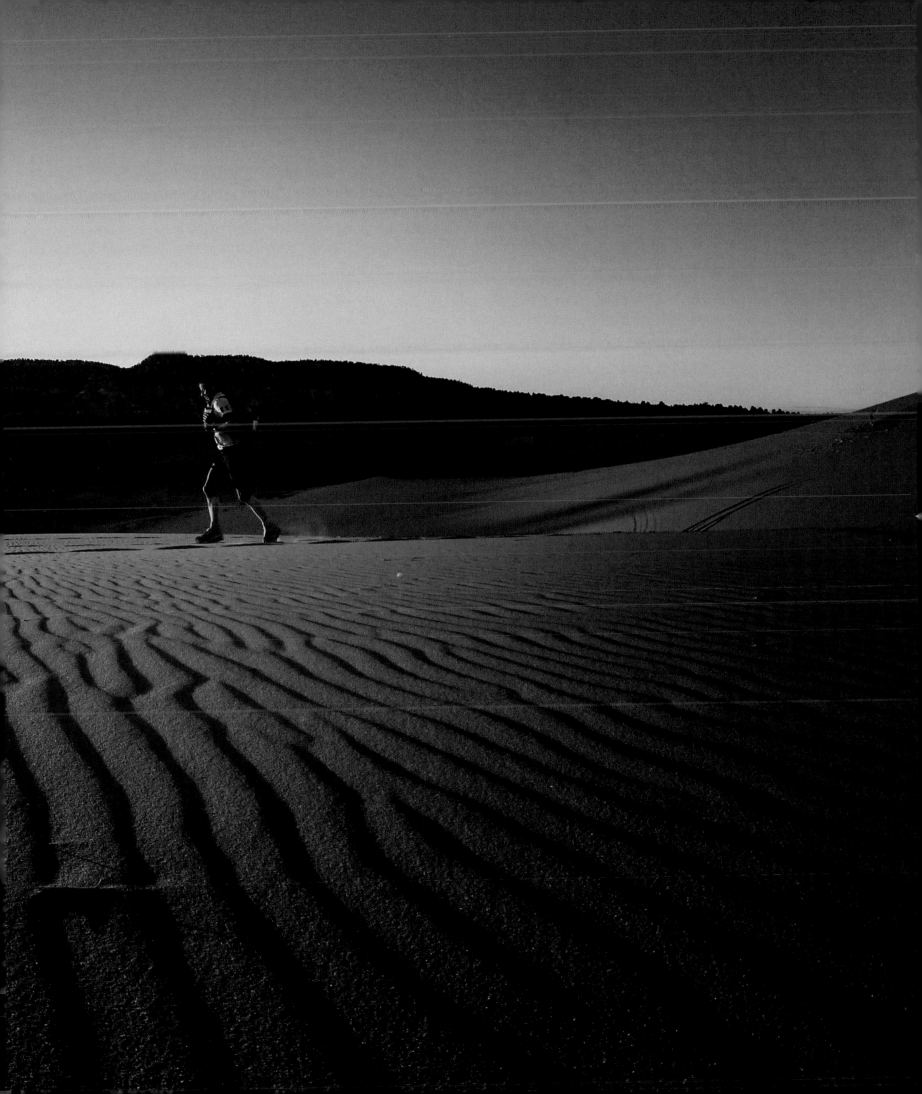

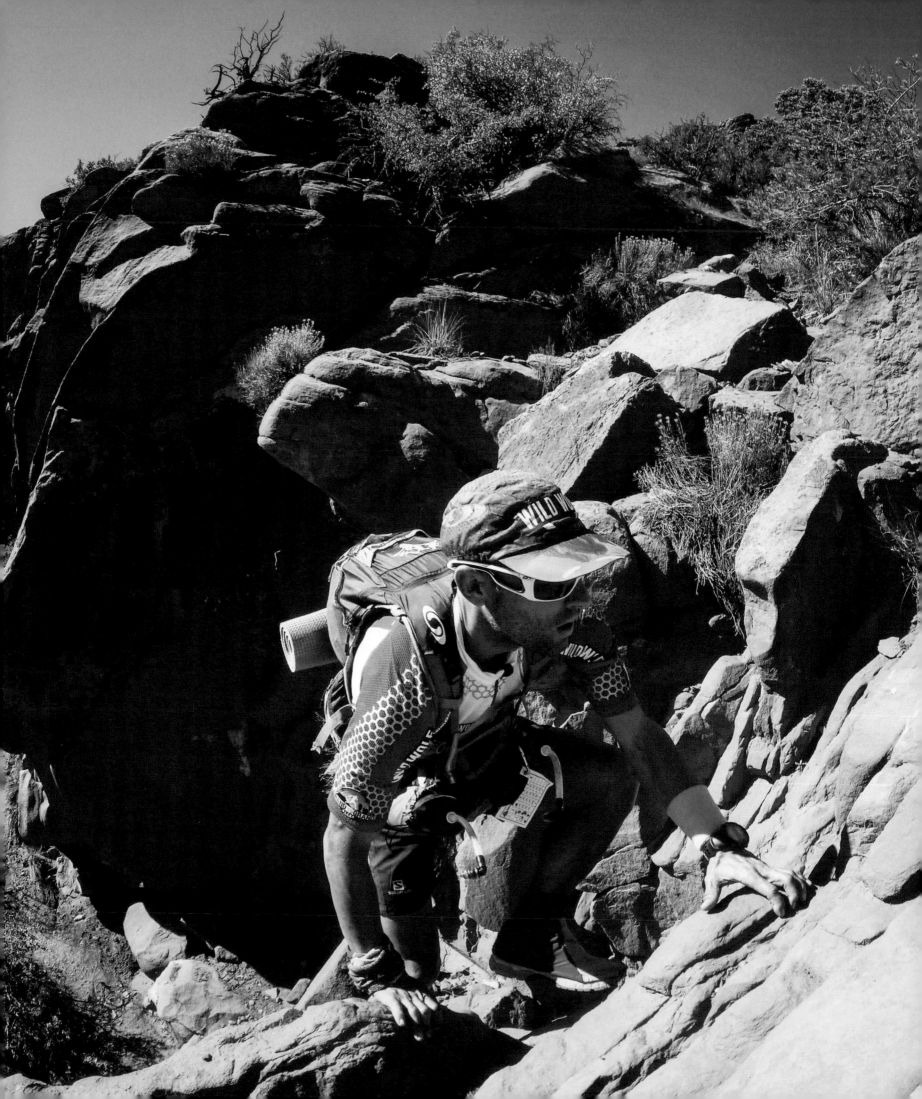

Daily distances are a little longer than many other multi-day races. Day one starts the pattern at just over 48 kilometres of dry dirt trails, brush and cacti. Running through juniper trees in the Kaibab National Forest and with some elevation gain, day two is a little kinder at just over the marathon distance. However, the weather here can be scorching, adding to the complexity of the event. This, plus the inclusion of the first soft sand as the day draws to a close, gives the runners a taster of what is to come.

Coming early in the race, day three is the long stage and at close to 81 kilometres, it's a tough outing even for the most prepared athlete. Going straight up the Mansard, rocks, sand, fields of cacti and bushes are negotiated before the stunning Rose Pink Dunes are covered. From here, the end is in sight. The long day provides speedier runners a full day of rest, but for many, day three continues from one day to the next, reducing recovery time.

The fourth day offers stunning views of the Zion National Park and covers just 1.6 kilometres less than the classic marathon distance. It's a day of good running but as the stage comes to a close, hard ground once again transitions to soft and a rock tunnel provides an epic trail to a final climb up and out of the canyon.

LEFT: Vicente Juan Garcia Beneito climbing the red rocks of Utah, on his way to victory in 2013.

Extraordinary red-rock slot canyons provide the highlights for day five. Arguably, it is what many runners have come to the Grand to Grand to experience. They personify Utah and the region. Like day four, the race distance is just under a marathon, but a little more elevation gain adds to the fatigue that the runners have already endured. Day six is a fun run – the race is over and, with just 13 kilometres to cover, it is a day of celebration. Climbing 837 metres on mainly single-track trail, the finish line is on the summit of the Pink Cliffs of the Grand Staircase-Escalante, and the higher elevation offers participants a wonderful retrospective look over the terrain covered in the previous days. It is an astonishing panoramic landscape, framed by rock formations that date back two billion years.

The camaraderie, adventure and friendship that stage racing naturally creates are reflected at the Grand to Grand. Continuous days of hardship and difficult challenges that push individuals to the limits inevitably create a bond. As Salvador Calvo Redondo, winner of the inaugural edition of the race in 2012, describes, 'We learn that what really gives quality of life is not the things that are fixed, such as results, numbers or rankings, but rather what is intangible – when all your thoughts break their bonds, your mind exceeds its limits, your consciousness expands in every direction and you see a wonderful new world.'

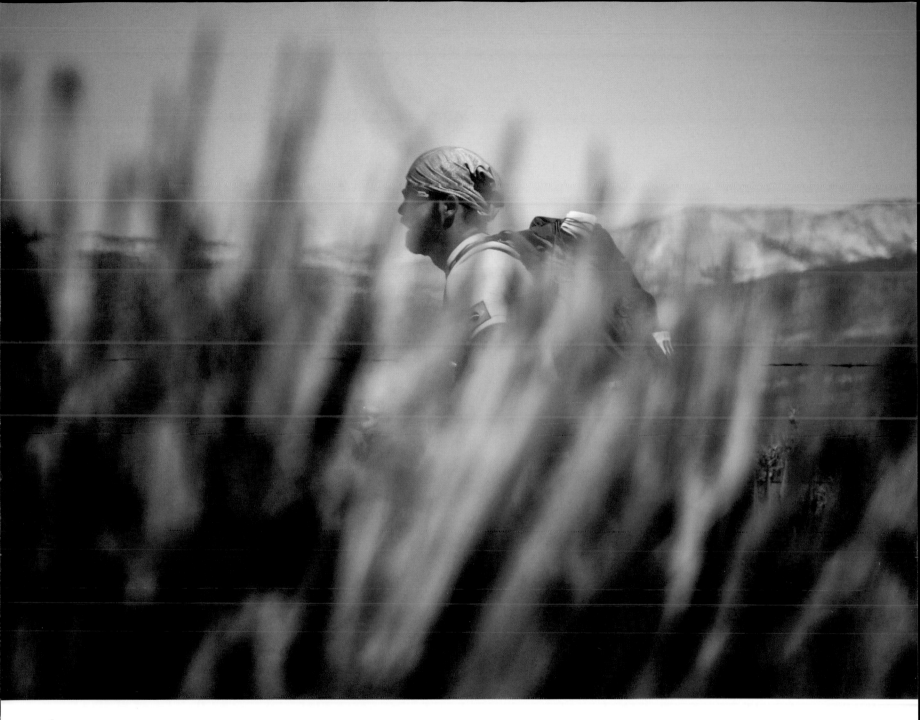

' WE LEARN THAT WHAT REALLY GIVES QUALITY OF LIFE IS NOT THE THINGS THAT ARE FIXED, such as results, numbers or rankings, but rather what is intangible – when all your thoughts break their bonds, your mind exceeds its limits, your consciousness expands in every direction and you see a wonderful new world.'

Salvador Calvo Redondo, winner of the inaugural edition of the race in 2012

ABOVE: Lush green vegetation camouflages a runner.
OPPOSITE: Cowboys provide the catering for the staff and support crew.
NEXT PAGE: The flat expanse that lines each side of the Grand Canyon.

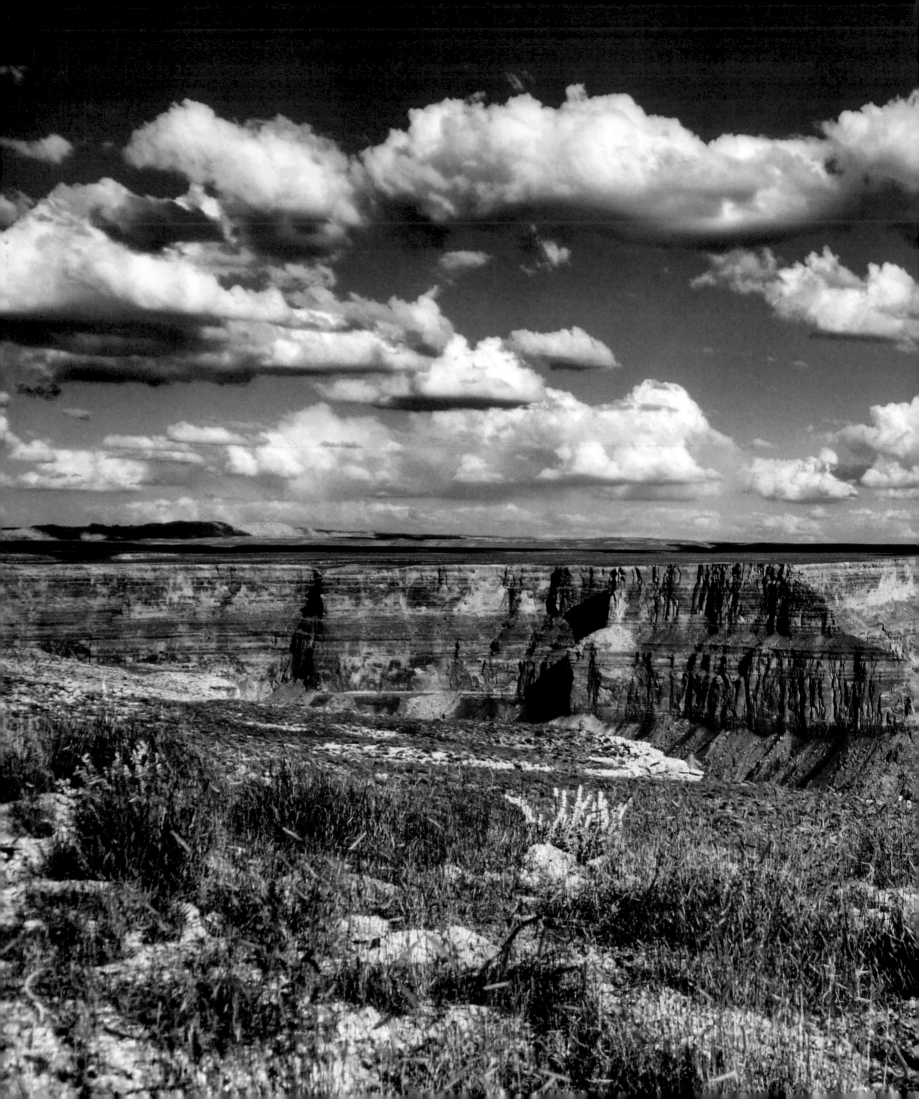

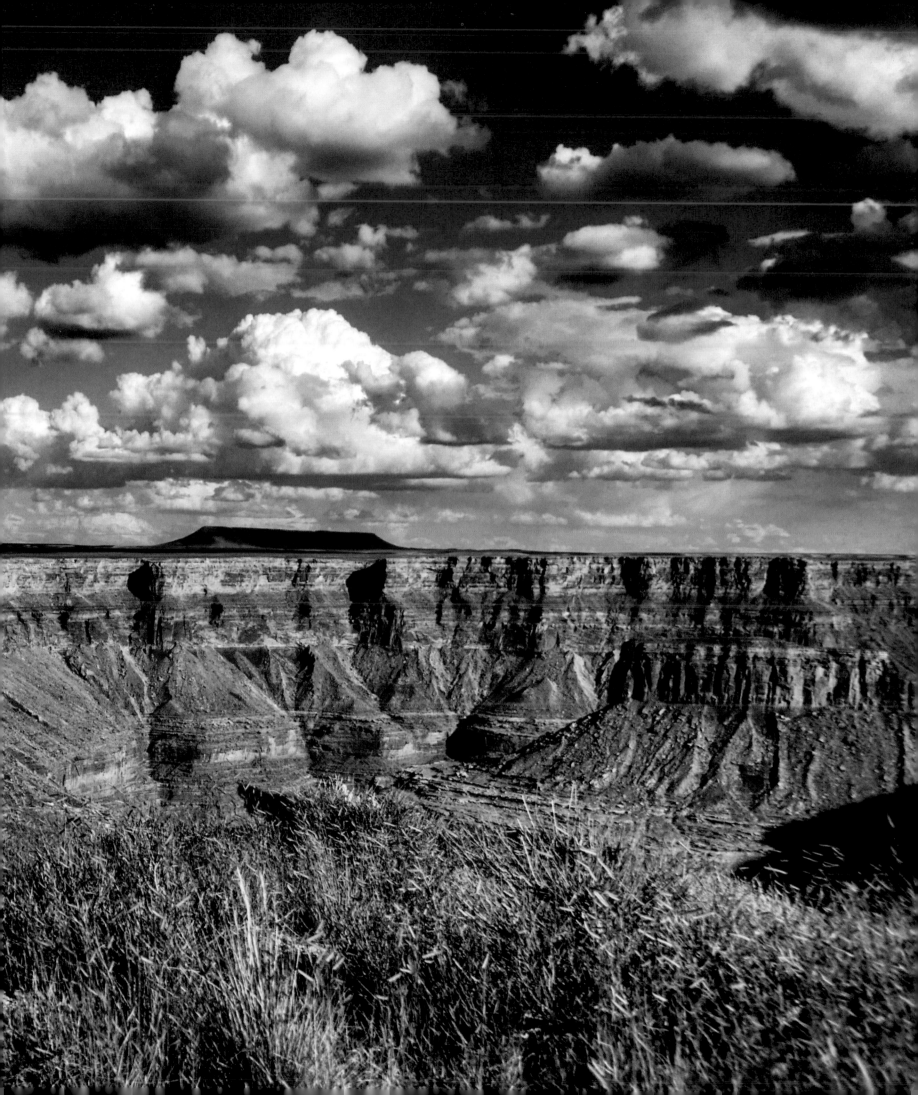

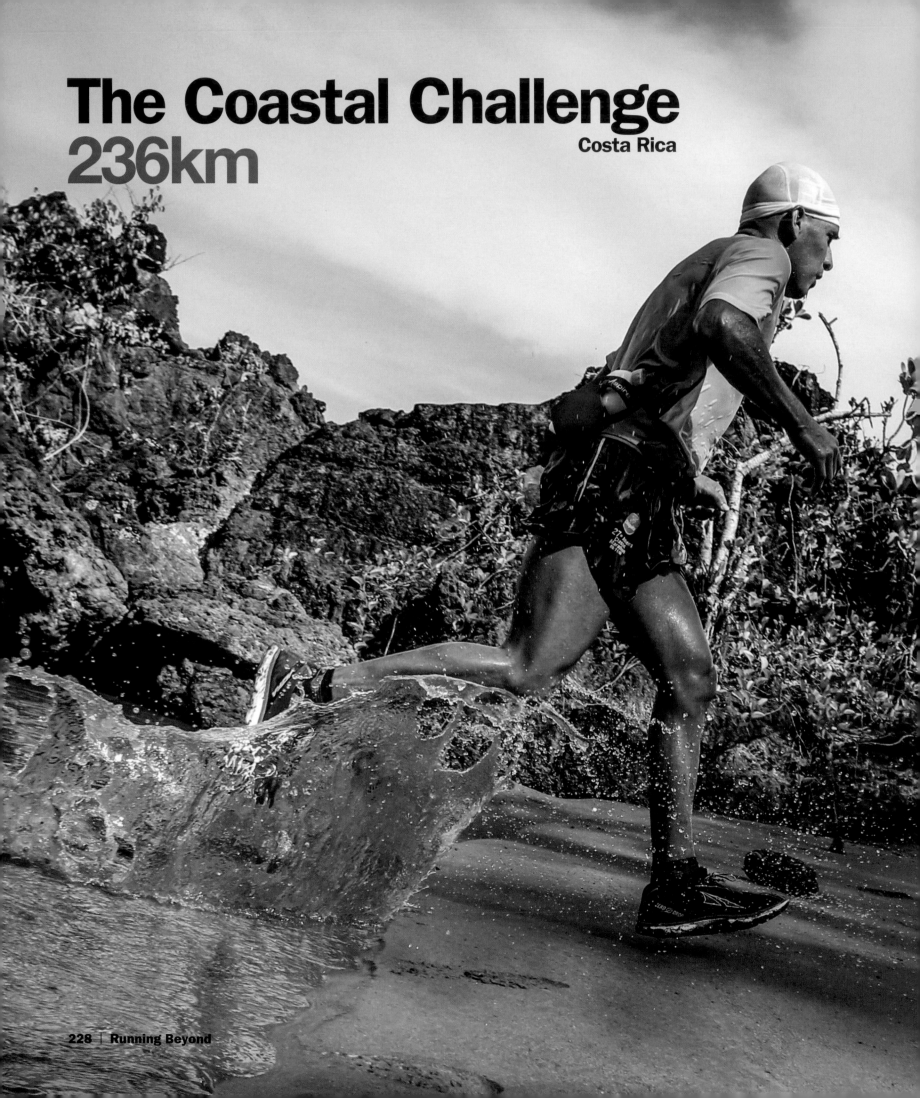

The Coastal Challenge
236km
Costa Rica

Known locally as the 'Rainforest Run', The Coastal Challenge (TCC) is a multi-day race run every year along Costa Rica's lush and tropical Pacific coastline. Weaving in and out of the Talamancas – a coastal mountain range spread across the southwest corner of the country – the race covers a demanding 236 kilometres over six days. Part jungle, trail and alpine race, the TCC is an assault course of topography.

Up mountain paths, through rainforest, down dirt tracks and following trails over ridges, highlands and coastal ranges, The Coastal Challenge is bursting with terrain variety. The course takes runners along gorgeous sandy beaches and past reefs, wades through tantalizingly clear river estuaries and pushes the legs up and over barren rocky outcrops, leading the racers to the UNESCO World Heritage Corcovado National Park at Drakes Bay. Here participants are rewarded with an experience within what is considered one of the world's premier rainforests.

Immersed in brilliant bright greens and rich browns, the race passes a cascading waterfall and demands agility to hop rocks across a ravine to follow a trail through wide-open country fields down to the pristine, champagne-coloured sandy beach beyond. The rhythm of your breath, which usually fills the ears while running, is eclipsed by the chorus of thousands of insects and birds – the vibrant buzz of life.

Started in 2004 by Costa Rican adventure racer Rodrigo Carazo and Tim Holmstrom, the TCC may be similar in format to the Marathon des Sables in that the race is multi-stage, point to point over six days, but unlike the MDS, the TCC is supported – runners are not required to carry anything other than water and food for the daily runs. Running light and fast, gear may be kept to a minimum – hand bottles or small bladder packs for hydration only. Delicious food is provided at the finish camp as well as at checkpoints or feed stations along the route. Base

THIS PAGE: Costa Rica's Roiny Villegas crossing one of the many beaches at Drake Bay.

Fact File The Coastal Challenge

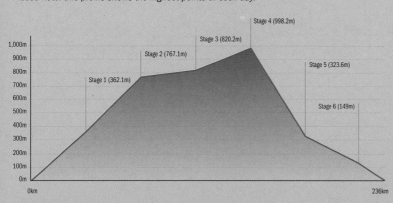

DISTANCE: 236km

TERRAIN: Trail

TOTAL HEIGHT GAIN: 10,540m

FASTEST TIME: Iain Don-Wauchope 24:25:11 and Ester Alves 33:04:32

HIGHEST POINT ON ROUTE: 973m (approx)

Please note: this profile shows the highest points of each day.

Stage 1 (362.1m)
Stage 2 (767.1m)
Stage 3 (820.2m)
Stage 4 (998.2m)
Stage 5 (323.6m)
Stage 6 (149m)

1,000m
900m
800m
700m
600m
500m
400m
300m
200m
100m
0m

0km — 236km

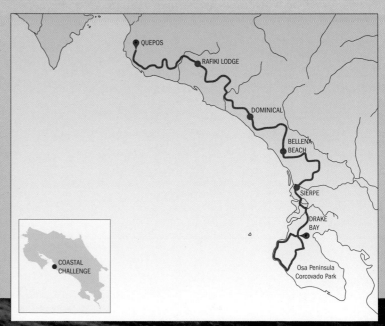

QUEPOS
RAFIKI LODGE
DOMINICAL
BELLENA BEACH
SIERPE
DRAKE BAY
Osa Peninsula Corcovado Park

COASTAL CHALLENGE

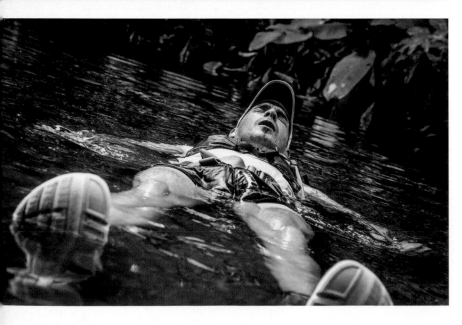

camp is set up by the race team, to which the runners' luggage and a tent are transported.

The Costa Rican coastline can be as hot as the Sahara, and its sultry, 35-degree heat comes with punishing humidity. Starting in Quepos, the course boasts a total elevation gain of more than 10,540 metres. The race finish, near the border of Panama, is in a small and serene fishing village that until recently was only accessible by boat.

Open to individuals and teams of individuals (amateur or professional runners), the TCC offers a choice of races: Expedition or Adventure. The Expedition category is a true test for the more experienced runner, whereas the Adventure category offers reduced distances through the diverse and challenging landscape of one of the most magical and inaccessible places in the world.

Iain Don-Wauchope from South Africa won the 2015 edition of the race, and in the process set a new course record. 'This is no easy course,' he said. 'It's a really tough event and I didn't feel great on days one and two, but I have got better as the days progressed. I have loved every moment. It's a stunning race and the last day around Drake Bay is just so special.'

Ultimately, every person who races has a unique story that they hold within themselves for ever. To cross the line on the final day takes commitment, dedication, tenacity and a little luck. Mike Murphy from Canada participated in the 2015 edition of the race, arriving with steely determination and commitment to perform. From day one he pushed hard, racing at the front and dictating the pace. One day he would lead and the next he would fall back after the previous day's efforts. On the penultimate day, it all became too much; dehydration had taken its toll and, unbeknown to the race organizers, Murphy was nursing a broken elbow from a fall. His race came to an abrupt end.

'It's easy to go through life giving 80, 90, 95 per cent,' he says. 'It's safe, it's predictable, and it's easy to maintain the self-image that we want. At those outputs, in racing and in life, it's possible to control both how we see ourselves and how we project ourselves to others; we sort of

LEFT, TOP TO BOTTOM: Mike Murphy from Canada, legs torn apart by the harsh and tough rainforest; At the end of the day, it's all about relaxing, recovering and drying out your equipment; Runners are recommended to cool off whenever they can. Here, Roiny Villegas seizes an opportunity.
OPPOSITE: New Zealand's Anna Frost.

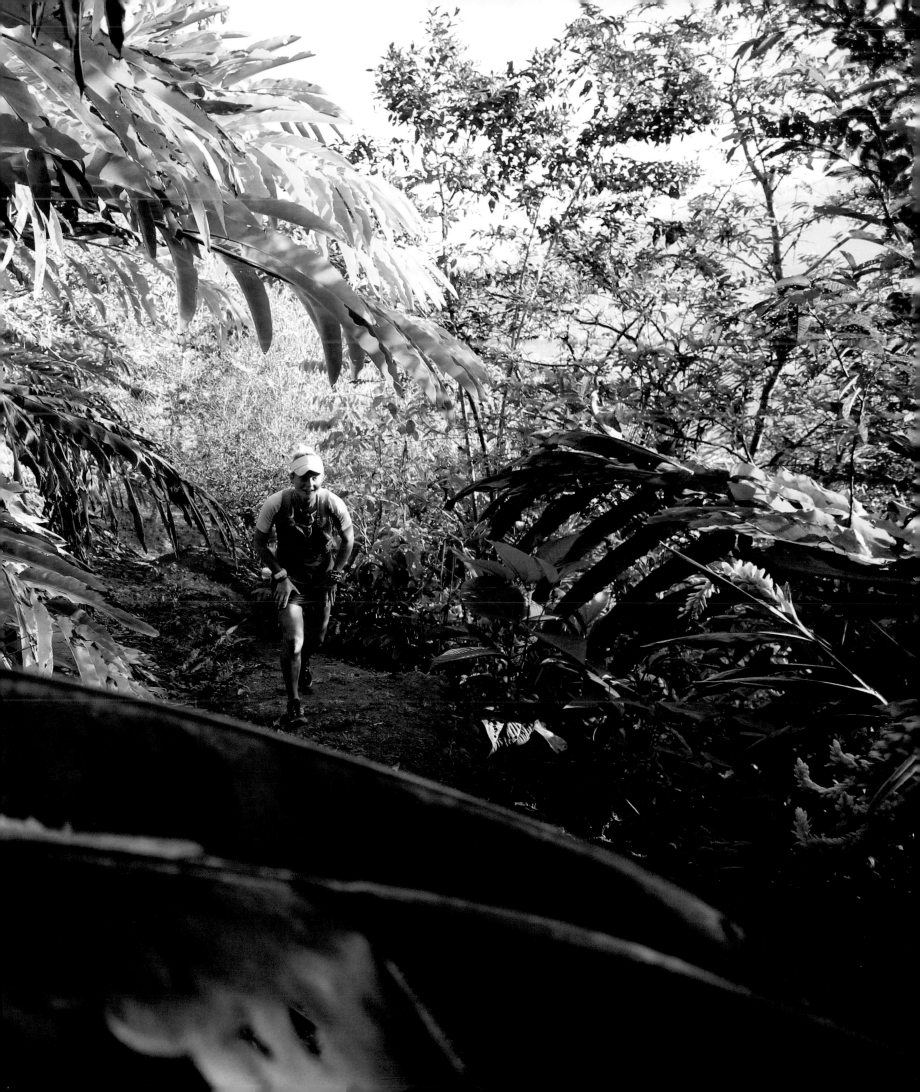

hide the bad spots. But things change when you absolutely lay it all out there, especially in a race. When you fully commit, and give everything that you have. Then you strip yourself right down to the truth. It's sometimes unpleasant and brutal, but it's also cleansing and addictive. I always want to get back to that spot to see if I am any better or stronger than the last time. It's tough to get there, though; you can't always find 100 per cent, but when you make it there, it's always worth it.'

The excitement and – often – fear of stage races is that anything can happen, and the TCC always provides more than its fair share of excitement. But as a battle rages on for victory at the front, behind, the story is often one of survival, perseverance and enjoyment in equal measure.

Irrespective of pace or effort, the Costa Rican coastline never stops providing inspiration. It's important to look at TCC as so much more than a race – it's a journey, a running holiday and a voyage of discovery. Friendships made in the rainforests, on the beaches and in the camps are ones to last a lifetime.

'Today was truly Costa Rican,' said competitor Anna Frost after a day's running. 'Jungle, trail, beaches and wonderful people. Oh, and darn hot!'

The Coastal Challenge concludes on the beach – where else? Beers flow and as the sun disappears, another stunning race comes to an end. Everyone knows that all those who achieved the finish line became a winner. The TCC is more than a race; it's a journey. A journey to the edge for many – but as we all know, if it were easy it wouldn't be interesting or challenging. Departing the bay in speedboats, it is easy to see the inspiration on each runner's face as the chatter turns from, 'Thank goodness that's over!' to 'What's next?' or 'I can't wait to come back.'

RIGHT: Two-time champion and course record holder, Iain Don-Wauchope from South Africa.

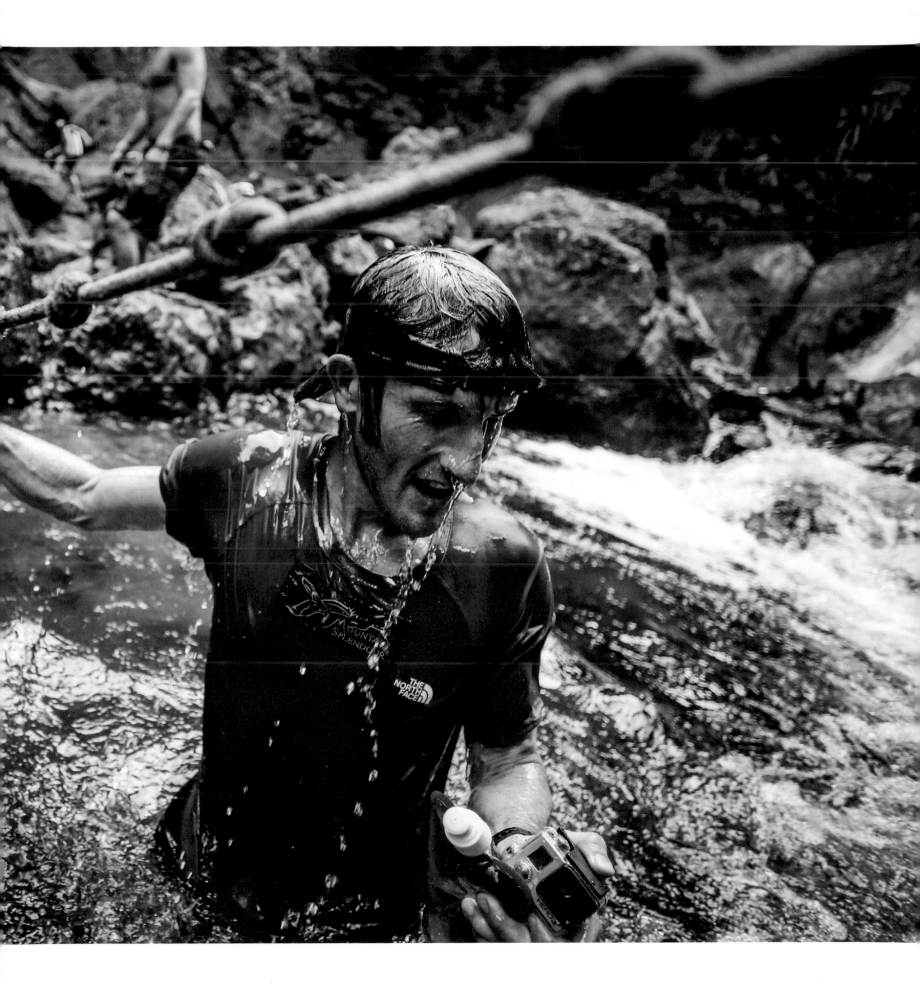

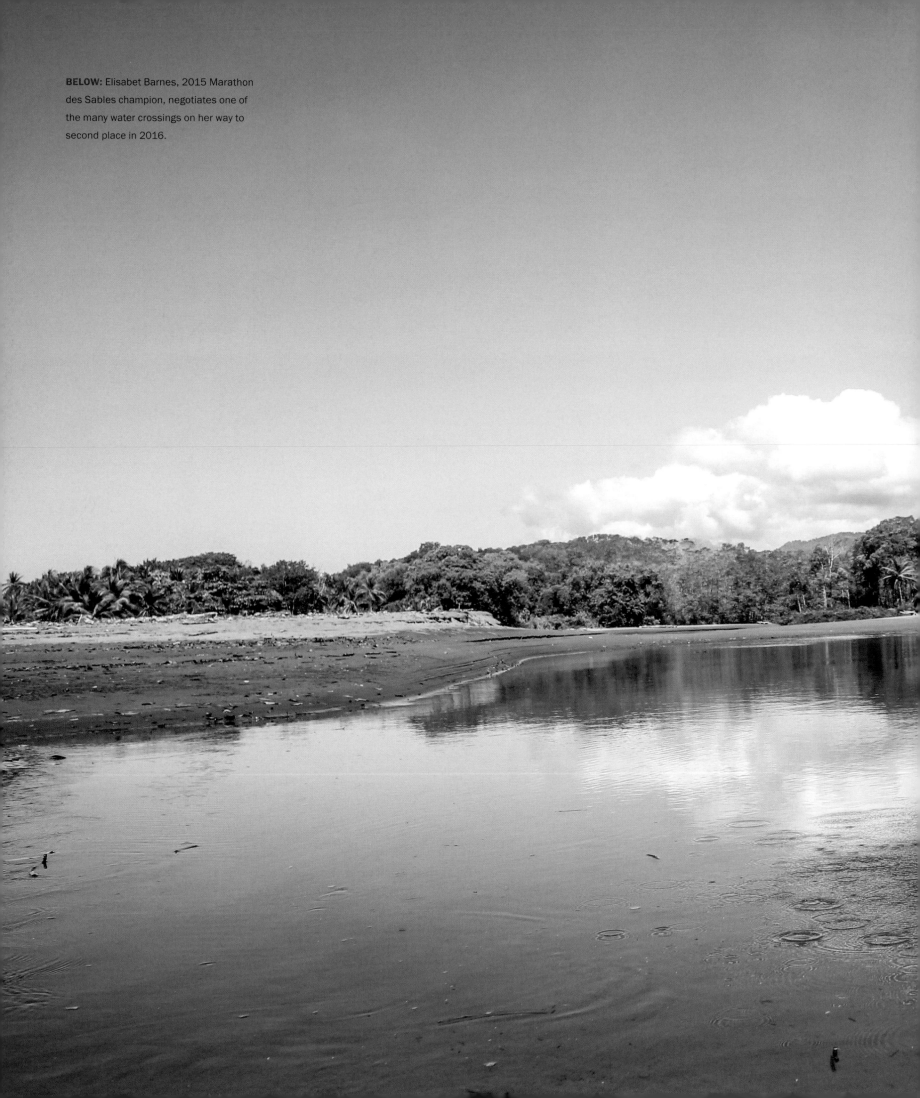

BELOW: Elisabet Barnes, 2015 Marathon des Sables champion, negotiates one of the many water crossings on her way to second place in 2016.

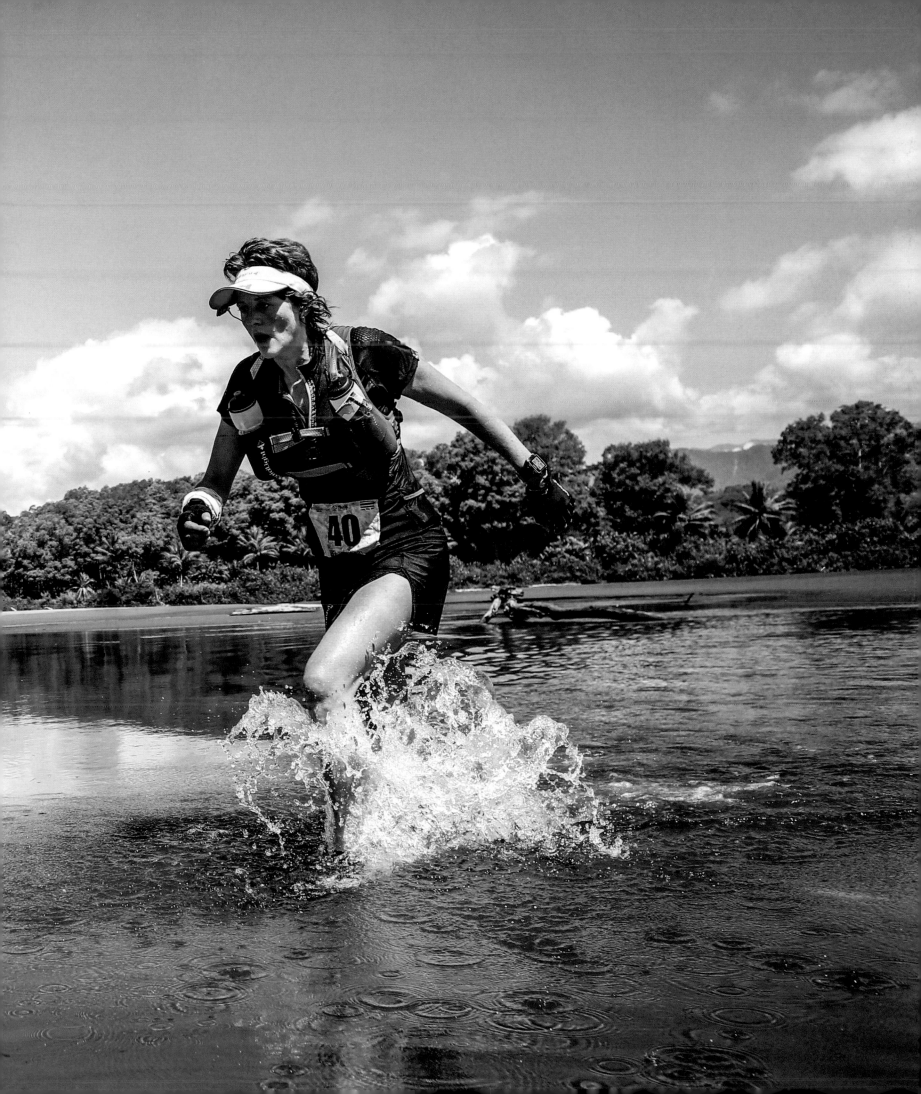

Index

Acuña, Marciano 35
Ahansal, Lahcen 162
Ahansal, Mohamad 162
Ainsleigh, Gordy 216
Albon, Jonathan 118, 120, 121, 142, 148
Allen, Hillary 82
Alves, Ester 38
Andorra 52–9
Antolinos, Fabien 68, 76, 77
Armajani, Dylan 213
Australia 202–3

Barnes, Elisabet 62, 161, 162, 234
Bauer, Patrick 162, 165, 167
Beneito, Vicente Juan Garcia 223
Benoît, Cori 74
Bertrand, Gilles 74
Bertrand, Odile 74
Birkinshaw, Steve 92
bladders 236
Bland, Billy 98
Bob Graham Round 98
Bonnet, Rémi 147, 148, 186, 189, 191
Bosio, Rory 84
Bousseau, Fred 75
Brizio, Emanuela 157
Brunod, Bruno 153
Buffalo Stampede 202–3
Byrne, David 203

Cadí-Moixeró Natural Park 43
Calitz, AJ 48–50
Cameron, John 213
Campbell, Donnie 184
Campbell, Jared 55
Canary Islands
 Haría Extreme 30–5
 Transgrancanaria 24–9
 Transvulcania Ultramarathon 12–21

Canepa, Francesca 69
Carazo, Rodrigo 229
Carmont, Niandi 12
Castillo, Javier 63
Chorier, Julien 52, 55
Clapham, Vic 168
The Coastal Challenge 228–35
Colle, Franco 80, 206, 209
Collison, Kim 112
Columbus, Christopher 24
Cometi, Anna 80, 196, 197
Comrades Marathon 112, 168–9
Consani, Debbie 101
Consani, Marco 101
Cooper, Matt 52–5
Corcovado National Park 229
Costa Rica 228–35
Curien, Yann 77

Dapit, Fulvio 157
De Gasperi, Marco 124, 151
Delgado, Jose 198
Desco, Elisa 50
Dewalle, Christel 143
D'Haene, François 69, 73, 80, 89
DNF 236
Doke, Linda 125
Dolomites Skyrace 140–5
Dolomites VK 140–5
Don-Wauchope, Iain 230, 232
Douglas, Kevin 94
Dragon's Back Race 90–5
Du Plessis, Carien 177

Eacott, James 193
Ehlers, Aaron 212
Elmorabity, Rachid 161
Evans, Mike 93
Everest Trail Race 192–201

Faria, Manuel Diniz 38
Fast and Light 151
Favre, Corinne 157

Festival de l'Endurance 74
Fiennes, Sir Ranulph 165
First World War 168
Folcik, Kristina 214
Following Whispers 198
Foote, Mike 206, 207, 208
Forsberg, Emelie 20, 42, 44, 45, 48, 69, 71, 102, 106, 107, 117, 121, 157, 205, 209
France
 Grande Course des Templiers 74–7
 Ice Trail Tarentaise 66–73
 Ultra-Trail du Mont-Blanc 80, 84–9
Frost, Anna 12, 20, 23, 230, 232
Fuencaliente lighthouse 12, 14

García De Los Salmones, Azaha 49
Gerenz, Bob 213
Germany 138–9
Giacometti, Marino 107, 120, 148, 153, 155, 159
Gilpin, Terry 98
Glen Coe Skyline 102–7
Gonon, François 133
Gonzales, Andy 216
Götsch, Philip 142
Govignon, Virginie 68
GR131 12–21
Graham, Bob 98
Gran Canaria 24–9
Grande Course des Templiers 74–7
Grand to Grand 218–27
Greenwood, Ellie 77, 168, 216, 217
Grinius, Gediminas 24, 25, 28

Hamelinck, Wouter 92
Haría Extreme 30–5
Haugsness, Eirik 118

Haukøy, Malene 120
Hawker, Lizzy 84
Hegge, Jake 214
Heras, Miguel 75, 88
Hernando, Luis Alberto 17, 23, 31, 71
Hillary, Sir Edmund 193, 201
Himalayas 8
Holmstrom, Tim 229
Hong Kong 186–91

Ice Trail Tarentaise 66–73
Ireland 108–15
Italy
 Dolomites Skyrace 140–5
 Limone Extreme 146–51
 Trofeo Kima 152–9
Itturieta, Zigor 32, 33
Iznik Ultra 180–5

Jebb, Rob 48
Jones, Dakota 8, 202
Jornet, Kilian 8, 42, 43, 85, 107, 118, 120, 124, 137, 145, 153, 154, 157, 159
Jurek, Scott 216, 217

Karnazes, Dean 216
Kasie, Enman 153
Kaspersen, Yngvild 188, 191, 207
Kelly, Ron 216
Kendall, Danny 167
Kimball, Nikki 84–5, 161, 165
Kimmel, Megan 128–33, 134, 142–3, 145
Knights Templar 74–5
Krar, Rob 216, 217
Kremer, Stevie 38, 112, 122, 125, 134
Krupicka, Anton 24, 28, 44

La Palma 12–21
Laithwaite, Marc 98, 101

Lakeland 96–101
Langton, Kevin 212–13
Lantau 2 Peaks 186–91
Lanzarote 30–5
Larger, Paolo 145
Laval, Benoît 182
Lewis, Ben 55
Lightfoot, Ricky 38, 48
Limone Extreme 146–51
Little Hollywood 219
Lupton, Anna 48

Macdonald, Grant 105
Maddess, Michael 189
Madeira 36–9
Madiba, Thabang 171
Maiora, Maite 48
Malek, Zaid Ait 41, 47
Mallorca 60–5
mandatory kit 236
Mann, Jim 92, 95
Marathon des Sables 160–9
Marchetti, Pierangelo 154
Matt, Mark 173
Mattei, Peter 216
Matterhorn Ultraks 128–37
Meek, Jo 98, 101, 109, 111, 112,
 167, 229
Menorca 60–5
Men's Running 105
Meraldi, Fabio 146, 148, 150, 151,
 157
Merillas, Manuel 143
Middleton, Owen 173
Mira Rai 45
Mityaev, Dimitry 186
Moehl, Krissy 84
Mont-Blanc 78–83
Morgan, Carol 97
Morgan, Casey 61, 62, 65
Morocco 160–9
Mourne Skyline MTR 108–15
Mourne Wall 108, 111
Mudge, Angela 48
multi-day races 138, 162
Murphy, Mile 230

Nass, Jameson 213
Nepal 192–201
Newton, Arthur 168

Nicea 180
Nichols, Alex 83
Norway 116–21

Odabasoglu, Caner 177, 180
Ohly, Shane 92–3, 102, 104, 107
Olmo, Marco 35, 85
Olson, Timothy 24, 216, 217
Orgué, Laura 142–3, 147, 189
Owens, Tom 48, 138, 139

Paffenbarger, Ralph 216
Paris, Jasmine 92, 95
Pascall, Beth 92
Picas, Nuria 24, 25
Pichrtová, Anna 124
Pivk, Tadei 49, 140
poles 236
Polyakova, Elena 183
Pont, Jean-Claude 124
Portugal 36–9

race vests 236
Rai, Mira 118
Ranger, Marina 16
Redondo, Salvador Calvo 224, 225
Reed, Robyn 213
Reiter, Philipp 138, 139
Rezac, Jason 210
Richtersveld Transfrontier Wildrun
 170–9
Ronda dels Cims 52–9
Run the Rut 204–9

Sa, Carlos 38
Sagarmatha National Park 201
Saintélyon 74
Salt, Zoe 181, 182
Sandes, Ryan 11, 29
Schwarz-Lowe, Adam 213
Scotland 102–7
Scotney, Marcus 183
Semler, Lesli 213
Sharp, Hilary 88
Sherpa, Dawa 75, 85
Shirman, Ken 216
Shvetsov, Leonid 169
Sierre–Zinal 122–9
Simpson, Robbie 122
skyraces 236

Skyrunner World Extreme 102
skyrunning 68, 102, 153, 236
Skyrunning World Championships
 71
Sleuyter, Steven 219, 220
soft flasks 236
Soggot, Katya 171, 177
Soto, Aydee Rayda 63
South Africa
 Comrades Marathon 112,
 168–9
 Richtersveld Transfrontier
 Wildrun 170–9
Spain see also Canary Islands
 Trail Menorca Camí de Cavalls
 60–5
 Ultra Pirineu 40–5
 Zegama–Aizkorri 46–51
Storkamp, John 211, 212
Suckling, Sandy 219
Superior 100 210–15
Superior Hiking Trail (SHT) 212
switchbacks 236
Switzerland
 Matterhorn Ultraks 128–37
 Sierre–Zinal 122–9
Symonds, Andy 75–6, 77, 138,
 139
Symonds, Joe 102, 105, 106

Tamang, Samir 197
technical trails 236
Tenzing Norgay 193, 201
Tevis Cup 216
Thompson, Dan 193, 198
Thompson, J. Marshall 111
Tierney, Paul 97
Timanfaya National Park 35
Tompsett, Gary 102, 107
Trail Menorca Camí de Cavalls
 (TMCdC) 60–5
Trail Menorca Costa Nord (TMCN)
 62, 64
Trail Menorca Costa Sud (TMCS)
 60–2, 64
tralls 236
Transgrancanaria 24–9
Transalpine-Run 138–9
Transvulcania Ultramarathon 8,
 12–21

Trason, Ann 216
Trekking Costa Sud (TCS) 62
Tressider, Esmond 102
Trofeo Kima 152–9
Tromsø SkyRace 116–21
Turkey 180–5
Twietmeyer, Tim 216

Ultra Pirineu 40–5
Ultra Skymarathon Madeira 36–9
Ultra-Trail du Mont-Blanc (UTMB)
 80, 84–9
United Kingdom
 Dragon's Back Race 90–5
 Glen Coe Skyline 102–7
 Lakeland 96–101
 Mourne Skyline MTR 108–15
USA
 Grand to Grand 218–27
 Run the Rut 204–9
 Superior 100 210–15
 Western States 216–17

Valero, Anne 69, 73
Vanoise National Park 68
vertical gain 236
Vigil, Pablo 124, 125, 126
Villegas, Roiny 229, 230
VK routes 236
Vollet, Greg 77
Vouillamoz, Damien 68

Wales 90–5
Warburton, Caine 202, 203
Wardian, Mike 229
Western States 216–17
Whitaker, Helene 92
Wild, Finlay 102, 105
Wraith, Lizzie 92, 112, 114
Wyatt, Jonathan 124, 127

Y
Yen Po Chen 219

Z
Zegama–Aizkorri 46–51
Zermatt 128
Zinca, Ionut 143
Zion National Park 223

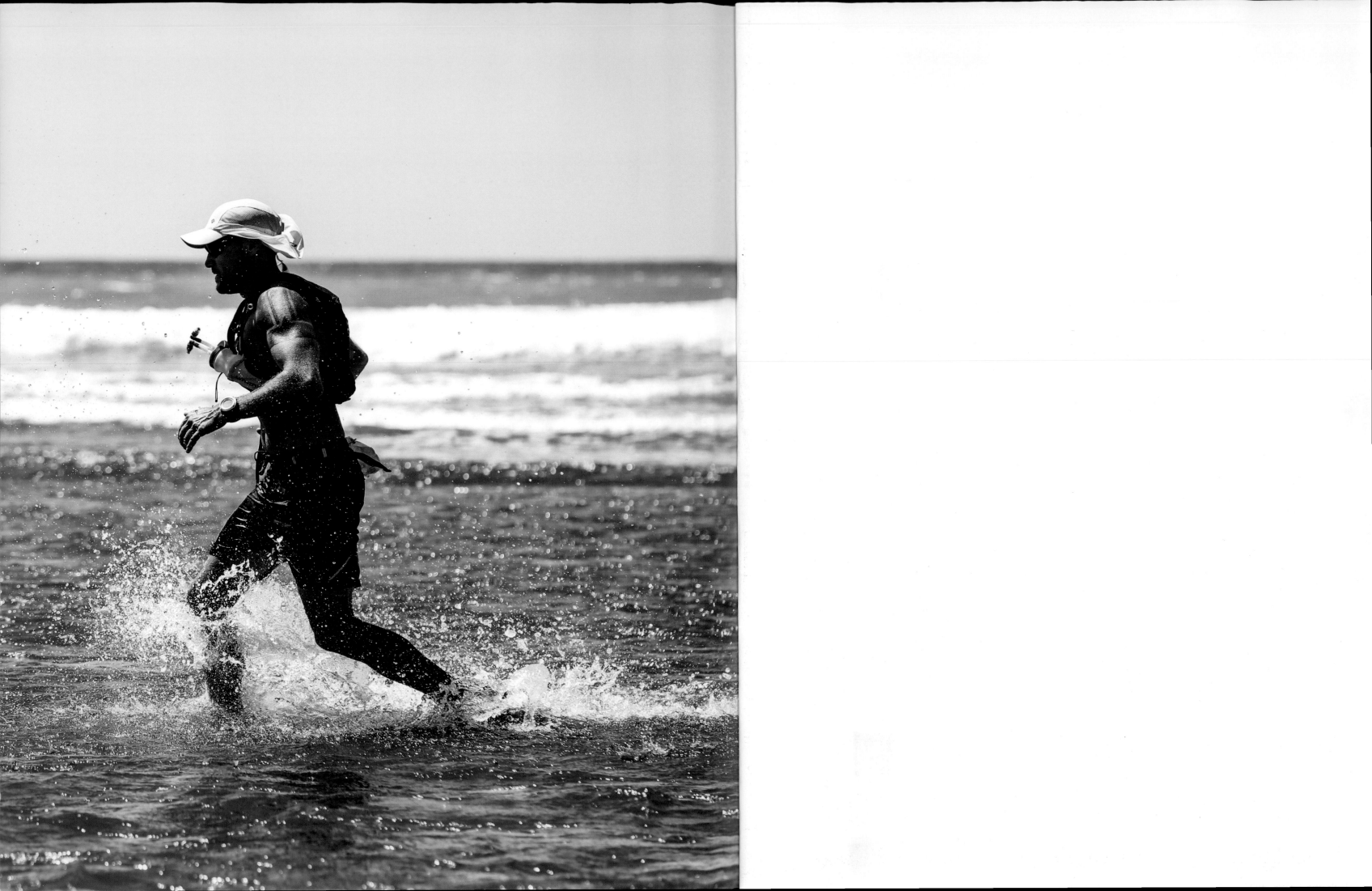